Romantic Art

Romantic Art

WILLIAM VAUGHAN

New York and Toronto
OXFORD UNIVERSITY PRESS
1978

CONTENTS

For Pek

Preface

The undertaking of this book was motivated by the somewhat outmoded conviction that the term 'Romantic' has a positive meaning for the art of the early nineteenth century. It is a conviction that has grown in the writing.

Much of the opening and concluding chapters has been given over to a consideration of the uses of the word during the period. At times this has led to citations of unpublished or little-known sources, and where this is the case I have included references in the chapter bibliographies. As this book is intended as an introductory characterization, however, it did not seem appropriate to garnish it with notes.

Like most writers on Romanticism I have adopted the convention of spelling the word Romantic with a capital 'R' when referring to the movement or specific theories, and a small 'r' when using it in a more general sense.

My principal debts to published works are recorded in the bibliography. I owe more than I can remember to Anita Brookner and Michael Kitson (my ever-patient supervisor), both of whom kindled my enthusiasm for the period when I was a student. I am also greatly indebted to Anita Brookner – as to David Bindman – for reading this book in manuscript form and being so generous with their help and advice. They have saved me from many follies – though not that of my own opinions. Among the many others who have stimulated and encouraged me in conversation are David Freedberg, John Gage, Timothy Hilton, Alexander Potts and Helen Weston. Like most teachers, I have found the help of my students invaluable.

It would be comforting to conclude like Montaigne that, since my memory is appalling, all my ideas must be my own; but alas I cannot. Too often, I am sure, I have presented other people's thoughts and observations as though they were mine. For all such plagiarisms I apologize.

W.V.

7

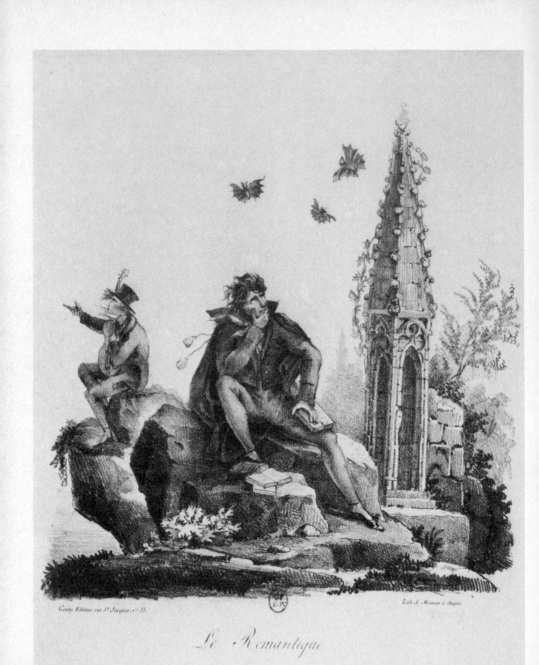

Genty Editeur, rue St. Jacques No 33. Lith de Mantoux à Angers.

Le Romantique

1 ANON. *The Romantic* 1825

Attitudes and ambiguities

The movement and the word

Whatever else is said about the Romantic movement, no one can deny that it really did happen. There really was a time in the early nineteenth century when to be a Romantic meant more than to be a dreamer or a love-sick youth; when an artist could accept the name with pride and take it to imply, as the writers Stendhal and Baudelaire did, that he was courageously facing the realities of his age.

While the significance of the word can be endlessly debated, the history of its use is not in doubt. The first writers and artists to become known as 'Romantics' were those associated with the German critics, the brothers August Wilhelm and Friedrich Schlegel, in Dresden at the end of the eighteenth century. Friedrich Schlegel himself provided the earliest definition of Romantic poetry – 'progressive universal poetry' as he called it – in their magazine *Athenaeum* in 1798. The name stuck and soon spread throughout Germany to describe all those who, like the Schlegels, believed the modern world to be spiritually incompatible with that of classical antiquity. A decade or so later this meaning of the word was exported by the French *littératrice* Madame de Staël, when her review of contemporary German culture, *De L'Allemagne*, was published in 1813. It was she who, as Samuel Taylor Coleridge was to remark a year later in the *Quarterly Review*, 'made the British public familiar with the habit of distinguishing the productions of antiquity by the appellation *classic*, those of modern times by that of *romantic*'. And it was this habit that generated so much controversy throughout Europe over the next four decades and then seemed to become irrelevant.

Like most uncontroversial statements, this history does not tell us much. It certainly does not tell us why the name was adopted.

It would be easy to follow the anonymous artist, and to suggest the whole business amounted to no more than a fad – a fashionable pretext for eccentrics and idlers to indulge their proclivities. Yet a word does not generate controversies – certainly not ones that rage over half a century – unless it seems to touch upon some fundamental issues. As the French poet Charles Baudelaire put it in his Salon review of 1846: 'Few people today will

1

want to give a real and positive meaning to this word; and yet will they dare assert that a whole generation would agree to join a battle lasting several years for the sake of a flag which was not also a symbol?'

Baudelaire's challenge was timely. For it came when the movement was sinking into apathy and outworn gestures. But who had actually been fighting? Certainly not the painter Eugène Delacroix, whom Baudelaire had especially in mind when talking of Romanticism. For this artist, despite the reputation he had acquired as a leader of the French 'Romantiques' in the 1820s, declared himself to be *pur classique*, and was disdainful of those who thought otherwise. This pattern could be repeated throughout the arts. In literature, for example, the English poet Byron, the proverbial romantic hero in his wayward life, considered the debate to be of no importance: while the German poet Goethe, the author of those two paradigms for the Romantics, *Werther* and *Faust*, denounced the movement as a disease.

Indeed, if one were to restrict the name to those who themselves adopted it, one would be left with a meagre and largely undistinguished assortment. In the visual arts it would amount to little more than a group of minor German painters active around 1800, and the lesser followers of Géricault and Delacroix in France after the end of the Napoleonic wars in 1815. A list of artists who were from time to time known as 'Romantics' by their contemporaries would certainly be more prestigious, and would include a majority of the leading painters working in the period 1800–50 – notably Goya, Géricault, Delacroix, Turner, Blake, Runge and Friedrich. Yet it would still leave out many, such as Constable, who now seem to us also to have been affected by the movement.

Part of the trouble lies in the difficulty of deciding whether to look upon Romanticism as an explicit movement or as a symptom of the times. Nor is this dilemma a modern fabrication, for it was in this period that this kind of question first arose with the claim that dominated cultural history for so long, that, as the poet P.B. Shelley put it in *A Defence of Poetry* (1821), artists reveal in their productions 'less their spirit than the spirit of the age'.

A 'spirit of the age' is proverbially elusive, and little would be gained here from attempting to define one for the early nineteenth century. Yet one cannot get far in the appreciation of any work of art without considering the concerns that lay behind it, the preoccupations of the artist when creating it, and the expectations it was intended to fulfil. The essential point here is that the word 'Romantic' was used by certain contemporaries in an attempt to isolate the central concerns of the day, and that their characterization was sufficiently telling to provoke prolonged discussion and reaction. It is this debate that forms the starting-point for this book. Since the course that this took is so varied it seems best to link it with an historical account of the art it

involved, and to save more general conclusions to the last chapter. Two fundamental issues, however, can profitably be mentioned here. The first – which will be discussed in the succeeding section of this chapter – concerns pictorial method, the extent to which Romanticism can be identified with stylistic as well as thematic tendencies. The second – which will be considered in the concluding section of this chapter – concerns the Romantic claim, that fatal assumption of universal relevance which Shelley made in the passage cited above, and which involved artists in such ambivalent relationships with the political and social upheavals of the time.

Towards a Romantic style

Baudelaire's defence of Romanticism in 1846 was more than a statement of belief. For he not only claimed the word stood for a real issue, but also hinted, through the image of a 'flag' which was also a 'symbol', at the mode of expression it represented. It was by an emphasis on association that the Romantics sought to find an approximation for their intimations in the material world. When A.W. Schlegel, inspired by contemporary metaphysics, called beauty 'a symbolical representation of the infinite' in the lectures on aesthetics that he gave in Berlin in 1801–2, he was indicating a special way of responding to a work of art, finding in its appeal the suggestion of a deeper and otherwise unknowable reality behind what can be perceived.

Since such ideas are concerned largely with interpretation, it is often felt that Romanticism is no more than an attitude of mind. It is certainly true that one cannot catalogue a Romantic style by means of an inventory of features, for the sense of a heightened reality can be felt as much in the dramatic bravura of a Delacroix like *Liberty Leading the People* as in the intense precision of a Caspar David Friedrich like the *Arctic Shipwreck*. But nor can one look upon Romantic art as the mere illustration of a set of ideas (an attitude that has often led Romanticism to be seen as 'unpictorial', something that has its place, no doubt, in literature but could only lead to a confusion of values in the visual arts). If a poem can indissolubly link a feeling and a rhythm of sounds, then a picture can also encompass the duality of imagery and form. And the way in which the former is suggested by the latter is a purely pictorial affair.

In this stylistic context the term 'romantic' can assume a role that still has a meaning for us today: as the opposite of the term 'classical'. While 'romantic' can be seen as describing the work of art that emphasizes the associative side of picture-making, 'classical' can be taken to describe the work that dwells on formal values. This was the distinction adopted by the Schlegels who, with predictable partisanship, associated 'romantic' with the spiritually

12
108

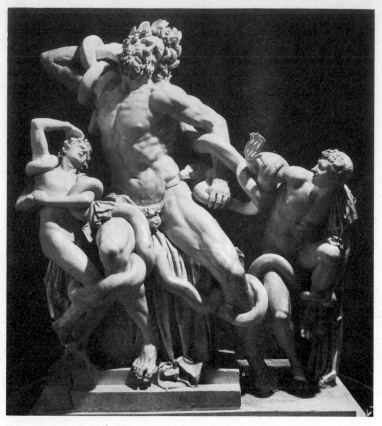

2 ANON. *Laocoön* 2nd–1st c. BC

inspired art of Christianity, and 'classical' with the pagan and, to them, physically orientated art of antiquity. They were in fact the first people explicitly to make this association: but in doing so they were joining a debate which had begun before them.

The question of inherent values in the visual arts is intimately connected with the age-old discussion on the comparison of painting to poetry. For the latter, being composed of words, seemed more fundamentally descriptive than the former. This debate had taken on a new life in the late eighteenth century when the critic and scholar Johann Joachim Winckelmann, the most influential advocate of the revived interest in Greek art, had wished to praise the comparative placidity of antique sculpture, which seemed to be at variance with the dramatic descriptions that can be found in classical poetry.

Using, improbably, the example of the Late Hellenistic and highly impassioned *Laocoön* group, he argued a stoic virtue for his heroes, detecting the deepest and noblest passions raging beneath their calm exteriors. The curiousness of this conclusion incited the Hamburg philosopher Gotthold Ephraim Lessing to propose another explanation in *Laokoon* (1766). Accepting the assertion that classical sculpture – including the *Laocoön* – was invariably tranquil, he attributed this to the inherent difference between art and poetry. Art was concerned with the presentation of a flawless beauty. Any display of strong emotion in a figure would distort its formal perfection; while a poet could describe an impassioned moment without endangering the correctness of his metre. In all classical art purity of form must come first; and in the visual arts this implied an almost total curtailment of expression.

The opinions of these theorists – neither of whom, incidentally, had seen a major Greek sculpture when they were writing about *Laocoön* – might have been of limited value to artists had it not been for the effect they had on informed taste and educational practice. As it was, no aspirant could pass through the art academies of the day without hearing of the calm repose of beauty in its pure state. Thus the students of the London Royal Academy in 1772 could hear their President, Sir Joshua Reynolds, warn them in his Fifth Discourse: 'If you mean to preserve the most perfect beauty in *its most perfect state*, you cannot express the passions, all of which produce distortion and deformity, more or less, in the most beautiful faces.'

He added, for those who felt depressed by such a restriction of their powers: 'We need not be mortified or discouraged at not being able to execute the conceptions of a romantic imagination. Art has its boundaries, though imagination has none.'

In using the word 'romantic' to defend the free expression of imagination and association in the arts, therefore, the Schlegels had chosen their name with care. They had taken a term that had already come to mean for academic theorists and the admirers of classical art those emotive extremes that lay beyond the proper sphere of the artist to depict. Even in poetry, despite the greater descriptive potential conceded to words, there were limits; for imagination was not to be allowed to disturb the clarity of narrative or form.

The word 'romantic', in fact, derived precisely from the kind of poetry that was felt to display such irregularities, the chivalric romances of the Middle Ages. Since the Renaissance the word had come to mean, as it did for Reynolds in the quotation above, all that was wild and fantastic, 'that imagination which is most free', as one early commentator, the philosopher Henry More, had expressed it in 1659.

3 TURNER *Heidelberg Seen from the Opposite Bank of the Neckar* 1844

In the pictorial sphere the word had evolved from this to describe sights that excited the imagination and led to reverie. When touring the English Midlands in 1794, the young J. M. W. Turner noted in his sketchbook that Nottingham Castle was 'romantic situated'. It is hard to divine what he meant by this from the later view he designed of Nottingham for his *Picturesque England*; for the castle is hardly situated here at all. Its squat form is cut off by the upper left edge of the picture, and one is left to conclude that in fact the *only* thing that Turner found romantic about it was its situation, the way it rose steeply above the surrounding town. However, Turner drew many other castles, and some of these combined the scenic advantages of Nottingham with greater inherent qualities. One such was Heidelberg, whose romantic properties had been noted by the philosopher Friedrich von Schelling during a visit in 1796: 'The castle hovers above the town and dominates it completely, increasing the romanticness of this moment. In the background, the ruins, resting in the dusky twilight.'

Ancient castles were only one kind of image to be noted for this kind of evocative quality. One could quote such examples as the 'romantic' branches

4 TURNER *Nottingham Castle* 1838

of a giant oak, 'grotesque and romantic' waterfalls or 'wild and romantic' mountains. Our own understanding of the word is similar enough for us to imagine in most cases what was meant in the eighteenth century when reference was made to a 'romantic' scene. Only occasionally does the designation seem curious, as in the title of a picture exhibited by Sir Francis Bourgeois at the Royal Academy in 1792 – *Romantic Scene with Goats*.

'Romantic art' – as opposed to the depiction of romantic scenes – began in a quite literal sense. The first painters actually to be described as working 'in a romantic style' were the Germans Franz and Johannes Riepenhausen. They were called such by the painter Franz August Klinkowström when writing to his friend Philipp Otto Runge on 27 June 1804. Artists of – to put it kindly – indifferent talent, the Riepenhausens gained their epithet through their adoption of the medievalizing subject-matter, the 'romances', favoured by the Schlegel circle in Dresden. It may seem curious that the works described by Klinkowström as being 'in a romantic style' – a series of scenes from the poet Ludwig Tieck's *Life and Death of St Genevieve* which were subsequently engraved in 1806 – should have been drawings in outline. For this sparse

6

5 FLAXMAN *Close to her Head the Pleasing Vision Stands* 1793

technique is normally associated with classical values. It was certainly used by the Neo-classicists of the late eighteenth century as a means of grasping the essence of form. This can be seen in the most famous outline drawings of the period, the illustrations of scenes from Dante and Homer by the English sculptor John Flaxman which circulated, in their engraved form, throughout Europe.

However, by the time the Riepenhausens came to design their outlines the method had been interpreted in a different light by their Romantic mentors. For when A.W. Schlegel reviewed Flaxman's outlines in his magazine *Athenaeum* in 1798, he dwelt not upon their formal succinctness but upon their evocative potential. Outline seemed to him the pictorial method that came closest to the allusive manner of poetry, since its sketch-like quality 'incited the imagination to complete' the details of the scene. Flaxman himself held firm to the classical notion of outline. As his friend Crabb Robinson noted in his diary, the sculptor disparaged Schlegel's appraisal of his work and felt that German artists had misunderstood its method completely. He reduced the details in his scenes, he emphasized, so that they

should not obscure the purity of the design. This is certainly borne out by his designs. As in an antique frieze, his heroes pose in a vacuous world, a timeless pattern of rhythms and arabesques. The Riepenhausens, on the other hand, use the schematic style for a truly Schlegelian evocation. The altar, religious trappings and architectural details in this scene are hinted at with as many clues as are the principal figures. The artists are intent upon inciting the imagination with a sense of historic atmosphere – with the religious devotion of the Middle Ages.

Although one cannot talk of a Romantic style, therefore, it can be seen that the notion of Romanticism, wherever it encountered the visual arts, did involve formal changes. The modifications that romantic attitudes brought about in outline drawing were to be matched and emphasized in many different art forms in the decades to come.

6 FRANZ AND JOHANNES RIEPENHAUSEN From *Life and Death of St Genevieve* 1806

In striving to express the ideal in terms of the real, the Romantic experienced both the exhilaration of acting as a prophet and the depression of coming to terms with everyday experience. And this accentuated an ambiguity in the artist's position; for while he had elected to be the spokesman for the 'spirit of the age', it was not clear whether he should do this by addressing his contemporaries or simply by recording them. If Shelley could triumphantly affirm in *A Defence of Poetry* (1821) that poets 'are the unacknowledged legislators of the world', the French novelist Charles Nodier could formulate, in *Mélanges de littérature et de critique* (1820), the passive side of the situation: '. . . romantic poetry springs from our agony and despair. This is not a fault in our art but a necessary consequence of the advances made by our progressive society.'

In both cases, however, there was a determination not to avoid the problems of the day. Nodier's ironic reference to 'our progressive society' reflected a bad conscience that had been growing in Europe since the middle of the eighteenth century. For it was at this time that the accelerating material progress in Western Europe led to the first serious doubts about the mores of civilized society.

No one had set himself up more successfully as the spokesman for these doubts in the eighteenth century than Jean-Jacques Rousseau. The true ancestor of Shelley's legislators, this thinker had inflamed Europe through his imagination; through his vision of a primeval liberated society in which all restricting conventions, even the ownership of property, were unknown. His *Social Contract* (1762), which expounded the notion of a primitive agreement which the rich and powerful had distorted to their advantage, provided with its stirring opening sentence, 'Man is born free, and everywhere he is in chains', one of the creeds for the French Revolution of 1789.

More important still was Rousseau's appeal to the emotions; for he claimed that human reason, when not accompanied by considerations of the heart, could act only in a way that was unproductive because insensitive. This doctrine was to cause the outburst of much irresponsible 'sentiment' among the fashionable; but it was also to provide a stimulus towards a timely humanitarianism. It was through following the dictates of his heart, for example, that the great reformer William Wilberforce devoted a lifetime to bringing about the abolition of slavery in the British colonies.

The slave trade represented one of the most heartless encounters between civilized Europe and the primitive societies in which its colonial interests were developing. At the same time as Rousseau was celebrating the harmonious existence of the uncorrupted 'Noble Savage', his fellow

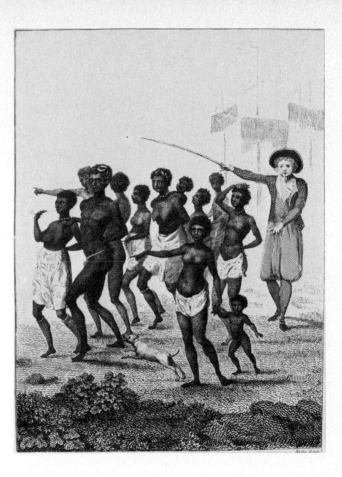

7 BLAKE *Group of Negroes, as Imported to be Sold for Slaves* 1796

Europeans were brutalizing these same people and forcing them to work the plantations of the New World. Both the obvious inhumanity of this practice, and, perhaps, the convenient distance at which it took place, made it one of the most unequivocal indictments of contemporary society for the liberals and humanitarians of the period. First-hand accounts of conditions in the colonies aroused great interest, and, when emphasizing the beauty, bravery and natural dignity of the slaves, became best-sellers. Such was Captain Stedman's highly popular *Narrative of a Five Years' Expedition against the Revolted Negroes of Surinam, in Guiana* (1796). It was appropriate that Stedman's friend William Blake should have been engaged, in his capacity as a commercial engraver, to provide some of the plates for this book. For Blake was an artist whose deep concern with enslavement on both a personal and a political level is made clear in his contemporary 'prophetic' books. It

7

can be no accident that his engraving of Negroes on their way to be sold should show many of the unfortunates in graceful classical postures.

No less distressing were the changes that progress was causing within Europe itself. The geometric multiplication of industrial potential which began in the cotton mills and iron foundries of the north of England brought about its own form of bondage in the development of sprawling slums and in the social isolation of the poor from the rich. By the 1830s even the most protected members of polite society could hardly ignore these consequences. For not only had the voice of the urban and industrial poor made itself heard in the Revolutions of 1830, but technological improvements, such as the development of the railways after 1840, began to affect people's way of life at a domestic level. It was to such a society that the architect A. W. N. Pugin
8,9 addressed his polemical *Contrasts* (1836). In the second edition of this the condition of a town in 1840 is compared to its state in the fifteenth century. Nor was this kind of criticism confined to the fanciful medievalist. It was equally appealing to the dour economist and historian Thomas Carlyle, who compared medieval and modern life, in his *Past and Present* of 1843, to point out the inequalities and spiritual poverty of the present age: 'We have more riches than any nation ever had before; we have less good of them than any nation ever had before.'

The ambivalent attitude of most observers, expressing admiration for the riches of imperialism and industrialization and horror at the human suffering that they had caused, was mirrored in the reactions of the artist. While Blake and Pugin uttered prophetic condemnations, others were overawed at the forces that had been released. Indeed, in the late eighteenth century, a whole new category of romantic imagery had emerged with the startling appearance of the industrial landscape. At times the two types of 'romantic' scenery, the idyllic and the dramatic, clashed as new factories encroached
10 upon the surrounding countryside, as in Coalbrookdale, in Shropshire, where blast furnaces emerged in a gently wooded valley. The local poetess Anna Seward, the 'Swan of Lichfield', lamented the despoiling of her favoured 'soft, romantic, consecrated scenes' by these intruders from the underworld; yet when the landscape painter Philip James de Loutherbourg visited the area to make drawings for his *Romantic and Picturesque Scenery of England and Wales* (1805) it was the intruders who monopolized his attention. The site was described in the text of the book as 'worthy of a visit from the admirer of romantic scenery no less than from the political economist', and Loutherbourg, who specialized in the dramatic, returned to the subject to create one of his most powerful oil paintings.

Equally telling were the artists' reactions to the political upheavals that followed on the Revolution in France in 1789. The libertarian outbursts of

THE SAME TOWN IN 1840

1.St Michaels Tower, rebuilt in 1750. 2. New Parsonage House & Pleasure Grounds. 3. The New Jail. 4. Gas Works. 5. Lunatic Asylum. 6. Iron Works & Ruins of St Maries Abbey. 7. Mr Evans Chapel. 8. Baptist Chapel. 9. Unitarian Chapel. 10. New Church. 11. New Town Hall & Concert Room. 12. Wesleyan Centenary Chapel. 13. New Christian Society. 14. Quakers Meeting. 15. Socialist Hall of Science.

Catholic town in 1440.

1. St Michaels on the Hill. 2. Queens Cross. 3. St Thomas's Chapel. 4. St Maries Abbey. 5. All Saints. 6. St Johns. 7. St Peters. 8. St Alkmunds. 9. St Maries. 10. St Edmunds. 11. Grey Friars. 12. St Cuthberts. 13. Guild Hall. 14. Trinity. 15. St Olaves. 16. St Botolphs.

8, 9 PUGIN *Contrasts* 1840

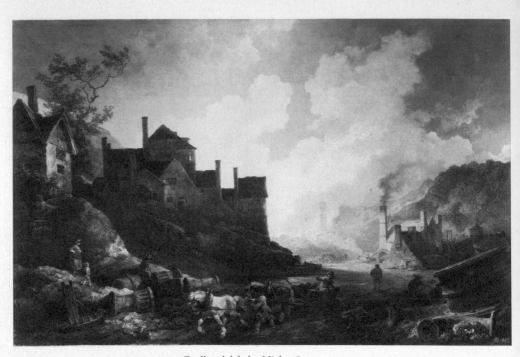

10 LOUTHERBOURG *Coalbrookdale by Night* 1801

the 1790s were countered first with the authoritarianism of Napoleon and then with the restoration of reactionary governments following his defeat in 1815; but the impact of revolution could never be eradicated. An ideal of democracy persisted through the nationalist movements in Greece, Italy, Germany and Eastern Europe and through innumerable local uprisings which culminated in the international Revolutions of 1830 and 1848. But if the revolutionaries of 1789 had been guided by the Rousseauian dictates of their hearts, the political agitators of the nineteenth century were learning a new language. While the events of the 1790s, in particular the Jacobin Reign of Terror in France, may not have destroyed the belief in liberty or even the faith in man's innate virtues, they had made it impossible to think that these could be exposed by a simple removal of existing constraints. What Baudelaire described as a 'sense of irreparable loss' had a very real meaning when applied to the memory of the Utopian dreams of the previous century. For those who still believed in what the poet Keats described as the 'holiness of the heart's affections', there was a persisting sense of disillusionment at the course of events. They were more aware of the tragedy and tedium of wars

and revolutions than of their achievements. In Spain the painter Goya was sufficiently aloof from the nationalist uprising during the Napoleonic wars to be later accused of collaboration with the French. The genuine compassion in his *Disasters of War* etchings is for individuals rather than for a movement, and the victims in his *Third of May* show fear rather than heroism. It is true that Byron went to fight for Greek independence in 1824, but he did so as a gesture of sympathy at a time when success was far from certain. It was the failures of the patriots at *Chios* and *Missolonghi* (Paris, Louvre), and not their ultimate triumph at the Battle of Navarino (1827), that were painted by Delacroix. Similarly, when this artist painted a celebration of an insurrection in his own country, the July Revolution of 1830, there was enough of the mock heroic about the result to seriously disturb those who saw it in the Paris Salon of 1831. Few of the Romantics spoke a clear political language, and it is not surprising that the revolutionaries of 1848, so much more radical than those of 1830, had little time for heartfelt emotions. They fought for very different ideals, inspired by the prophets of economic prediction.

No figure revealed the political ambivalences of Romanticism as completely as Napoleon. A classless man who climbed to be master of Europe, he was at the same time the product of the liberating forces of

11
64, 65
186
12

11 GOYA *It Will Be the Same* from the *Disasters of War* c.1810

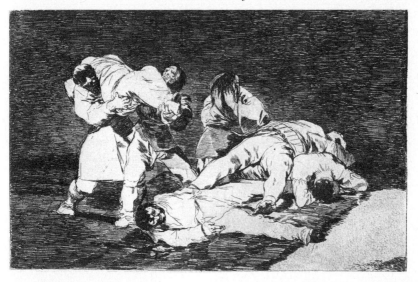

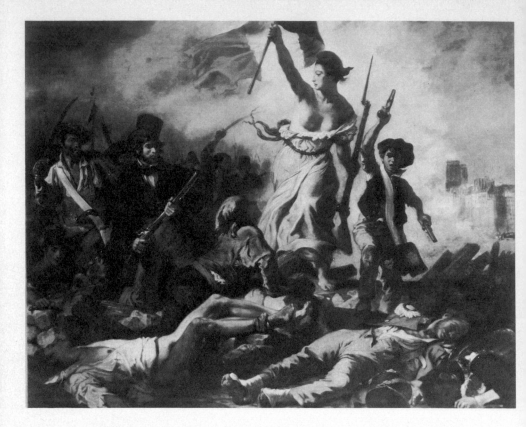

revolution and their downfall. During the years of his ascendancy many of the artists with liberal and republican sympathies who had formerly supported the French Revolution – like Blake, Wordsworth and Beethoven – were opposed to him. Those with similar sensibilities who adulated him – like his principal propagandist painter Gros – did not depict him as a victor but as a man of emotion, anxious in mid-battle, compassionately visiting the plague-stricken, or expressing horror at the consequences of war. It was not until after Napoleon's defeat that he became a fully Romantic hero, the martyred deity who presided over a myth of nostalgia until that too was defused later in the century in the unheroic outcome of the Second Empire.

Behind all these attitudes lay the determination never to let an idea or a theory submerge an emotion. And while no serious artist of the period denied the hard work, study and calculation involved in the creation of a work of art, all this was meaningless without the artist's inspiration. As the landscape painter Caspar David Friedrich said: 'The artist should not only paint what he sees before him, but also what he sees within him. If, however,

24

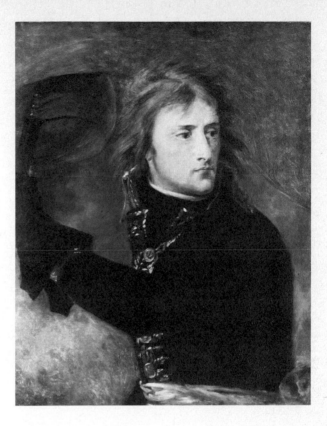

12 DELACROIX *Liberty Leading the People* 1830

13 GROS *Napoleon at Arcole* 1798

he sees nothing within him, then he should also omit to paint that which he sees before him.'

To preserve this inner inspiration the artist had to be prepared to run the risk of isolation, and this was certainly the price paid by Friedrich and Blake. But it was not always a matter of individual choice: artists in general were becoming isolated by social changes, by the growing anonymity of their audience. Private patronage did not cease in this period, but it certainly became a less significant outlet than the exhibition. The annual academy exhibition, which had become established throughout Europe by the late eighteenth century, increased in importance as an artistic and fashionable event throughout the period. The extent of its authority by the mid nineteenth century can be gauged by the concern with which *avant-garde* artists, such as the Pre-Raphaelites and the Impressionists, viewed the possibility of exclusion.

On the whole, artists welcomed this change, for the new purchaser was a customer, who was expected to buy what was on offer, and pay the asking

14

25

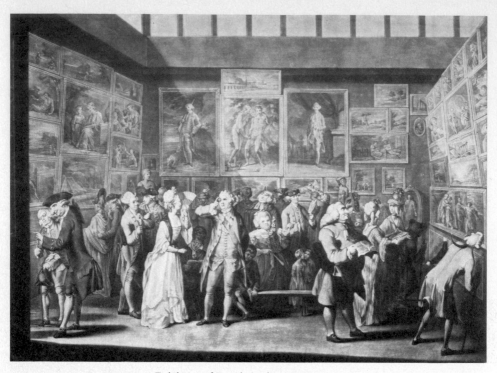

14 BRANDOIN *Exhibition of Royal Academy Paintings* 1771

price. 'Liberality, we want not liberality,' wrote Blake, against a part of Reynolds' *Discourses* that seemed particularly toadying in its adulation of noble munificence – 'we want a fair price and proportionate value and general demand for art.'

Yet, although the 'general demand' was anonymous, it was not passive. A public audience had to be addressed in public terms, in terms of the events that were considered most important, the books that were most read, the plays that were most attended and the fantasies that were most familiar. And even if the artist was successful, he could no longer be sure what that success was, what use his work had been put to.

His fate might be that of the poet described in Kierkegaard's *Either/Or* (1843), who 'is like . . . the unfortunate victims whom the tyrant Phalaris imprisoned in a brazen bull, and slowly tortured over a steady fire; their cries could not reach the tyrant's ears so as to strike terror into his heart; when they reached his ears they sounded like sweet music'. The artist who claimed to be the conscience of his time might be doing no more than providing it with entertainment. In an age of artistic ambiguities, this was the greatest.

26

Hope and fear

Rousseau's legacy

Every movement creates precursors. For one so wide-ranging as Romanticism they can be legion. Extremists like Friedrich Schlegel saw the whole of the post-classical world as Romantic, and commentators have found the necessary ingredients in virtually any artist who experienced frustration or expressed in his works a sense of longing or incompleteness. The exaltation of a Gothic cathedral, the struggles of Michelangelo, the reflectiveness of Rembrandt and even the ingenuity of the Greek painter Timanthes – in whose works, according to Pliny, 'more is suggested than is actually painted' – have all been seen as proto-Romantic.

These examples show the ubiquitousness of romantic attitudes; but they do little to explain the historic occurrence of the movement around 1800. For this, even close precedents can be deceptive. Thus the seventeenth-century cult of melancholy – evident in Milton's poem *Il Penseroso*, as in Jacob van Ruisdael's soulful depictions of his native heathlands – belongs to a different world: it is part of a Renaissance intellectual tradition, and while it encourages reflection, it is not transcendent. In Jacob van Ruisdael's *Jewish* 15 *Cemetery* we are made aware of mortal frailty; but there is no enigma. The keynote to the scene, the barren foreground tree, sets off a progression of images that culminate – in this version – in the rainbow, God's promise, behind the ruin. Formally, too, there are no surprises: the space is clearly defined, its recession calculated at every stage.

Only with the growth of that doubt that Rousseau exploited did such sentiments become more than a mode of expression and threaten to alter the structure of experience.

When he made emotion the guide to reason, Rousseau endowed it with a peculiar optimism. The image of a golden age, a state of innocence from which man had fallen, was hardly a novel one; yet no one had asserted before that this lost world could be rediscovered through the exploration of one's own natural predilections. Reflection led to liberation; and when the English editor of Rousseau's *Dialogues*, Sir Brooke Boothby, had himself portrayed 16 by Joseph Wright of Derby, the result was a new image of contemplation. For while Sir Brooke Boothby seems at first glance to show all the

traditional attributes of melancholy – stretched carelessly on a grassy bank by a stream, coat and waistcoat unbuttoned, book in hand, head supported by the right arm – there is no despair in his gestures. The book that he is holding – as the forefinger of his left hand indicates – is by Rousseau. It is almost as if he had been reading the passage in the *Confessions* where Rousseau speaks of the moment of revelation that inspired him to write his first work, the *Discourse on Inequality* (1750): 'Deep in the heart of the forest I sought and found the vision of those primeval ages whose history I bravely sketched.' Behind him, through the darkness of the woods, can be glimpsed an idyllic countryside; while a soft golden light pervades the scene.

However, Rousseau's legacy was a dual one. He believed in natural goodness and in the need to follow one's innate emotions; but what if the natural world were not fundamentally harmonious and beneficial? What if there were a darker side to nature? The followers of Rousseau had to make a

15 RUISDAEL *Jewish Cemetery c.*1670

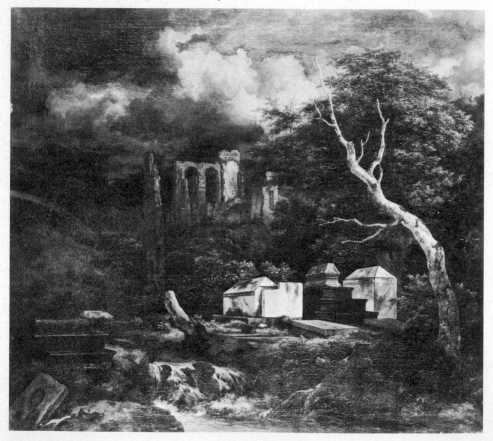

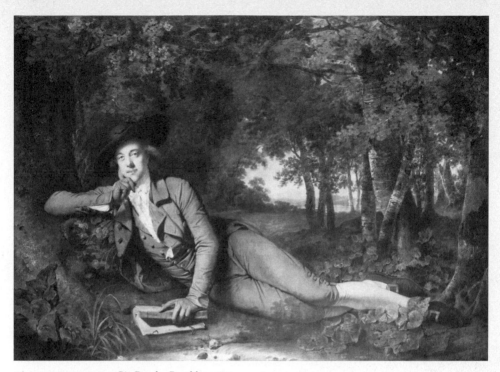

16 WRIGHT OF DERBY *Sir Brooke Boothby* 1781

choice. Either they could strive towards the liberation of 'natural man', or they could explore the full range of their emotions – wherever that might lead.

This dualism found a parallel in the divergent tendencies in the art of the period 1750–90. On the one hand there was an optimistic and affirmative classical revival – in which Rousseau's sentimental adulation of the primitive was allied to a purified concept of ideal beauty. On the other there was an increasing curiosity about those more equivocal kinds of aesthetic experience for which the concept of beauty did not apply. It was in this context that the terms 'sublime' and 'picturesque' took on key importance. Even the word 'romantic' assumed a new significance. Indeed, if it had not been for the subsequent development of a theory of Romantic art the word might still be chiefly associated with a meditative form of late eighteenth-century sentiment. Ultimately this exploration of the darker side of experience – abetted by the science and pseudo-science of the day – was to develop expressive dimensions and a psychological awareness that lay beyond the reach of any system of classification.

29

Classicism and the primitive ideal

The association between classicism and 'natural sentiment' was already clearly stated in the work that was most influential in publicizing the revived interest in the antique, Winckelmann's *Thoughts on the Imitation of the Art of the Ancients in Painting and Sculpture* (1755). At the time when this book was published its author – a German scholar of humble origins – was on the point of settling in Rome. Here he was to become the leading authority on antique art, pioneering methods of research and analysis that have laid the basis of modern classical studies. In this early work, however, his main aim was not to present new evidence but to draw attention to himself, and this he did most successfully by allying the antique world with fashionable contemporary preoccupations.

He began the polemic by suggesting that the supreme virtues of Greek art derived from the natural condition in which its creators lived. He even invoked the image of the contemporary 'noble savage' to demonstrate the physical perfection of the Greeks: 'Look at the swift Indian, as he hunts the stag on foot: how easily the blood courses through his veins; how supple and swift will be his nerves and muscles, how lithe his whole body! Thus Homer depicts his heroes.'

The fallen state of modern man was epitomized by his physical shortcomings, and it was only through the imitation of the 'noble simplicity and calm grandeur' of antique art that one could hope to recover the innate taste and ennobling sense of beauty of that lost world.

The emulation of the antique had never ceased since the Renaissance; but the artists who came under Winckelmann's spell in Rome in the 1760s displayed a new classicism of calculated simpleness that is sometimes charming and sometimes very dull. Winckelmann's principal familiar, the Dresden-born painter Anton Raphael Mengs (1728–79), is mainly remembered for the blandness of his ceiling fresco *Parnassus* (1761) in the Villa Albani in Rome; an innocuous pastiche of classical statuary and High Renaissance postures. Winckelmann declared that Raphael himself would have bowed before it, but if he had done, it would probably have been in embarrassment at the plagiarisms from his own fresco of the same subject in the Vatican. Yet even Mengs has a more appealing side, which can be seen in his portraits and in such anecdotal compositions as *Cleopatra before Octavius*, where the Egyptian queen beguiles the Roman commander with an affecting humility, and a decorous display of feminine charms. Nor can this kind of work be characterized simply as a reworking of the compositions of such classicizing artists of the seventeenth century as Poussin. For not only is the design less complex than any of these, it is also more intimate. The softened forms of the figures are reminiscent of those in the Late Roman domestic

17

wall-paintings that were then being uncovered in Herculaneum and Pompeii; while their gestures and expressions show them to be creatures of sentiment.

If Neo-classical painters in Rome could be responsive to the nobility of the primeval times, the explorers who came into contact with actual primitive cultures could believe that they had rediscovered antiquity. Often members of tribes in the Americas and the South Sea islands were given such names as Agamemnon, Hercules and Aphrodite, despite their most un-Grecian appearance and behaviour. The lands they lived in were similarly idealized. When William Hodges (1744–97) accompanied Captain Cook on his second voyage to the South Seas in 1772 in the capacity of official landscape painter he recorded such startling new sights as boiling craters in the sea and exotic New Zealand mountains. Yet when he presented such sights to his contemporaries in his exhibition oil paintings they emerged couched in the language of the classical landscape. In his often repeated views of Tahiti the 18 palms and the striking mountains fade into the distance as though viewed

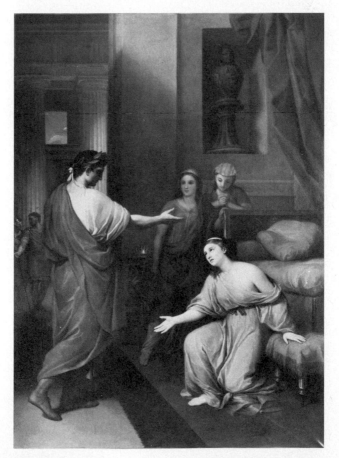

17 MENGS *Cleopatra before Octavius* 1760

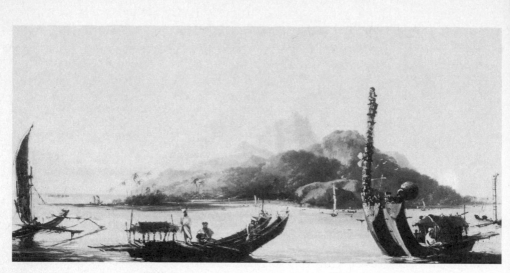

18 HODGES *Tahiti* 1772

across the Roman Campagna. In the foreground the natives disport themselves in Arcadian ease.

The sentiment and idealism behind this Neo-classicism has often led to it being seen as yet another manifestation of Romanticism. Certainly it revealed an attitude to antiquity that could not have been dreamed up in any other age. Yet it remained distinguished by the un-Romantic, rationalistic, conviction that reason and natural sentiment lay in perfect alignment. Its idealism was one of a logical system of moral values. The natural descendants of the gently optimistic paintings of the 1760s in Rome are the heroic canvases of David, where sentiment has become the servant of propaganda.

38

The Sublime

The momentous step of exploring the broad range of human emotion was taken, almost simultaneously with the publication of Winckelmann's first book, with the *Philosophical Enquiry into the Origin of our Ideas of the Sublime and the Beautiful* (1757) of the Anglo-Irish statesman Edmund Burke. Since the treatise of the late classical author Longinus it had been recognized that aesthetic pleasure could be stimulated not only by the awareness of beauty, but also by a more mysterious and elating experience known as the 'Sublime'. However, Longinus had considered the Sublime to be in effect an overpowering form of beauty, and associated it with the Neo-platonic belief which saw the ultimate perfection of earthly forms in Heaven, to suggest

that it provided the closest experience of the Divine. Burke's view, on the other hand, was less elevated. His approach was psychological, for he was concerned with the roots of emotion. He reasoned that man's two most powerful feelings were love and hate, expressed as attraction and repulsion. While a sense of beauty was aroused by those objects that seemed attractive, a sense of sublimity was induced by those objects whose properties seemed repellent, such as excessive size, darkness or infinite extension.

Burke's theory was vital to the Romantics both because it emphasized the suggestive quality of art and because it gave a new importance to the disturbing. The artist who concentrated on this now was not simply engineering a Baroque thrill; he had become an explorer. For Burke's notion of the Sublime emphasized that man was disconcerted primarily by that which lay beyond his control or comprehension. Ultimately repulsion could become a new means of intimating the Ideal which, for the Romantics, was always unknowable. Shelley, for example, declared that 'sorrow, terror, anguish, despair itself, are often the chosen expression of an approximation to the higher good'.

19 PIRANESI *Pyramid of Caius Cestius* 1748

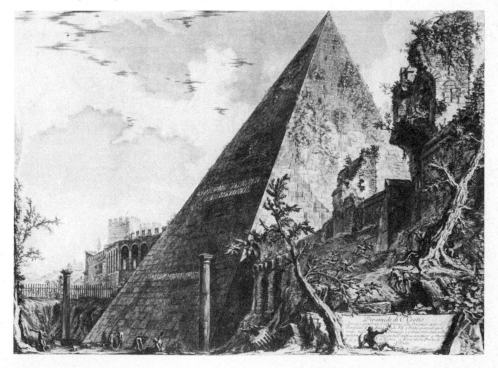

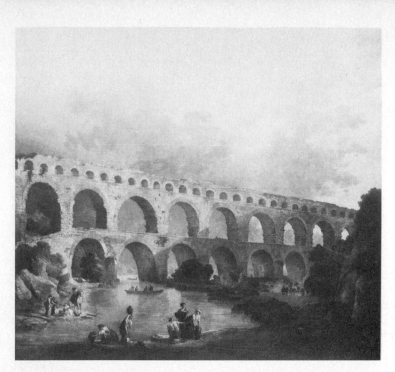

20 ROBERT *Pont du Gard* 1786

21 PIRANESI *Carcere d'invenzione* 1745–61

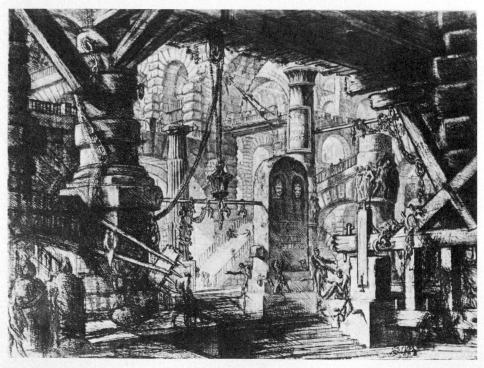

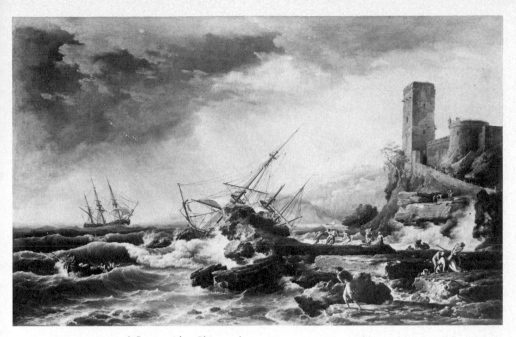

22 CLAUDE VERNET *A Storm with a Shipwreck* 1754

Burke was himself a connoisseur and a friend of artists like James Barry. Yet while his enquiry includes an analysis of the pictorial manifestations of the Sublime, his conceptions here are limiting. Just as his image of beauty suggests no more than an insipid prettiness, so he sees sublimity essentially in terms of exaggeration and excess. In this he was following rather than leading the artists of his time. Rococo and Early Neo-classical art rarely surpasses the pretty, while the current masters of the frightening worked principally through distortions of shape, scale and lighting.

This was emphatically the case with Giovanni Battista Piranesi (1720–78), a Venetian-born architect and engraver who settled in Rome in 1740. From 1745 onwards Piranesi built up an international reputation for his *vedute*, engraved views of the monuments of Rome in which proportions are exaggerated to provide an overpowering sense of grandeur. In 1771 the English connoisseur Horace Walpole wrote of 'the sublime dreams of Piranesi, who seems to have conceived visions of Rome beyond what it boasted even in the meridian of its splendour'. Certainly the dramatic splendour of Roman antiquity was something that Piranesi wished to enhance. For he was utterly out of sympathy with Winckelmann and his

19

notions of Grecian simplicity, and published tracts to defend his views. While Piranesi was most admired in his lifetime for his unique way of describing existing places, he is now most highly prized for his pure fantasies; notably the *Carceri d'invenzione* (*c*. 1745–61), imaginary 'prisons' of immeasurable dimensions and startling contrasts in which his powers of suggestion were given full rein.

Burke certainly provided a vocabulary for describing such works, and this in itself may well have encouraged the development in the 1750s of a kind of landscape of excess. It was in this decade that the French artist Claude-Joseph Vernet (1714–89) turned to the production of pictures of natural disasters, especially shipwrecks. And when the influential critic Diderot sought to characterize these in his Salon review of 1767, he did so in the language of Burke:

'The great landscapist has his own peculiar obsession; it is a kind of sacred horror. His caverns are deep and gloomy; precipitous rocks threaten the sky . . . man passes through the domain of demons and gods.'

What Vernet did for nature, the younger painter Hubert Robert (1733–1808) did for ruins, with his depictions of French and classical scenes, which also gained the admiration of Diderot. And it was the French-trained artist Loutherbourg who finally brought this type of painting to the land in which this special meaning of the word 'Sublime' had been formulated, when he settled in London in 1771.

The Picturesque

Despite his concern with the sensational, Burke was no disciple of subjectivity. His actual enquiry began from the assumption that: 'It is probable that the standard both of reason and Taste is the same in all human creatures'; and his very admission of the two categories of the Sublime and the Beautiful had been an attempt to bring an undeniable opposition within the confines of one system. Eventually the assumption of a single and universal taste was to be broken down by the Romantics, but before this happened, the growing empirical recognition of a plethora of viewpoints had led to a proliferation of subdivisions and categories.

Perhaps the most influential revision was the one that led to the formulation of the category of the Picturesque. Burke himself had considered those emotions that depended upon mere 'interest', rather than love or hate, to be unworthy of aesthetic consideration; but there were those who devoted a lifetime to taking an interest in things, and they were inclined to disagree. For them the term 'Picturesque' – implying, as it did, 'worthy of a picture' – seemed suitable for that pleasurable area that lay between the Beautiful and the Sublime.

36

23 GILPIN *Non-Picturesque Mountain Landscape* 1792

24 GILPIN *Picturesque Mountain Landscape* 1792

Appropriately enough, the principal champions of the Picturesque were rural clergymen and landed gentry with a taste for the arts. Its most vociferous exponent, William Gilpin, belonged to the former variety. In a lengthy series of books, starting with *Observations on the River Wye . . .* (1783), he explored the countryside of Britain in search of sites which could provide the kernel for a Picturesque experience. His proverbial remark, 'I am so attached to my picturesque rules that if nature gets wrong, I cannot help putting her right', aptly explains the lack of relationship between the compositions that Gilpin inserted in his volumes and what he actually saw on his travels. Indeed, the Picturesque was in Gilpin's hands so unrelated to any particular place that he could demonstrate its qualities abstractly in a pair of comparative plates in his *Three Essays . . .* of 1792. Here Gilpin opposes two designs in which 'the *great lines* of the landscape are exactly the same' in order to show that it is the principle of roughness that creates variety in a landscape and gives it picturesque interest.

23, 24

Although there was a lot of bickering about what was and what was not picturesque, the sudden changes and textures caused by irregularity and variety were generally accepted as its touchstones. As another theorist, Uvedale Price, observed: 'The two opposite qualities of roughness and of sudden variation, joined to that of irregularity, are the most efficient causes of the picturesque.'

Curiously the formal characteristics of the Picturesque are, like those of Burke, concerned principally with line and chiaroscuro. The less definable area of colour lay outside even this theory. Furthermore, the Picturesque, while certainly drawing attention to a greater variety of scenes, had none of the associative implications of Burke's categories. It remained a formal principle, and the theorists were notoriously unconcerned with the individuality of any one place; their insensitivity to the life of the countryside, too, could be such that they were capable of such remarks as Uvedale Price's 'in our own species, objects merely picturesque are to be found among the wandering tribes of gypsies and beggars'.

It is from these theorists that further light can be cast on the use of the word 'romantic' to describe scenery at this time. For Gilpin, 'romantic' implies a type of scene too irregular even to be accepted as Picturesque. In his *Observations on the Highlands . . .* (1808) he found Edinburgh romantic rather than picturesque on account of the 'odd, misshapen and uncouth' feature of Arthur's Seat, adding: '. . . a view with such a staring feature in it, can no more be picturesque than a face with a bulbous nose can be beautiful'.

By this designation Gilpin was also saluting the degree to which 'the Romantic' (to cast it in the appropriate mould) was dependent upon associative qualities for its appeal. A younger and more speculative defender

25 KENT Rousham gardens *c.* 1740

of the Picturesque, Richard Payne Knight, attempted to annex this quality for the Picturesque; yet in Germany such clear-cut categories were already being swept away by more penetrating enquiries into the nature of aesthetic judgments. The unresolved relationship of the use of Romantic in this sense to the Picturesque survived in their vernacular usage, however, as can be seen in the numerous topographical works whose titles began with the coupling 'Romantic and Picturesque . . .', from Loutherbourg's *Romantic and Picturesque Scenery of England and Wales* of 1805, to L. Schücking's *Picturesque and Romantic Westphalia (Das malerische und romantische Westphalen)* of 1839–41. 10

Landscapes of association

If such divisions can be found in the description of natural scenery, they were also used for works of art. In that activity in which taste and nature meet most directly, gardening, there was in the eighteenth century a gradual relaxation of methods. The garden is a place where man can modify nature to suggest the environment that he would most like to live in, and during this period the paradigm changed from the geometric formality of the seventeenth-century French garden – which had reached its apogee in the lay-outs of Le Nôtre at Versailles – to a relaxed and harmonious parkland; and then again to an evocative wilderness.

39

It was in England, once again, that this movement towards a freer nature began to take place. The precise origins of the 'landscape garden' are still contested but at the time it was thought that the man who – in Horace Walpole's phrase – first 'leaped the fence and saw that all nature was a garden' was William Kent (1685–1748). Having spent the second decade of the eighteenth century in Italy, he returned an indifferent architect and a poor painter. But he was full of the Arcadian ideal and this, at least, he could enact for his patrons in their gardens. At Rousham in Oxfordshire, one can still see how he coaxed the English countryside into a Claudian composition.

The inspiration for the evocative garden seems to have come from a more exotic source: from the Chinese. Already in 1692 the keen gardener Sir William Temple, in his *Garden of Epicurus*, had contrasted the regularity of the European garden with the informality of the Chinese, who contrive figures 'where the beauty shall be great, and strike the eye, but without any order or disposition of parts'.

Quite where Temple got his knowledge of Chinese gardens, or found the curious word 'Sharawaggi' to describe them, is not known. But the story of the Chinese garden persisted, and was given an even greater impetus by the architect Sir William Chambers (1726–96) in his *Designs of Chinese Buildings, Furniture, Dresses, Machines and Utensils* of 1757. Chambers, later to erect the Pagoda in Kew Gardens, had at that time recently returned from nine years' travel in the Far East. Despite this, his account of the art and manners of the Orient is clearly based as much on imagination as on observation. The deception was a timely one, however, and greatly stimulated the idea of gardens that can be made to excite reverie. For in the section dealing with gardens Chambers dwells longest on those two types of gardens that, he claims, the Chinese call 'horrid and enchanted'. While his description of the 'horrid' seems to correspond most closely to the Sublime, with its 'impending rocks, dark caverns, and impetuous cataracts rushing down the mountains from all sides', the 'enchanted' corresponds, he tells us 'in a great measure to what we call romantic'; in this for example 'they make a rapid stream, or torrent, pass under ground, the turbulent noise of which strikes the ear of the newcomer, who is at a loss to know from whence it proceeds'.

In Chambers' mind there was a clear distinction between the horrid and the romantic, between the frightening and the mysterious. And it was the latter that was more appropriate to describe the rambling lay-outs of the wilder gardens that were to come. This is certainly the case with the most extreme of all such wildernesses, the random plantations arranged by William Beckford around his Gothic fantasia of Fonthill.

Turner was commissioned to paint a series of views of Fonthill by Beckford in 1799. It is not known whether the eccentric millionaire

26 TURNER *Fonthill c.* 1799

stipulated the way these should be handled; but Turner seems to have responded appropriately to the occasion. The jerry-built 'abbey' – as yet uncompleted, but already falling down – has been reduced to an immaterial shimmer on the horizon, while the rambling grounds in which Beckford – 'ever the same romantic being' as he described himself to his friend the landscape painter Alexander Cozens – would roam in solitude, are shown in such a way as to make them almost undistinguishable from nature unadorned.

Alexander and John Robert Cozens, the two landscape painters who were most closely associated with Beckford, characterize the move towards a more sensitive and imaginative awareness of nature. The peripatetic Alexander Cozens (*c.* 1717–86), who began his life in Russia and arrived in Rome in 1746, was the most insistent of eighteenth-century landscape artists on the need for stimulation of the imagination in his art. An ingenious man who, in the words of Beckford, was 'almost as full of systems as the universe', he is best remembered for *A New Method of Assisting the Invention of Drawing Original Composition of Landscape* (1785). In this he declared that 'too much time is spent in copying the works of others, which tends to weaken the

powers of invention, and I scruple not to affirm, that too much time may be spent in copying the landscapes of nature herself'.

These were brave words in a century in which nature and tradition were the guiding principles. Cozens' alternative was to allow a free range to the imagination by suggesting that compositions should be discovered in the chance configurations of random ink marks. Such a suggestion provokes many interesting parallels; the recommendation by Leonardo to use accidental shapes on a wall to inspire landscape, or the spontaneous methods of the Zen landscape painters of the East. It even takes on a psychological dimension when compared to the Rorschach test. Yet Cozens was interested neither in spiritual revelation nor in an exploration of the subconscious. He is doing no more than suggesting a new path for an old journey. And, indeed, he ends his book by listing 'Descriptions of the Various kinds of Composition of Landscape' in which sixteen formulae are given. These are the schemata that his invention is to enliven. But they remain the system, and he prefaces them with some lines from Pope:

> *These rules which are discover'd, not devised,*
> *Are nature still, but nature methodized.*

In Cozens' own works there is a highly poetic mood, particularly in his wash drawings; yet he breaks no new ground, and his fanciful mountains and cascades lead right back to the more exotic landscape painters of the seventeenth century. It was only when such imaginativeness was brought to bear on the description of actual places that further developments arose.

The merging of these grew naturally out of the desire of the country gentleman to have his house and possessions recorded in a manner appropriate to the new sensibility, and from the wish of the traveller to bring

27 ALEXANDER COZENS
Ink blot composition
1785

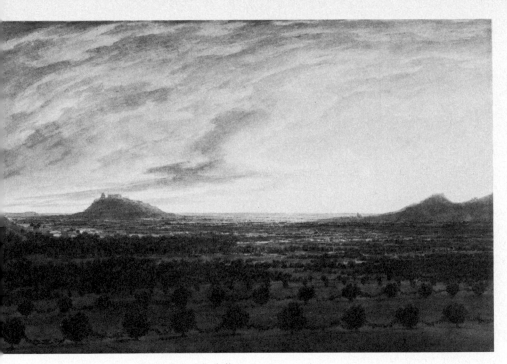

28 JOHN ROBERT COZENS *View from Mirabella* 1782–83

back with him mementoes of his experiences. Above all it was the scenes in Italy that sparked off a new approach to topography; for it was these scenes that were supposed to have inspired the great classical landscape painters themselves. As the English painter Jonathan Skelton wrote to his patron William Herring when travelling the Campagna in 1758, 'This antient city of Tivoli I plainly see has been the only school where our two most celebrated landscape painters Claude and Poussin studied.'

The English studied it too, and when they did so they used watercolour. Employed at first for convenience as a sketching medium, this rapid technique was admirably suited for capturing the most transient and fleeting moments of a landscape, the changes of light and atmosphere.

No watercolour painter did more to raise topography above the level of *reportage* than Alexander's son John Robert Cozens (1752–97). He developed his father's sense of mystery and sensitivity to light to a degree that led Constable later to exclaim that Cozens was 'all poetry'. In the works that resulted from his visits to Italy – in particular those from his second visit, made in the company of Beckford in 1782–83 – such poignancy is present almost to the point of painfulness. Whether he is recording the barren,

43

overpowering mountains of Sicily, or a simple view across vineyards on the plains, the scene is responded to with unguarded sensibility. He was fascinated above all with moments of changefulness, when every feature becomes transformed, to arouse a new curiosity. In the view across the plains the vines, with their connecting creepers, become strange silhouettes. The hills are stranded in a limitless plain, which the dark clouds are encroaching. All is described with the most careful gradations of tone – largely monochrome, but with telling hints of blue and green. Fantasy has become experience. Yet perhaps there was more urgency to the process than mere curiosity. For it was less than a decade after painting such works that Cozens lost his reason. He died insane in 1797, at the age of forty-five.

The natural sciences

No other artist of his generation perceived landscape so closely as John Robert Cozens. Yet there were many others who sought to relate incident to emotion and explore the range of experience. It is hardly surprising that observations often came close to the activities of contemporary scientists or 'natural philosophers'. Scientists of a former, more rationalist age had, like Sir Isaac Newton, postulated a model of the universe which functioned with clockwork precision and regularity and believed that observation and deductive reasoning would uncover all its parts; but the scientists of this age were more aware of the limitations of man's knowledge and the way in which the unknown seemed always to slip his grasp. As the chemist Sir Humphry Davy said: 'Though we can perceive, develop, and even produce, by means of our instruments of experiment, an almost infinite variety of minute phaenomena, yet we are incapable of determining the general laws by which they are governed; and in attempting to define them, we are lost in obscure though sublime imaginings concerning unknown agencies.'

The mechanistic universe was replaced by one that was inspired by the idea of organic growth. It was a time of rapid expansion in the natural sciences, with the development of such new fields as comparative anatomy, which was to have a formative effect on the evolutionary theories of Jean-Baptiste Lamarck and Charles Darwin, and the supplementation of Newton's analysis of the spectrum with the investigation of the physiological and psychological effects of light. While few scientists would have accepted the poet Goethe's assault on Newton's analysis in his own *Theory of Colours*, they would have seen the justice in his remark that dissection will not tell you enough to understand the functions of a living organism. It was only when he had succeeded in devising an experiment that allowed him to observe electricity in motion that Michael Faraday was able to trace the generation of an electromagnetic field.

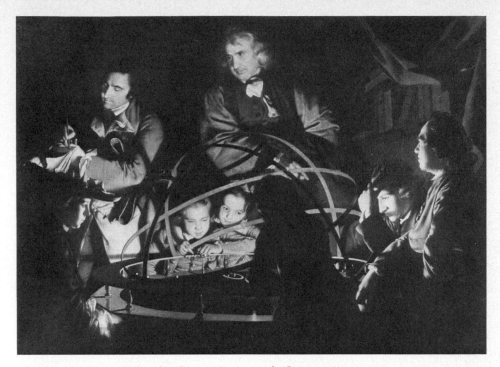

29 WRIGHT OF DERBY *Philosopher Giving a Lecture on the Orrery* 1766

The mysteries of nature, which could enthrall Sir Humphry Davy, could also excite the layman. The fashionable would attend experiments conducted by famous scientists, and the general interest was exploited by itinerant demonstrators with a repertoire of simple devices. Joseph Wright of Derby (1734–97), always a responsive recorder of informed interests, used a number of such occasions as a basis for some of his lamplight pictures during the 1760s. Just as he had exploited the effects of chiaroscuro in *Three Persons viewing the 'Gladiator' by Candlelight* (1764–65) to suggest wonderment at the antique, so he recorded a similar sense of excitement at nature in his *Philosopher Giving a Lecture on the Orrery* (1766) and *Experiment with an Air Pump* (1768). The fascination of the philosopher's audience in the *Orrery* is reflected as the light falls on their faces. The lamp which illuminates them – concealed from our gaze by the silhouette of the boy in the foreground – occupies the position of the sun in the model of the heavens that is being explained to them. Each has a different reaction. The children are excited, the adults thoughtful; with the exception of one – apparently a local cartographer – who takes notes. The philosopher, who looms above

29

45

them in a halo of darkness, is distinguished from the observers by his rhetorical gesture and slightly unkempt appearance. Yet he may not have been such a mysterious figure to them, for he was probably John Whitehurst, a local watchmaker. Certainly the figures are portraits, and the circumstances of the occasion need not have been contrived: for the lighting conditions would have been necessary for the orrery to operate effectively.

These entertainments were made more appealing by the benefits that were felt to derive from them. Davy recommended amateur scientific investigation because it 'may become a source of consolation and of happiness, in those moments of solitude, when the common habits and passions of the world are considered with indifference. It may destroy diseases of the imagination, owing to too deep a sensibility; and it may attach the affection to objects, permanent, important, and intimately related to the interests of the human species.'

Maybe. But the study of science by laymen – which produced valuable contributions by such gifted amateurs as Erasmus Darwin and Goethe – could also provide a cover for charlatans. The kind of showmanship that enthralled the inhabitants of Wright's pictures can also be found in such figures as Friedrich Mesmer (1735–1815), the German doctor who claimed to be able to cure disease through the agency of 'animal magnetism' and was in the habit of stroking his patients with an actual magnet in a dimly lit room to the strains of soft music.

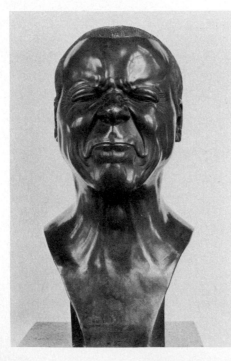

30 MESSERSCHMIDT *The Worried Man* 1770+

Like watchmakers and doctors, many artists had the kind of speculative ingenuity that encouraged them to dabble in such activities. Philip James de Loutherbourg, that master of special effects, abandoned painting in 1789 and took up faith healing – until his house was stormed by an angry and disappointed mob. A more extreme case was that of the Austrian sculptor Franz Xavier Messerschmidt (1736–83), who emerged from a severe illness in 1774 believing himself to be oppressed by evil spirits. He thereafter lived a life of seclusion, devising a system of facial expressions with which he felt he could counter his supernatural persecutors. These grimaces, which he considered to be a genuine discovery, were recorded by him with obsessive realism in a series of sixty-four self-portrait heads. Messerschmidt was clearly 30 a pathological case, yet his derangement was fed by the fashions of his times. In his association of expression and physiognomy with the spirit one can recognize an affinity to Jean Gaspard Lavater's pseudo-scientific *Essays on Physiognomy* (1775–78) in which it is asserted that 'Each perfect portrait is an important painting since it displays the human mind with the peculiarities of personal character.'

Character and expression

Messerschmidt belonged to that generation of Central Europeans that had been encouraged to give full rein to their emotions in the belief that expression was the key to revelation. Their inspiration had been that group of writers known in German by the epithet 'Sturm und Drang' – 'Storm and Stress'. Lavater, a Swiss theologian and philosopher, was also associated with the movement, whose principal exponent was the German writer Johann Gottfried Herder. While the movement's emphasis on self-expression and 'Character' were to be vital for Romanticism, it was itself limited in its analysis of emotion. It was more in sympathy with the cathartic effects of the Sublime, than with reflection and evocation. Goethe's early masterpiece *Werther* (1774) epitomized this exaggeration of emotion, with its story of a man who could literally die for love; a magnification of the author's own chagrin at a rejection.

While 'Storm and Stress' was, strictly speaking, a German literary movement, its characteristics reflected a more general exploration of expression. The concept of character gave a new dimension to extremism during the 1770s. An artist like John Hamilton Mortimer (1741?–79) indulged in eccentricities to an extent that verged upon schizophrenia. Coming from a comfortable bourgeois background on the South Coast of England, his art flashed from polite conversation-pieces of Dutch serenity to wild scenes of crime, eroticism and madness. His fiery, short career (he died at the age of thirty-nine) was acted out in a welter of senseless escapades. He

47

captained boats and engaged in fake battles – almost losing a hand in one of them. Once, when engaged to paint a ceiling for a noble family, he incensed his employers by draining their pond and leaving the fish in it gasping, spread out in rows on the lawn. The reason for this, he informed the lady of the house, was that her beauty 'had so bewitched him that he knew not what he was about'.

If one is tempted to approach Mortimer's art first through his biography, it is because he himself insisted on the importance of the artist's character. His personal model was Salvator Rosa – the seventeenth-century Neapolitan painter of *banditti* who was then commonly believed to have been one himself – and his self-portrait shows him in an appropriately swashbuckling role. Yet there is truth as well as pose in this picture. The features betray a genuine disturbance in the uneven line of the eyebrows puckered across the forehead, which he has just managed to pass off as a gesture of bravado and contempt.

Undoubtedly the most remarkable artist in this generation was Henry Fuseli (1741–1825). A native of Zürich, he was a fellow student of Lavater under the philosopher Bodmer. Having trained as a Zwinglian minister and then embarked on a literary career, he came to painting late. The conversion occurred only after he had settled in England (he came to London in 1763) and been encouraged by Sir Joshua Reynolds.

Fuseli had close contacts with the leaders of 'Storm and Stress' both as a student and as a writer, when he spent some time in Germany and met Herder; the expressive nature of his art certainly accords with this background. He was an admirer of the antique; he spent eight years studying in Italy, from 1770 to 1778. However, his concept of the grandeur of classicism was closer to Piranesi than to Winckelmann, despite his translation of the latter's essay on the imitation of Greek art. His image of the artist overcome with emotion as he reflects on the remains of a colossus betrays a hero-worship which found an outlet in his admiration for the dynamic figures of Michelangelo. Himself small and fiery, he seems to have become obsessed with muscular exaggeration in both his male and female forms.

42 Fuseli's admiration for the antique – which was later to be constantly emphasized in the lectures that he gave at the Royal Academy – seems to have accorded with his desire for a powerful and positive art. If he admired expression, he abhorred vague speculation, and his attitude towards the burgeoning romantic tendencies, which he lived to see grow into a movement, was vituperative. Always a pragmatist, he attacked the 'romantic reveries of platonic philosophy' and declared as early as 1798 that 'the expectations of romantic fancy, like those of ignorance, are indefinite'. While he responded to the legends and history of Northern Europe as much

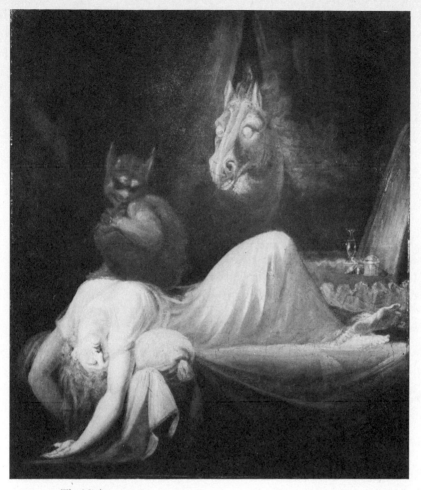

31 FUSELI *The Nightmare* 1791

as he did to those of Greece, he was interested above all in their heroic and erotic potential. His intentions were always definite. As a reviewer was later to say in the *New Monthly Magazine* in 1831, 'It was he who made real and visible to us the vague and insubstantial phantoms which haunt like dim dreams the oppressed imagination.'

Presumably this writer had in mind Fuseli's most notorious work, *The Nightmare*. The subject, first exhibited at the Royal Academy in 1781 and amended in a subsequent version, is certainly unforgettable, and it remained 31 one of the best known and most plagiarized of contemporary works up to

the mid nineteenth century. At first it might seem that its compulsion depends on the uncovering of some subconscious drive, particularly as it concerns sleep and dreaming; yet it is more intimately connected with the picture's rhetoric. As Nicholas Powell has pointed out, Fuseli does not 'set out to illustrate a dream, so much as to depict the sensations of terror and stifling oppression experienced in a nightmare'.

Typically Fuseli is more interested in eroticism than the irrational in this work; and for this he could draw upon recent medical opinion. For nightmares in young girls are, as Dr John Bond had noted in 1753, often induced by 'a copious eruption of the menses'. Such dreams, suggested both by the pressure against the chest and the supine position of the sleeper, are usually about violent sexual assault – the kind of dream that gave rise to rumours of intercourse with the devil. Sometimes the assailant was described as having come in the form of a fiery steed; though this was more commonly associated with male victims. In this case Fuseli has drawn on a more pictorial tradition of equating the stallion with rampant masculinity; for the startling eruption of its fuming head through the curtains amounts, in visual terms, to a rape.

Whatever his special interests, Fuseli had created a new subject for dramatic treatment, and one that could easily be transformed in to an
57 exploration of the irrational. Seventeen years later, in *The Sleep of Reason*, Goya was to show a man oppressed by fantasies that no medical explanation could dispel.

This era saw the emergence of a greater expressive range in almost every kind of painting. In animal painting the traditional themes of wild and fighting animals were imbued with a new expressive dimension. George Stubbs (1724–1806), a painter of supreme accomplishment who first made his name by raising the traditional English horse portrait to an unprecedented pitch of expertise and elegance, began in the 1760s to create works in which dramatic and violent themes are evident. Perhaps these more startling works, like Fuseli's, were an attempt to establish a reputation as a historical painter; one who was capable of expressing a noble range of emotions. Certainly these subjects coincide with the commencement in 1760 of exhibitions by the Society of Artists, to which Stubbs was a regular contributor. His concern with precision led not only to an admiration for the antique – he went to Rome in 1754 and based some works on classical sculptures – but also to a rigorous study of nature which resulted in a number of distinguished anatomical publications, one of which, his *Anatomy of the Horse* (1766), has yet to be superseded.

Stubbs is one of those artists for whom precision provides a way of expressing an extreme refinement and sensitivity. The impeccable forms of

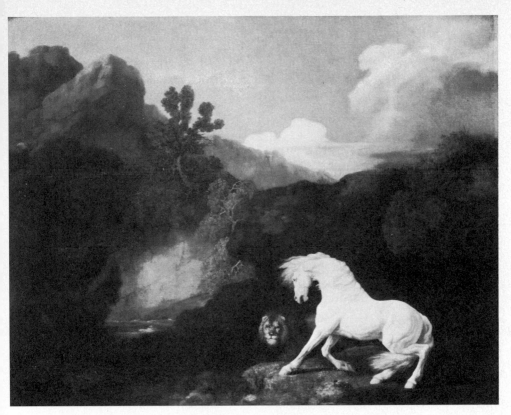

32 STUBBS *Horse Frightened by a Lion* 1770

his animals, set against glinting landscapes, inspire amazement; yet they do not on the whole invite empathy. There is no surrogate humanity to be found in his struggling horses and wild beasts as there is in those of James Ward and Théodore Géricault. They remain exhibitions of intricate violence, like the animal fights of Hellenistic art or the Baroque. Only one work, the *Horse Frightened by a Lion*, suggests a romantic pathos. Designed as a pendant to one of his many versions of *Horse Attacked by a Lion*, one can still trace in it a memory of that Hellenistic group that inspired the latter. However, while that work describes an action, this implies a threat. Whether or not the landscape was painted in, as has been suggested, by George Barret, the unity of mood is complete. The tense arching of the horse's back echoes the rough contours of the surrounding rocks. Its startled gasp evaporates into a darkened gully, where the lion waits with a menacing though incalculable attentiveness.

175

32

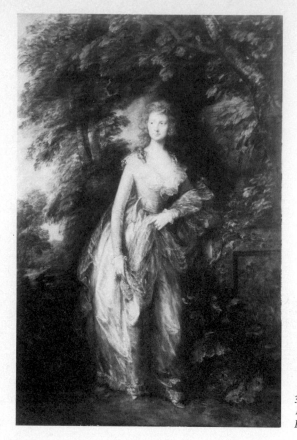

33 GAINSBOROUGH
*Mary, Duchess of
Richmond* 1785–88

Portraiture

This mounting sensibility is felt most clearly in the image of man himself,
not as a type but as an individual, in the portrait. 'Face painting' was the most
commercial of arts, but it could still be the most perceptive. Jonathan
Richardson – a poor painter but a thoughtful writer – put portraiture at its
highest premium when he wrote in 1715: 'A portrait painter must
understand mankind, and enter into their characters, and express their minds
as well as their faces.'

Yet an eighteenth-century painter worked to his clients' satisfaction. It
was their sentiments, not his own, that Richardson sought to discern; 'and as
his business is chiefly with people of condition, he must think as a gentleman,
and a man of sense, or it will be impossible to give such their true and proper
resemblances'. Such a directive presented little problem to most artists, for at

52

that time they were still flattered at the thought of seeming like gentlemen. And as 'men of sense' they followed closely the changing patterns of opinion.

No artist reflected these nuances more assiduously or appealingly than Thomas Gainsborough (1727–88). An intelligent, perceptive, though not over-learned man, he became the incomparable master of enlightened sensibility. From his early Suffolk portraits of the 1750s to his full-scale essays in the grand style in London in the 1780s he recorded the growing liberality of mood. His love of delicate feeling was such that he refused to strengthen or exaggerate his manner for the sake of making a show at the Academy – as Fuseli had done – and at one time ceased to exhibit there at all. The mentor of his later works was Van Dyck, whose nervous grace he endowed with a new

34 PRUD'HON *Georges Anthony* 1796

warmth and lyricism. His rival Sir Joshua Reynolds, who deplored Gainsborough's lack of 'learned composition', was nevertheless fair-minded enough to concede that Gainsborough's 'unfinished manner' – which he felt was a dangerous example to the students – 'contributed even to that striking resemblance for which his portraits are so remarkable'. Reynolds' explanation for this, that Gainsborough provides the 'general effect of the countenance' which stimulates the imaginations of those who know the sitter sufficiently to 'supply the rest', is perhaps over-literal. Such fine and indistinctive faces as that of *Mary, Duchess of Richmond* seem rather to capture some private fleeting mood. Gainsborough's lifelong passion for landscape enabled him not only to fill his portraits with the ambience of nature – even when the forms of it were purely schematic; it also enhanced his sense of the momentary. Above all it is the passing subtleties of light and atmosphere that seem to bring out the individuality of his sitters' features.

Yet however sentient, his figures are rarely disconcerted. His fine ladies and gentlemen are never so moody as to be ungracious or lose their sense of poise; while his more intimate portraits of friends are full of charm and amusement.

Gainsborough died eleven months before the storming of the Bastille; but many inhabitants of his world of sensibility survived into the revolutionary age. In France, the centre of disturbance, such *hommes de sensibilité* as Chateaubriand 'could not understand how it was possible to live in those times'. Even wholesale admirers of the new order felt the confusion. Pierre-Paul Prud'hon, a painter every bit as receptive as Gainsborough, was an enthusiastic supporter of the Revolution. So was his friend Georges Anthony, a young landowner in the Franche-Comté, whose portrait he painted when staying there to avoid a plague in Paris. Feeling and grace still have much meaning for these two, yet they provide little consolation. Anthony's fleeting gaze encounters no pleasant reflection. His stance – so near to that of the Duchess of Richmond – is no longer supported by a secure world. Cut off at the knees, closed in and closely viewed, he is shown in the open air – but hardly in a landscape. The horse, who contemplates us with disconcerting prescience, and the slanting tree-trunk, do not provide the traditional enhancements. Rather they increase the fragmenting mood. The diagonals they create strengthen the two directions in which Anthony is drawn – his body facing one way, his head the other. It seems to mark a crossroads in a career of many vicissitudes – which were to include a spell as a Cossack Hetman after 1812. Here he is hesitating. But he is already past the point of no return.

The heroic era

It was in the late eighteenth century that the creative genius came, in the words of the art historian Wittkower, 'to be thought of as the highest human type'. Such claims are now so familiar that they can hardly surprise us; they have ensnared too many generations. At the time, however, they implied a deepening sense of purpose.

This new view of the artist was greatly encouraged by current philosophical developments. But it was the dramatic political and social upheavals of the 1790s that brought matters to a head. At a time when the destiny of Europe hung in the balance, what was the creative genius to do? Should he enter the fray, creating propagandist proclamations for the faction he supported? Or should he remain aloof and provide an art whose nobility was an inspiration to man without dictating individual acts? Should he treat his contemporaries to the benefit of his own prophetic insights? Or should he use his perception to puncture pretence and draw attention to the basic human problems that the current conflicts involved?

All these attitudes can be found among artists in Europe during the 1790s. Among those who favoured supportive action the greatest and most influential was the French painter Jacques-Louis David, who ostentatiously placed his art at the service of the new Republic in France. Heroic independence, on the other hand, was essayed by the German artist Asmus Jacob Carstens. But more remarkable than either of these – whose contributions can be seen as extensions and intensifications of the traditions of the history painters – were those two great artists who developed prophetic and critical forms of independent commentary that were new to art: William Blake in England and Francisco de Goya in Spain.

David and the 'exemplum virtutis'

In many ways the rhetorical art of David can be seen as the culmination of a heightening mood that had been developing in history painting since the 1770s. Although the representation of the noble deed, the *exemplum virtutis*, had long been the concern of the history painter, this type of subject became transformed in the late eighteenth century. Just as the revived interest in the

classical ideal was given a Rousseauian topicality, so the example of virtue became couched in the language of sentiment. The readers of such heartfelt moralities as Samuel Richardson's *Pamela, or, Virtue Rewarded* (1740), or of the exploratory stream-of-consciousness of Laurence Sterne's *Tristram Shandy* (1759–61), expected a similar psychological sophistication from their subject painters – whether these were representing contemporary events or themes from ancient history. Furthermore, the growth of regular academy exhibitions stimulated a new type of commentator: the literary art critic who judged a picture above all by rhetorical standards, by the depth of thought in it, by the sincerity of its narrative, by the technique's emotional impact.

The most imposing of such critics was undoubtedly Denis Diderot. His great reputation as *philosophe* and editor of the truly exhaustive *Encyclopédie* (the French Enlightenment's Authorized Version of all existing knowledge) gave his opinions on art undeniable authority. As befitted an *encyclopédiste*, Diderot was fully briefed on the technical aspects of painting. But the main preoccupation of his Salon reviews (1759–83) was to encourage painters to abandon the frivolities of the Rococo, to make their art thoughtful and sober. He longed to see the artist 'at last collaborating with dramatic poetry in order to move, to educate, to improve us and induce us to virtue'.

It has been remarked by Anita Brookner that Diderot's call was finally met by the emergence of Jacques-Louis David, whose epoch-making *Oath of the Horatii* was exhibited at the Salon the year after Diderot's death. For no other French artist of the time possessed the genius to be able to enact the writer's dictum 'paint as they spoke in Sparta' in all its stylistic, moral and intellectual implications.

Diderot himself had to be content with pretenders. For a time he thought he had found his man in Jean-Baptiste Greuze (1725–1805), the author of the *Death of a Paralytic*, the work that inspired the outburst quoted above. Originally entitled *The Results of a Good Education*, it certainly had the right kind of programme. Greuze also took care to address his public in an appropriate language, and the tender emotions expressed by the dutiful family surrounding the dying paralytic were enough to bring at least one young lady visitor to the Salon of 1763 to the verge of tears. The portrayal of the subject was sentimental, but not vulgar. There was enough of a classical composition in the design, enough sobriety in the handling of the paint, to appeal to people's sense of decorum.

Yet while Greuze was able to exploit his contemporaries' sensibilities, he could not satisfy more rigorous demands. When he attempted a subject in the grand manner, *The Emperor Septimius Severus Reproaching his son Caracalla for Having Plotted against his Life*, in 1769, the result was limp and

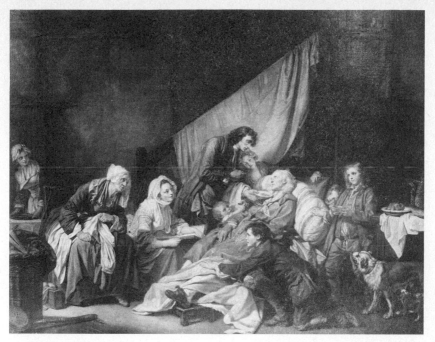

35 GREUZE *Death of a Paralytic* 1763

36 GREUZE *The Emperor Septimius Severus Reproaching his Son Caracalla for Having Plotted Against his Life* 1769

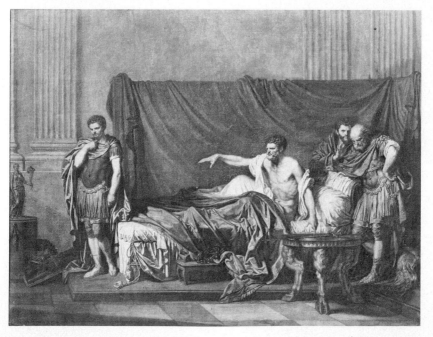

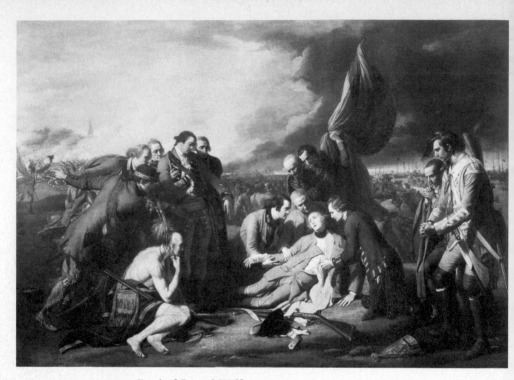

37 WEST *Death of General Wolfe* 1770

vacuous. It earned him the contempt not only of the Academy but also of Diderot; for, in exposing his own limitations, Greuze had also exposed the failure of modern painting to live up to the *philosophe*'s expectations.

 Undoubtedly the immense success in London one year later of Benjamin West's (1738–1820) *Death of General Wolfe* lay in his skilful interweaving of high art with contemporary appeal: of the grand manner with *reportage*. And, while Greuze flattered the sentimental with visions of virtue, this American-born artist – who had settled in England after a period of study in Rome – could make colonial wars of expansion seem truly heroic. Disregarding Reynolds' assertion that a heroic subject could be rendered adequately only if the figures were draped in the 'generalized' clothes of the antique, West took care to record the actual uniforms of the British soldiers, and the barren landscape of the heights around Quebec, arguing that the 'event took place on 13 September 1759, in a region of the world unknown to the Greeks and Romans, and at a period of time when no such nations, nor heroes in their costumes any longer existed'.

37

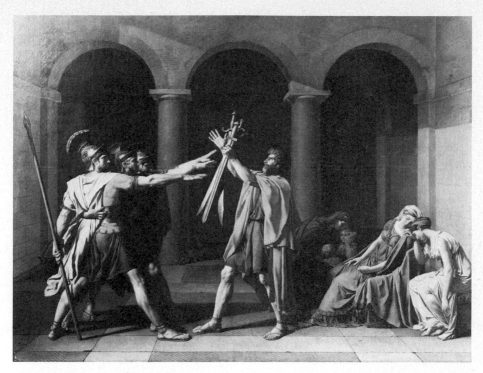

38 DAVID *Oath of the Horatii* 1784

Yet this actuality is only superficial. It clothes a composition which bears no relation to the circumstances of Wolfe's death. In the best traditions of the grand manner, everything enhances the central theme. The group with the dying hero – looking for all the world like a Christian *Pietà* – is flanked by sorrowing officers. (Most of these were nowhere near Wolfe at the time, but paid West £100 each to have their portraits included.) The *gravitas* of their grief culminates in the drooping pennant that is held above the protagonist. Even the elements pay tribute, for the storm clouds are being dispelled by the English victory, indicated by the messenger who bursts in, in the nick of time, from the left. In the foreground the artist lapses into pure allegory with a fictive Indian who, apart from providing some regulation nudity, also symbolizes the place and also, with his pensive gesture, the mood of the occasion.

West had shown triumphantly that modern subjects could be heroic without losing any of their sense of the moment. The results of his success were more far-reaching than might at first be expected, for it encouraged

59

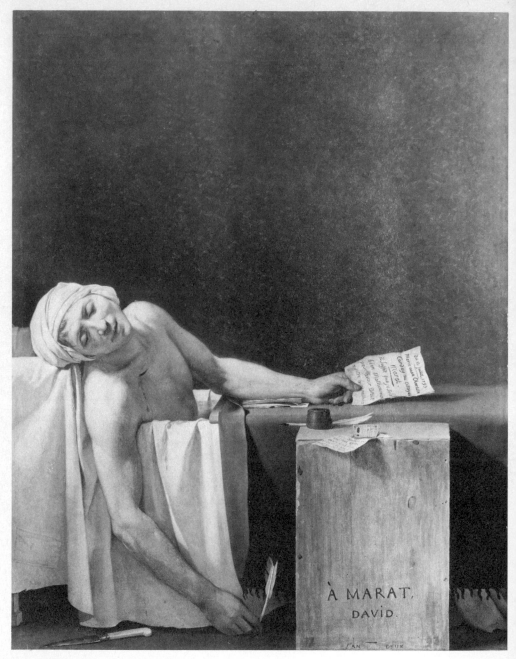

39 DAVID *Death of Marat* 1793

accuracy of detail in all forms of history painting. West himself provided, at the request of George III, a medieval *Death of Bayard* (1772) and a classical *Death of Epaminondas* (1773) as pendants to his *Wolfe*. In France the vogue for historical accuracy led to such medieval costume-pieces as Berthélemy's *Retaking of Paris from the English*, which superficially resemble the later art of 70 the *romantiques*.

Jacques-Louis David (1748–1825) himself held West in the highest esteem for his achievement, and, like him, painted historical pictures in a thoroughly modern way: the success of the *Oath of the Horatii* which shows 38 the three brother heroes of ancient Rome swearing to fight to the death for their country, was not simply due to the effect of the purist Neo-classical tendencies that he had picked up in Rome; for the work contains as well a dramatic sense of *reportage* heightened by the suggestion of archaeological exactness. The full shock of its radical design comes from the way the highlit diagonals of the figures cut across the background symmetry. The crescendo of the action – the outstretched hands and clutched swords – is as sharp and loud as the oath that the Horatii must be uttering.

Set in a box-like space and illuminated by a raking light, the picture is – in the best sense of the word – staged. It is hardly surprising to find a later composition of David's, the *Brutus* of 1789, becoming the subject of a tableau at the end of a presentation of Voltaire's play on the theme. The *Horatii* is a revolutionary work; but the revolution is a pictorial one. In political terms it represents nothing so much as the reforms that had been encouraged in French official art by Louis XVI's minister with responsibility for the arts (the Surintendant des Bâtiments), the Comte d'Angivillers. Just as Louis himself had attempted to restore morality at court and check the country's economic ruin, so the Rococo had been virtually ordered out of the Academy by Angivillers. The theme of the *Horatii* – patriotism – was hardly subversive. In any case, David's work was commissioned by Angivillers, and was gratefully acquired on behalf of the Crown after it had received tumultuous applause when exhibited in Rome and at the Paris Salon. If the picture later came to be seen as a herald of the French Revolution, it was because the monarchy had been less successful in fostering reform in the economy than in the arts.

Yet whatever the political background to the picture, its uncompromising directness also reflected the artist's personal determination and passion. It was only through such qualities that he had been able to overcome the unpromising beginning to his career – he won the Prix de Rome only at the fourth attempt. Throughout his life he was to follow his convictions with undiminished ardour. The events of the Revolution made him a committed republican, one of the signatories of Louis XVI's death warrant. Later he was

overwhelmed by the personality of Napoleon, declaring that 'there is a man to whom altars would have been raised in ancient times'.

This public life – so much a consequence of his heartfelt (if changeable) private convictions – was matched by an equally public sense of art. The winning of the Prix de Rome mattered so much to him that he attempted suicide on the third occasion that he failed. During the Revolution he became a virtual Minister of the Arts, and used his authority to dismantle the Academy (whose powers he had long resented), to establish a museum, to design uniforms and to stage sumptuous celebrations and processions. His art, too, was not simply great, it was demonstrably better than that of his rivals; better produced, more capable of appeal and inspiration. Old opponents like J.F. Peyron (1744–1814) changed their style to fall in line with his; while for younger generations – even down to Delacroix – he remained the father of modern French painting.

David's declamatory art translated readily into the portrayal of modern heroes. He recognized his public duty to honour such heroic moments of rebellion as the *Oath of the Tennis Court* and immortalize the Revolution's
39 fallen heroes. His *Death of Marat* was designed to form the focus of a quasi-antique memorial celebration – together with a similar portrayal of another Jacobin martyr, Lepeletier. The simple tribute on the upturned box in the foreground, À MARAT, DAVID, was addressed by the artist to one he believed to be the equal of Plato, Aristotle and Socrates.

Although David glamorized his subject, it was still a first-hand record. For as well as the studies that David made of the victim, on the day before the event he had seen him at work in the same bath in which he was assassinated by Charlotte Corday; the bath in which he had to spend most of his days to ease a skin disease. David painted the picture in the heat of emotion, completing it by 14 October 1793, just three months and a day after the Jacobin leader had been murdered.

It is characteristic that David should be at his most moving when he is most daring. Nowhere else does the familiar placing of human accidentals in a sparse rectilinear structure achieve such a pared-down image, yet nowhere else is the mood so tender. While the arms of the *Horatii* move tautly upwards, those of *Marat* fall in a gently declining rhythm. Around them is scattered the evidence. The letter by which Charlotte Corday gained admission to see him is in his left hand, the knife with which she stabbed him is beneath him in the shadows. The *Horatii* culminated in a shout; here there is utter silence. All motion has ceased, except that of the quill pen as it sinks from his lifeless hand to the ground.

After the fall of his hero Robespierre and his own subsequent imprisonment in 1794, David moved from the forefront in both art and

politics. He was later appointed Napoleon's Painter, but he never wielded the same authority again. Even his style ceased to be a paradigm for others. His most successful pupils, Gros and Ingres, painted in quite different ways, while in his own studio there emerged a group of dissidents, the Primitifs, who adhered to a more rigorous view of antique art and denounced the sensationalist side of their master's style as 'rococo'. Obscure and now forgotten as artists, the Primitifs under their chief spokesman Mauricé Quai were influential as propagandists among their contemporaries. David did himself modify his art, reducing its drama and feeling for texture to make it more 'Grecian'. Yet by doing so he lost the enlivening sense of the momentary. By the time he went into exile (as a regicide) at the 1815 Restoration the old power could be felt only in his portraits, which still impress for the honesty with which they make their record. 'My art consists of deeds, not words,' he once wrote. Pictures were for him events; public demonstrations of what he knew to be true. He was not like those other great geniuses, Dante and Milton, who after a political career turned in their years of disgrace to the production of their finest achievements. As his public life declined, so did his artistic.

Napoleon had no less use for propaganda than had the Jacobins, and David – as his official painter – certainly did his best to provide it for him. But although he produced some magnificent portraits of his master, his vast records of Napoleonic deeds carry none of the conviction of those of his pupil Antoine-Jean Gros (1771–1835). For Napoleon's mode of leadership was quite different from that of the Deputies of 1789. He commanded allegiance through a personal charisma that he strengthened by an appeal to tradition – restoring Christianity in France and calling himself Emperor – and by the exotic pageant of his foreign campaigns. Gros had been trained in David's studio between 1785 and 1792, when the latter's style was at its most dramatic. Since then he had developed a greater sense of colour, movement and atmosphere by studying Rubens and the Venetians. The plea of his pictures is no longer one of rationality. There is no logic in the theme of the *Plague at Jaffa*. It shows Napoleon during his Egyptian campaign of 1798, 40 when he was entertaining notions of establishing an empire in the East. When a large part of his army succumbs to the plague, Napoleon restores morale in a courageous gesture by visiting the sick. Gros builds up the atmosphere vividly, exploiting the full exoticism and horror of the scene. Yet the central action – Napoleon touching a sore on one of the victims – has no meaning; or rather, its only meaning must be a miraculous one suggesting superhuman powers. Furthermore, the incident itself was deceptive. For Napoleon apparently ordered the sick to be poisoned, so as not to delay his campaign. And even if Gros was unaware of this, he nevertheless perpetrated

40 GROS *Plague at Jaffa* 1804

pictorial inaccuracies. For he updated the costumes of the soldiers to the more dashing uniforms of Imperial times.

Unwittingly Gros provided the lead for the French Romantics. For if Géricault and Delacroix could appreciate the drama in David's art, they found even more to admire in the sheer pictorial indulgence of Gros's painterliness. For his part Gros, who became an establishment figure in Restoration France (he was created Baron in 1824 after decorating the Panthéon with royalist and patriotic scenes), did what he could to counter the new sensuousness. As Delacroix later wrote, 'he made it a point of honour to continue in his lessons all the traditions of David'. Yet in this he failed. His inability to maintain the old standards was cruelly underlined when his ultra-classical *Hercules and Diomedes* was poorly received at the Salon of 1835; not long afterwards he took his own life.

Gros committed the final act of renunciation; but it was for failing to maintain an established order. Neither he nor David wished to make that break with society that was the prerequisite of the Romantic hero. However, even in the age of public heroism alternatives existed. Contemporary with David were those who saw the artist not simply as the painter of heroic subjects, but also as a hero in his own right; and one who claimed the prerogative of independent action.

Heroic genius

Behind the concept of heroic genius lay the belief that it was man's innate gifts that were to be valued above all else. In this there was a conflict with the viewpoint that made the acquisition of learning supreme; and this conflict can be felt in many of the exchanges of the period – not least in the annotations that the outcast visionary William Blake wrote in the margin of his copy of Sir Joshua Reynolds' *Discourses*.

Delivered at the Royal Academy of which he was founding President, Reynolds' *Discourses* (1769–90) were designed to encourage learning in the artist. It is true that their author was far too sensitive a critic not to feel moved by those great artists whose achievements transcended any system. Yet he was always seeking to rationalize the products of genius: even in the case of his great hero Michelangelo, he felt that inspiration had been guided by expertise: 'I will not say Michael Angelo was eminently poetic only because he was greatly mechanical, but I am sure that mechanic excellence invigorated and emboldened his mind to carry painting into the regions of poetry.'

Blake thoroughly opposed the notion that acquired skill in any way supplied the artist's vision. When Reynolds wrote 'our minds should be habituated to the contemplation of excellence', he expostulated: 'Reynolds

41 JAMES BARRY
*Self-portrait c.*1802

42 FUSELI *The Artist Moved by
the Grandeur of Antique Fragments*
1778–79

thinks that Man Learns all that he knows. I say on the Contrary that Man Brings All that he has or can have Into the World with him.' For Blake, it was only by protecting man's original innocence that his vision could be preserved. As Blake's contemporary, the German poet Schiller, declared in his *Letters on the Aesthetic Education of Man* (1795), 'A true genius must be naïve or it is none.'

Schiller's and Blake's insistence on this primal inspiration implies a fear of its loss. This same fear underlies the nostalgic self-portrait by a less gifted

41 contemporary, the history painter James Barry (1741–1806). Painted when the artist was in his sixties, it harks back to the time of his youth, when he was a rising talent – the protégé of Edmund Burke, and a prize-winning student in Italy. Since then he had struggled to counter the neglect of monumental art in Britain by painting murals for the Society of Arts at his own cost; and he had been ignored. Here – as in the Society of Arts murals – he appears as the Greek painter Timanthes, the very same artist whom Pliny had used as an example of the power of suggestion in painting. He is holding in his hands a work of his own, a reconstruction of Timanthes' *Sleeping Cyclops* as described by Pliny, in which scale is suggested by the device of showing some satyrs measuring the giant's thumb with a thyrsos. Emotionally, too, this image of the young Barry/Timanthes is about incompleteness; for it was in the enactment of Barry's career that something had gone wrong.

An artist who stands up for his vision, in the way Blake, Schiller and Barry did, has to have a heroic temperament. No doubt each of these would have agreed with Baudelaire when he wrote that 'extreme genius' must possess, besides an 'immense passion', a 'formidable will'. It was presumably some such thought that made Barry place himself in his self-portrait at the feet of Hercules. Like most of his generation, he expressed the heroic by means of size.

If the heroic were simply a matter of scale, Fuseli would be its master. But the fact that his sketch of himself overcome at the sight of the remnants of a

42 colossus on the Capitoline Hill in Rome now tends to appear comic, reveals
39 the shortcomings of his art. Few would want to laugh at David's *Marat*, for it strikes one with the force of a revelation. In art the heroic implies a meaningful presentation of a significant thought or event; and exaggeration can never be a substitute for insight.

The faith of the Enlightenment in the revelations of wisdom, and in their power to change man's destiny, encouraged a growing veneration of artists

43 and thinkers. The project of the French architect Etienne-Louis Boullée (1728–99) for a cenotaph to Sir Isaac Newton is perhaps its most eloquent pictorial expression. The drawings for it suggest a structure that would have exposed an idea with overwhelming clarity. Although Boullée probably

43 BOULLÉE *Project for a Cenotaph to Sir Isaac Newton* 1784

never did more than dream of his design being carried out, he characteristically regarded it as his most important creation. The central chamber – with the sarcophagus at its base – is a perfect sphere, and all the supporting forms – cylinders and curves – are its derivatives. The interior suggests the firmament (there are holes in the surface through which daylight can produce the effect of the constellations of the night sky) while from the outside the idea of the sphere is preserved by means of curves cut in the lower cylinder. Perfection and the Universal are thus indissolubly linked; and Boullée honours Newton as the genius who brought these concepts closer to man's grasp: 'O Newton, as by the extent of your wisdom and the sublimity of your genius you determined the shape of the earth; I have conceived the idea of enveloping you in your own discovery.'

According to A.M. Vogt this 'discovery' was Newton's deduction that the earth had originally been perfectly spherical before it had become 'flattened' through rotation. In Boullée's estimation he thus took his place alongside Rousseau as one of the revealers of a primal perfection since corrupted by experience.

The starkness in the forms and mood of this project can be compared with other major works of the 1780s. It would be tempting to connect such 'revolutionary' creations with the growing political unrest in Europe; yet it

69

44 LEDOUX Customs house, Paris 1784

would be unwise, for there are few direct links. Boullée showed no interest
in political affairs, and the other great 'revolutionary' architect of the day –
44 Claude-Nicolas Ledoux (1736–1806) – created spartan customs houses
which imposed the hated royal levies.

It was in the 1790s, when ideals were being put to the test, that the heroic
gained a more urgent dimension. Such writers and artists as Blake, Schiller
and Goya – who had supported enlightened liberalism against oppression in
their respective countries – were now thrown back on their own resources.
Schiller's crisis was the one that was expressed most publicly – as indeed had
been his previous social involvement through such plays as *The Robbers* (*Die
Räuber*), 1781. In the early 1790s, after the Reign of Terror in France, he
examined anew his political convictions and the significance of his, the
artist's, role for his contemporaries. He firmly believed that art became
more, rather than less, important during times of upheaval: 'if man is ever to
solve the problem of politics in practice he will have to approach it through
the problem of the aesthetic, because it is only through Beauty that man
makes his way to Freedom'.

Schiller felt that the connection between art and politics was on the level
of individual reflection. It was the sensibilities aroused by art, the awareness
of innate beauty and nobility, the freely chosen involvement of the faculty of
judgment, that could develop in man those qualities necessary for the
possession of true liberty.

Both the independence and the moral responsibility assumed here were to become central to Romantic thought. They underlie Shelley's *Defence of Poetry*, and are shared by critics as dissimilar as Ruskin and Baudelaire.

For all his independence of thought, Schiller's sense of ennobling beauty was still inspired by a vision of antiquity. In this he was close to the greatest Northern monumental artist of his generation, the German Asmus Jacob Carstens (1754–98). This artist's life took the form of a long and painful pilgrimage from a poverty-stricken home on the Baltic to his Mecca, Rome. He died there after six years' residence, at the age of forty-four.

Carstens' pride and sense of independence were continually driving him into difficulties, but they also provided him with the highest sense of his responsibility as an artist. 'I belong to humanity, not to the Academy of Berlin,' he retorted on the memorable occasion when he was requested by a Prussian minister to return to his teaching duties. His own desire was for 'a wall seventy ells high, like that of Michelangelo's *Last Judgment*, on which he can work himself to death and become immortal'.

Although Carstens never got his wall, his large chalk designs – which form the major part of his mature work in Rome – are saturated with the Michelangelesque. Often he seems to be too close to his hero. But his best-known work, *Night with her Children, Sleep and Death*, has a deeply personal 45 pathos. Against the turmoil of the Three Fates spinning and cutting the

45 CARSTENS *Night with her Children, Sleep and Death* 1795

thread of man's life, the introspective figure of Night draws her veil over Sleep and Death in a simple and affecting gesture. Perhaps Carstens was aroused by the uncertainties of the times or even by his own approaching death. In any case, he seems to have taken to heart the passage where Schiller calls on the artist to be the 'child of his age' without being its 'minion'. For this artist of Schiller's, after having 'come to maturity under a distant Grecian sky', should 'return, a stranger, to his own country; not, however, to gladden it by his appearance, but rather, terrible like Agamemnon's son, to cleanse and purify it'.

Such high-flown idealism may seem to us overstated. Yet there were many at the time who were seeking for an art that could equal the extremes that they had experienced, and these people had a special sympathy for the heroic. When Stendhal came to see the Sistine Chapel, after serving under Napoleon on the Russian campaign, he recognized a 'daring power' which recalled his most awesome moments:

'When, during our wretched retreat from Russia, we were suddenly awakened in the middle of the night by a burst of cannon fire which seemed to be coming closer all the time, all our strength appeared to flow into our hearts; we were in the presence of destiny, and, indifferent to matters of vulgar interest, were prepared to measure our lives against fate. The sight of Michelangelo's pictures re-awakened in me this almost forgotten sensation. Great souls are sufficient unto themselves; others become frightened and go mad.'

The prophet

'Jesus and his Apostles and Disciples were all artists.'

There is no mistaking the voice of William Blake (1757–1827). This painter-poet, the most impenitent of visionaries, has always been a paradox. Even today opinion divides between regarding him as a curious eccentric and as the most profound spirit of his age. It is more difficult to take a middle ground. One cannot play the connoisseur with him; either one believes in Blake or one does not.

Like Schiller's artist (see above), Blake gives the illusion of being formed apart from his age. Yet his vision was forged in the language of his contemporaries. He was not the only prophet to emerge in the wake of revolution. Quite apart from faith healers and spiritualists like Mesmer and Loutherbourg, there were such millenarians as Joanna Southcott (1750–1814), the religious fanatic who claimed the gift of tongues, pronounced herself the woman in Revelation 12 and thought herself to be pregnant with the second Messiah, 'Shiloh', shortly before her death of dropsy. More generally there was a yearning for the spiritual that had first

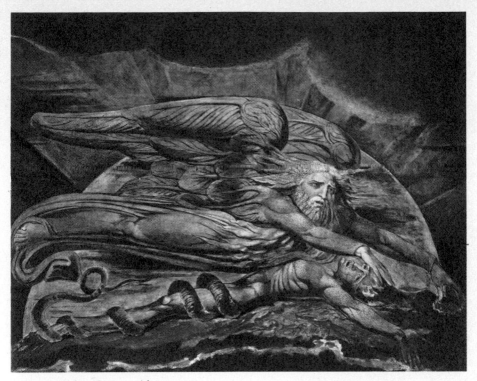

46 BLAKE *Elohim Creating Adam* 1795

been expressed in the writings of the Swedish divine Emanuel Swedenborg and now led to the revival of Rosicrucianism and Freemasonry.

There is much to connect Blake with such movements. His paintings and writings were part of a visionary message, often issued in the form of illuminated prophetic books in which he evolved a personal mythology. Yet he offered no patent cures or formulae for salvation. All he offered was the revelation of an artist's insight. His assertion that Christ was an artist was a recognition that an artist's vision, like that of a religious prophet, was synthetic rather than analytic. More than any of his contemporaries he appreciated that creativity had nothing to do with the rational. Unlike Swedenborg, he did not attempt to align mysticism with the Enlightenment. 'Talent thinks, genius sees,' he declared.

It was quite in keeping with this viewpoint that Blake laid little importance on Christ's miracles. For him the Saviour's real message lay in his challenge to authority, his acting 'from impulse, not from rules'. Blake reached right back to the subversive spirit of primitive Christianity, before

the faith had become an established religion. In doing so he was drawing inspiration from the same source as a long tradition of radical millenarians; for him, however, the spirit had been preserved through art. He envisaged Joseph of Arimathaea, the 'secret apostle' who was supposed to have brought Christianity to England, as 'one of the Gothic Artists who built the Cathedrals in what we call the dark ages'.

47

It was the making real of this vision that was the artist's task:

> To see a World in a Grain of Sand
> and a Heaven in a Wild Flower
> Hold Infinity in the palm of your hand
> and eternity in an hour.

The experience must come through seeing and holding, the action of the senses, 'the chief inlets of the soul'. Blake rejected the intellectual separation of mind and body. The visible must be recognized, in a Neo-platonic sense, as one manifestation of a greater entity. All his prophetic books involve contemporary situations. His most ecstatic, *Jerusalem*, is full of references to London, the city that was Blake's earthly reality. And it was through the

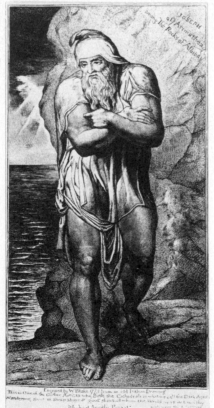

47 BLAKE
Joseph of Arimathaea 1773

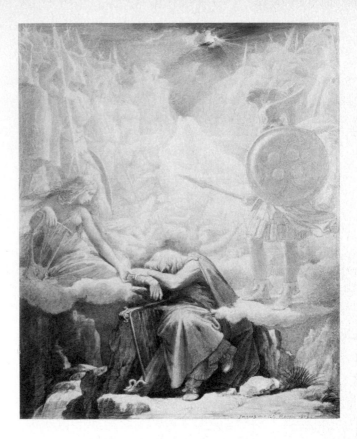

48 INGRES *Dream of Ossian*
1809

recognition of this continuum that he hoped to reveal the Kingdom of God on Earth.

In his writings and in his paintings, Blake's method could be described as naïve. Nor would he have taken exception to this, for he found archaic man and the child to be nearest to the Divine. His approach was archetypal. In a way more generally familiar since Jung, he studied ancient myths to discover primal meanings.

Blake's point of departure was the growing admiration for 'primitive' poetry that had led to the revaluation of Homer and Hesiod as the bards who had preserved the legends of Greece before they could be debased by civilization. This concern for rediscovering original purity had also turned Western Europeans back to their own early history, to the epics of Dante and the legends of the German *Nibelungenlied*. It had even led to the discovery of a Homer of their own, the fictive Gaelic bard Ossian, whose sagas (almost complete fabrications) were published by James Macpherson in 1762–63.

75

Ossian fulfilled the eighteenth century's highest expectations of the primitive. His heroes were both courageous and courteous; far better behaved, in fact, than the squabbling protagonists of the *Iliad*. Their religion, too, was more 'natural', being based directly on elemental spirits. By the 1770s Ossian was famous throughout Europe. The hero of Goethe's *Werther* (1774) preferred him to Homer, and so did the Primitifs in David's studio. Napoleon's house at Malmaison was decorated with scenes which combined his own legend with that of the bard, such as Girodet's *Ossian Receiving Napoleon's Generals*. Ingres emphasized the inspirational side of Ossian in his 48 *Dream of Ossian*, a preliminary design for a ceiling in the palace Napoleon was to have occupied in Rome.

The Ossianic sagas provided a format and a metre which Blake adapted for his own prophetic books. Although he did not borrow any of the stories, he copied the primitive flavour of the names.

In keeping with the primitive and naïve aspects of his poetry, Blake also limited his painting techniques. The explicitness of outline was preferred to effects of colour, and the illusionism of oil painting was rejected in favour of a simulation of tempera painting, which he referred to as 'fresco'. Despite this hardness of style, Blake was highly suspicious of the antique. Like the Schlegels (with whom he shared the concept of art as religious experience) he came to see Grecian art as mechanical: 'Grecian art is mathematical form, Gothic art is living form.' He explained the virtues that did exist in classical sculptures by considering them to be pale copies 'from greater works of the Asiatic Patriarchs'. He seems to have been seeking to rediscover some such archetype when adapting the figure of Skiron from the Temple of the Winds 46 for the figure of the Creator in *Elohim Creating Adam*.

In material terms Blake's career was a modest one. The son of a London hosier, he was trained as an engraver and attended the Royal Academy Schools to continue his education. Although he later described himself as 'having spent the Vigour of my Youth and Genius under Oppression of Sr Joshua and his Gang of Cunning Hired Knaves Without Employment', he appears to have achieved some recognition at first both as a designer and an engraver. Watercolours of historical subjects in a gentle linear style were exhibited by him at the Royal Academy in the 1780s, placing him in the company of the more imaginative Academicians, like Barry and Fuseli. He was also to be found at this time in fashionable intellectual circles. There are accounts of contact with such radicals as William Godwin and Mary Wollstonecraft, the great champion of female liberty. He is even reputed to have been the man who persuaded Tom Paine to leave England when that propagandist, whose *Rights of Man* (1791) called for the overthrow of the British monarchy, was on the point of being arrested for high treason.

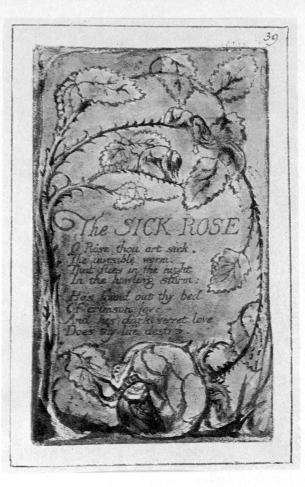

49 BLAKE *The Sick Rose* 1794

The period which saw Blake's change to a more isolated path is marked by the publication of his *Songs of Innocence* (1789) and his *Songs of Experience* (1794). The first, true to its title, affirms a belief in natural human goodness. Man is seen as the embodiment of the 'Divine Image', full of 'love, mercy, pity, peace'. The *Songs of Experience* mimic the simple lyrics of the former work while opposing its message. Even though Blake finally suppressed the most savage page, in which the 'human form Divine' now stands for 'cruelty . . . Jealousy . . . Terror . . . and Secrecy', he openly questioned throughout the enigma of evil in a God-created world.

In these works Blake became independent in a more material sense. For he devised for them a simple form of relief etching which he could print himself

77

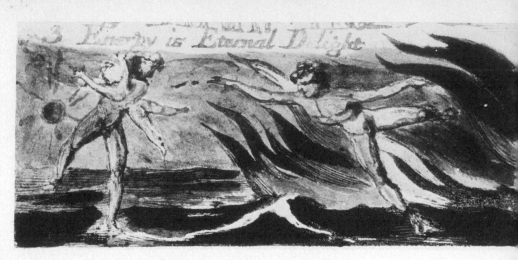

50 BLAKE From *The Marriage of Heaven and Hell* 1793

in his own home without the need. of an expensive press. The resulting impressions were then touched up, coloured and bound by himself with the aid of his devoted wife. This was the method he used for all his illuminated books. Since word and image were combined in the same plate – as in a medieval manuscript – it led to a close synthesis of Blake's two means of expression. The poem exists in both simultaneously. In *The Sick Rose* it is left 49 to the design to show the fatigue of the deep red bloom as it weighs the weakened stem to the ground.

As events in France inflamed hostility to radicalism in England, Blake went into semi-retirement, renting a small house in Lambeth, then just outside London, on the south bank of the Thames. Disillusionment led him to question his former assumptions; he saw the traditional concepts of good and evil as distinctions that attempted to blot out what could not be 50 comprehended. In his *Marriage of Heaven and Hell* (1793) he sought to abolish the division. It is the devil here who asserts that 'Energy is Eternal Delight'. Evil becomes for him the primal urge. Like the seventeenth-century mystic Jacob Boehme (republished in England in the 1760s), he believed it was the oppression brought about by earthly laws that caused this libidinous force to be considered evil.

Blake's prophetic books deal with the repression of energy – political in *America* and *Europe*, social in *Urizen* and sexual in *The Visions of the Daughters of Albion*; and a series of large prints demonstrate the clouding of the spirit by materialism. Newton, who ten years earlier had been celebrated by Boullée as a liberator, here becomes an oppressor, dissecting the world with his dividers. God the Father, too, is oppressive; for it was He, the lawgiver, who

sundered Heaven and Hell by His expulsion of the devil. Called by Blake by His first Biblical name Elohim ('judges') He is shown virtually dragging 46 Adam into existence. These works, exactly contemporary with Carstens' *Night with her Children*, show a similar creation of monumental vigour by 45 the compression of bold figures into a tight space. Both Carstens and Blake drew in fact on Michelangelo's Sistine ceiling for this, and for the morphology of their figures. But unlike Carstens, Blake had inherited none of the Renaissance master's humanism. Nothing could be further from Michelangelo's God, making in man the beauteous embodiment of His own image, than this terrifying picture of a free spirit being enslaved by mortality – with the serpent already entwining his leg.

The dark years of the 1790s were followed by three years in the country (1800–3) at Felpham. When he returned to London he was no more accepted than before – his only one-man show (held in 1809 at his brother's house) was dismissed by the one newspaper that reviewed it as a 'farrago of nonsense'. Yet he seems to have felt a new inner peace, for his interest turned from oppression to salvation. This was the message behind *Jerusalem*, on which he was to work for the next twenty years.

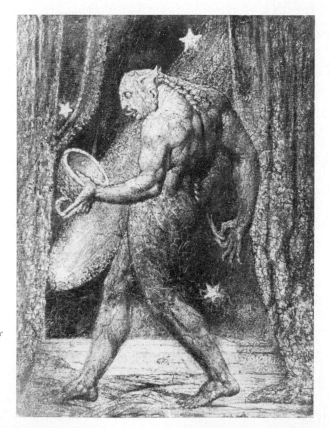

51 BLAKE *Ghost of a Flea* 1819–20

In his art, the titanic forms had given way to more linear and intricate designs. In the long series of scenes of the life of Christ, painted for one of his few devoted patrons, Thomas Butts, the 'friend of my angels', a new appreciation of the Gothic emerges. Gothic form had fascinated Blake ever since he had been sent as an apprentice to make copies of the tombs in Westminster Abbey; yet now the art was to take on a special spiritual meaning for him. It was at about this time – around 1808 – that he revised his apprentice engraving after Michelangelo to identify it as the 'Gothic' artist, Joseph of Arimathaea. Not only do these designs gain energy from the linear rhythms of Gothic art, but they also show at times the adoption of the hierarchical frontal symmetry of the medieval altarpiece – as in the exquisite *Angels Watching over the Tomb of Christ.*

At this time Blake's reputation was at its nadir. Even such sympathizers as Coleridge and the Germanist Crabb Robinson – who compared Blake's views on religion and art to those of Wackenroder (*see* p. 107) – viewed him principally as an intriguing madman. A few years later, however, there emerged a younger generation which was prepared to take him more seriously. Some of these were occultists, whom Blake treated in cavalier manner. He humoured the amateur astrologer John Varley by pretending to have 'visions' in a literal rather than metaphoric sense. He pretended that certain historical figures actually appeared before him, and would draw them as they posed. It was on one such occasion that he sketched the anthropomorphic *Ghost of a Flea*, a bloodcurdling visualization which he later worked up into a tempera painting.

Although still desperately poor, Blake had now achieved the serenity of a patriarch. Perhaps his new circle of admirers – which included such artists as John Linnell (*see* p. 198) – may have stimulated the lyrical mood of his pastoral wood-engravings for Virgil's *Pastorals*. His illustrations to the Book of Job certainly contain a personal message. For the cause of Job's trials lay in the limits of his understanding of the Lord. In the beginning Job had worshipped the Lord piously, obeying all the laws, but, as is written beneath the first picture, 'the letter killeth, the spirit giveth life'. When he had resisted the temptation to curse God for having broken the 'rules' – that is, brought him bad fortune when he had done no wrong – the Lord appeared to him in a whirlwind and revealed to him the mystic totality of the universe. In these illustrations the picture dominates. They show Blake undiminished in vigour both as a visionary and as a practitioner of conventional line engraving – no doubt used because actually financed by Linnell.

When Blake died he was working on another project for Linnell: the illustration of Dante's *Divine Comedy*. Blake's pictorial commentary responds to the imagination that was liberated in Dante as he passed through

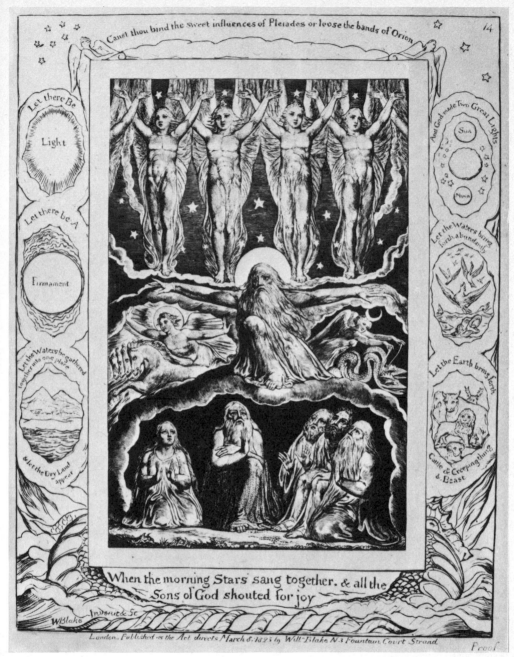

The following text appears within the illustration:

Canst thou bind the sweet influences of Pleiades or loose the bands of Orion

Let there Be Light

Let there be A Firmament

Let the Waters be gathered together into one place

& let the Dry Land appear

And God made Two Great Lights

Sun

Moon

Let the Waters bring forth abundantly

Let the Earth bring forth

Cattle & Creeping thing & Beast

When the morning Stars sang together. & all the Sons of God shouted for joy

W Blake Invenit & Sc

London, Published as the Act directs March 8. 1825 by Will. Blake N.3 Fountain Court Strand.

Proof

14

52 BLAKE *When the Morning Stars Sang Together* . . . from *The Book of Job* 1823–25

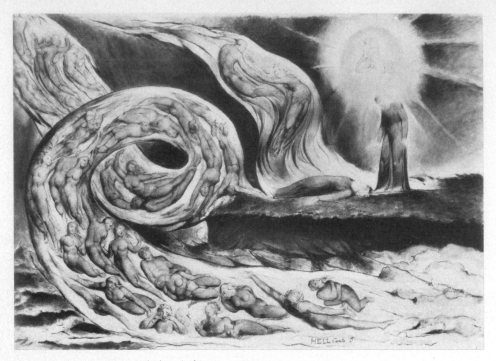

53 BLAKE *Whirlwind of Lovers* c.1824

Hell, but laments his return to the conventional Church in Heaven. As Dante is led by Virgil through the circles of Hell they are shown clothed respectively in red and blue, the colours of feeling and imagination, so essential for the poet. In these watercolours (there was also an uncompleted series of engravings after them), Blake's Michelangelesque forms have become so completely imbued with flickering colours and Gothic linearity that the whole appears as a trance-like rhythm of energy. Such scenes as the *Whirlwind of Lovers*, in which the unfortunate Paolo and Francesca are seen with the others who share their fate, form the perfect conclusion for the career of an artist who had always insisted on the strength and clarity, the super-reality, of the visionary.

Blake died, as he lived, praising the Lord. His latter days of joy and steadfastness are perhaps the most compelling witness to his achievement. In the existential terms that he laid down he had succeeded in reconciling the contraries of Heaven and Hell that had been sundered by the lawgivers. He had survived isolation and degradation with his resilience and his receptiveness unimpaired.

The vision was one way of penetrating the surface; satire is another. Yet this most anti-heroic form of insight assumes many shapes. Sometimes it proceeds by wit, and sometimes by fantasy; and when it does so by the latter it implies the grotesqueness and absurdity of the caricature.

The eighteenth century was a consummate age of satire. The charm and irresponsibility of the Rococo itself was a mockery of the pompous Baroque. Mythology disintegrated into erotic adventures, and that type of social-life painting was popular that poked fun at human conceits. In England and France, where social and political reform were matters of genuine concern, however, such mockery had a serious side. The ironic allegories of Swift, Hogarth and Voltaire were designed to change people's awareness, to make them feel the need for reform. Yet none of these satirists saw any place in their work for the free-ranging inventiveness of caricature. For them it remained too close to the Italian word that described it: *caricare*, 'to exaggerate'; they wished to expose by an appeal to reason. Voltaire would no doubt have agreed with the *Encyclopédie* of his colleague Diderot, when it defined caricature as a kind of *libertinage d'imagination*, which might be used for harmless amusement, but could have no more serious purpose.

For William Hogarth (1697–1764) the distinction between this and the mockery of his 'Modern Life' series was a crucial one. He dissociated himself utterly from caricature. The advertisement to his classiest production, *Marriage à la Mode*, was a series of head studies entitled *Characters and Caricaturas*. In this, a set of 'character' studies after Raphael's tapestry cartoons are opposed to a group of grotesques that one is tempted to describe as caricatures of caricatures. Most telling of all is the artist's arcane allusion in the text below to the preface of Henry Fielding's novel *Joseph Andrews*; for here is written: 'in the Caricatura we allow all licence. Its aim is to exhibit monsters, not men.' There was no place for monsters in Hogarth's art, only for the exposure of human weakness.

For the Romantics, caricature ceased to be a vulgar harmless pleasure; they lived in a world in which the irrational could no longer be discounted. The visions and demons that visited Blake, Fuseli and Goya suggested a new repertoire to the cartoonist, and raised his trade to an art. Never before would one of them have been described as 'the foremost living artist of the whole of Europe' as James Gillray was in 1806.

Gillray (1757–1815) came to his profession with the highest credentials, for he had studied at the Royal Academy Schools. He was the true mock-heroic counterpart to the history painter. His etchings display all the expertise of a first-class draughtsman; they abound too in erudite cultural allusions that would have been appreciated by the fashionable society that

54

54 HOGARTH *Characters and Caricaturas* 1743

55 GILLRAY *Smelling Out a Rat* 1790

flocked to the shop of his publisher, Mrs Humphreys. In the increasingly troubled political and economic climate of the late eighteenth century the public desire for topical news brought about the emergence of widespread regular journalism; it was Gillray above all who made the political cartoon a distinguished part of this development.

Gillray does not tell his story in crude icons; he evokes a situation. His *Smelling out a Rat* shows Edmund Burke – now a champion against the French Revolution – sniffing out the activities of the notorious radical clergyman Dr Richard Price. Ostensibly the print is against 'the Atheistical-Revolutionist disturbed', but Gillray makes a more complex point in his balancing of observation with invention. For Price's discoverer is reduced to a fantasmagoria of superstition. He emerges absurdly from a cloud – all nose and no head – holding up the tokens of Church and State, and masking himself with his own *Reflections on the Revolution in France*. Gillray had the supreme Romantic gift of extending reality through fantasy. One or other political faction might try to buy his allegiance, but they could never control the range and quality of his imagination.

Francisco de Goya

It was a painter – the greatest of the age – who understood most fully the compulsion of such fantasy. For when Francisco de Goya (1746–1828) came to design his satirical *Caprichos* he found himself being drawn from a mockery of Spanish society into a world of inexplicable demons.

Like Blake, Goya is often thought of as an isolated phenomenon; a solitary genius (isolated still more in later years by deafness) in an ailing society. Certainly Spain had long ceased to enjoy the central place in European affairs that it had occupied in the sixteenth century. But although Spain was a backwater, it still felt the eddies of events elsewhere. The ideals of the Enlightenment were no less decisive here than in other outlying regions of European society like Russia. Charles III, under whom Goya grew to maturity, was sympathetic to change, and ministers like Floridablanca put in hand sweeping economic and agricultural reforms.

With the death of Charles III in 1788 and the dismissal of Floridablanca by his successor Charles IV in 1791 this brief moment of progress vanished. It had been, as one Spaniard put it, 'a flash of lightning illuminating us for an instant only to leave us in greater darkness'. Revolution took place in France; the Spanish court watched helplessly. Napoleon first ignored the country, then invaded it; the monarchy capitulated. There was a glorious movement of resistance from the Spanish people, but when the French had finally been expelled its leaders were exiled or executed by a new repressive regime.

The 'flash of lightning' of the 1780s had been enough to make Goya a

confirmed liberal. He was a friend of such progressives as the poet Meléndez Valdés, the translator of the English 'nature' poet Edward Young, and the philosopher and statesman Jovellanos. And when Ferdinand VII suppressed the constitution in 1823, Goya, then seventy-seven, left Spain to spend his last years as an exile in France.

56 Despite his sympathies, Goya could not ignore the strength of ignorance and superstition in his country. A small panel, the *Flagellants*, echoes the gruesome scenes of religious masochism that still took place in the processions of Holy Week. If one is to believe what Goya wrote, his intention in portraying such irrationalities was to expose them through confrontation. When he sought to address such satires to a wider public by the publication of the *Caprichos*, he advertised the work as an attack on folly and superstition. The plate originally chosen to preface the work was to have carried the explanation: 'The artist dreaming. His only purpose is to banish harmful, vulgar beliefs and to perpetuate in this work of caprices the solid testimony of truth.'

57 The artist improved on this in the published version, entitled *The Sleep of Reason Produces Monsters*. Now the subtitle reads: 'Imagination abandoned by reason produces impossible monsters; united with her, she is the mother of the arts.' The night creatures that surround Goya are not 'impossible monsters' but owls, bats and a lynx; one, the owl, is actually prompting the artist to action, holding his chalk at the ready for him. It could be taken as the symbol of Athena, goddess of wisdom and the arts. As such it would associate Goya with the long line of intellectual melancholics who discover new truths from the thoughtful contemplation of the unknown. Yet this explanation says nothing of the fear the artist is feeling, or of the unwillingness with which he turns to his task. As the change of subtitle shows, Goya thought up the interpretation of his plates after he had conceived them. Many of the other captions express, as André Malraux put it, 'Goya's astonishment before figures which are partly strangers to him'. He may have set out to mock folly and absurdity, but his imagination took him beyond all control.

Such artistic integrity was perhaps a tribute to the laborious development of his early years. Like Blake and David, he had had to work hard to achieve proficiency. He failed twice to win a scholarship to the Madrid Academy; however he did have the determination to finance himself on a visit to Italy, and the experience seems to have started latent forces developing within him. In any case he appears to have gained the approval of Mengs. For it was this artist who, as principal painter to the Spanish King, was responsible for Goya's employment engagement in 1771 as a designer for the royal tapestries.

58 Goya's tapestry cartoons were painted with a light-toned elegance

56 GOYA *Flagellants* 1794

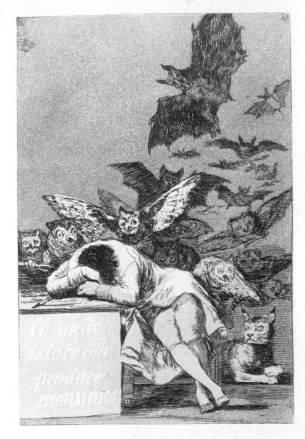

57 GOYA *The Sleep of
Reason Produces Monsters
c.* 1798

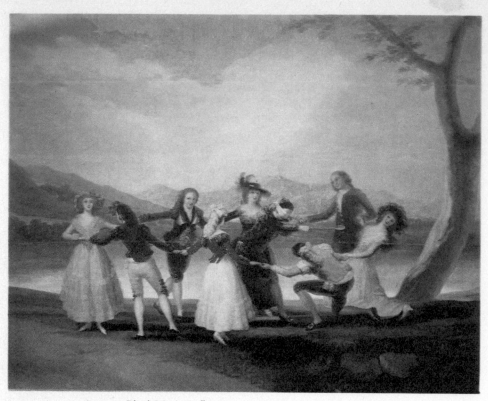

58 GOYA *Blind Man's Buff* 1789

appropriate to that genre. These conventions he learned from his brother-in-law and former master, Joseph Bayeu, who was also employed on such commissions. Yet at the same time he was learning much from his new surroundings in Madrid. The frescoes painted by Tiepolo and Mengs for Charles III showed him the range and accomplishments of contemporary decorative art from Italy. From the royal collection he could gain a first-hand acquaintance with the great Venetian, Flemish and Spanish painters of the past. He seems to have taken to heart Mengs' assertion that the best school of painting for a young artist was the work of Velazquez, for he made a series of etchings after the works of this master, which were published in Madrid in 1778.

Even in tapestry designs he was able to move gradually away from the conventions of the Rococo. For the Spanish court aped the new French taste for simplicity. In the place of simpering allegories they now preferred scenes of rural life and even of craftsmen at work. They also liked depictions of themselves dressed in the national Spanish costume of the proletarian *majos*

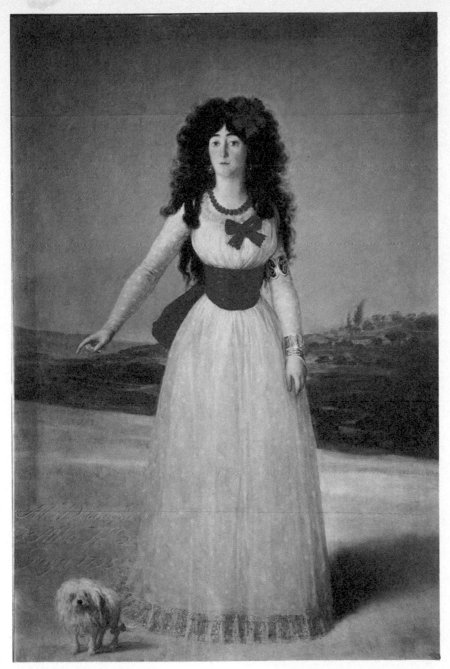

59 GOYA *Duchess of Alba* 1795

and *majas* – a taste comparable to Queen Marie-Antoinette's masquerading
59 as a milkmaid at the French court. Such subjects nurtured Goya's
observation.

58 In the late design *Blind Man's Buff* affectation plays a game with the
natural. Some of the lords and ladies are in their plebeian guise, but there is
no loss of manners. They hold hands neatly in a circle, bobbing away in turn
from the blind man's baton – like dancing puppets. If the fluent handling of
gauzes and telling touches of pure black remind one of Goya's admiration
for the portraits of Velazquez, the changeful light and deep foreground
shadows hint at his other hero from the past – Rembrandt. Yet the darkness
that creates a unifying mood in Rembrandt's reflective, close-toned pictures
seems here to menace the carefree protagonists.

Long before Goya achieved the title of First Painter to the King in 1799, he
held the stage as Madrid's most fashionable portraitist. Yet in his pictures of
dignitaries about their business, or society ladies in landscapes, there is no less
confrontation than in *Blind Man's Buff*. No graceful trees or noble columns
59 offset the dominating presence of the *Duchess of Alba*. As she stands before us
with her startling mane of black hair and her outfit of white, red and gold,
one feels the full concentration of her elegant and imperious personality. It is
not hard to believe the French visitor who declared that 'The Duchess of
Alba has not a hair on her head that does not provoke desire.' Surrounding

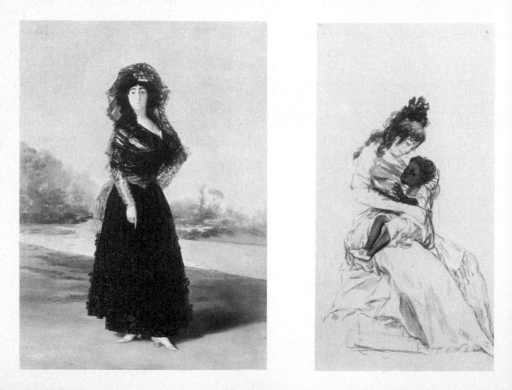

herself with a bizarre entourage, she lived a life of tempestuous adventures and love-affairs that ended in a mysterious death – possibly from poisoning – at the age of forty.

In this portrait – where the Duchess's commanding gesture presides over nothing more than the ineffectual dog at her feet – Goya can still view this bewitching lady with a certain detachment, and suggest the emotional emptiness that accompanied her quixotic way of life. Yet it was soon to be his turn to kneel to her bidding. In the summer of 1796, when she was recently widowed and he was recovering from the illness that had left him deaf, he joined her at her country estate at Sanlúcar de Barrameda, near Cadiz. A portrait of her from this time shows her in widow's weeds. But the rings on her right hand are inscribed ALBA and GOYA and she points to the ground where SÓLO GOYA – 'only Goya' – is scratched in the sand. Goya's sketchbooks from this visit also contain light-hearted scenes showing the Duchess in a more informal mood, fondling her young Negress ward or flirting with a gentleman on the road. Yet three years later her features were to appear in some of the bitterest plates in the *Caprichos* on themes of fickleness and rejection, with titles like *Dream of Inconstancy*, *They flew away* or *God forgive her: and it was her mother*.

Goya's explorations of a private world had in no way affected his career as a court painter. Yet there is a new frankness in the observation of his later

60

61

62

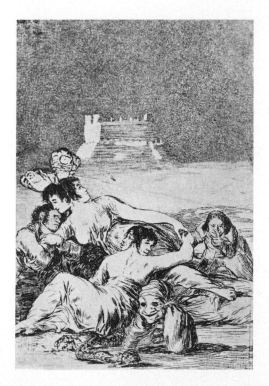

60 GOYA *Duchess of Alba* 1797

61 GOYA *Duchess of Alba with Black Girl* 1796

62 GOYA *Dream of Inconstancy* c.1799

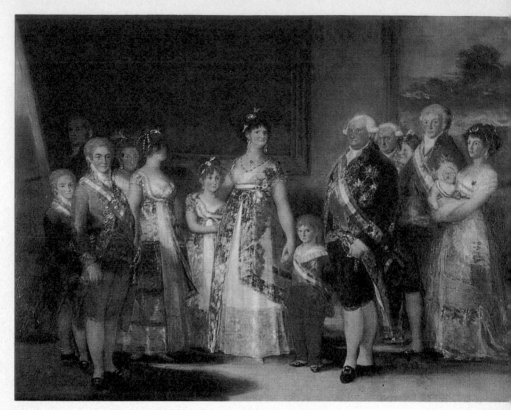

63 GOYA *Charles IV and the Royal Family* 1800

portraits. Thoughts that were only hinted at when he was painting works like the *Duchess of Alba* now appear in full orchestration. When he painted the neglected wife of the dissolute Prime Minister Godoy, he showed her seated in a darkened room, pregnant and cornered, glancing nervously about her like a fieldmouse. With daring expertise he turned his grandest and most formal commission, the life-size portrait of Charles IV and his family, into an exercise in exposure. There is no difficulty in discovering the bluff stupidity of Charles IV in the decorated plum-coloured figure in the right foreground. Nor is there any thought of concealing the overbearing and licentious character of the Queen as she stands in the centre, casting her unlovely face into half profile for the spectator to get a better look. Near the shadows, clothed in blue, is the viperous Ferdinand, who was ready to unseat his father at the bidding of Napoleon and later became one of Spain's most disastrous rulers. Goya himself has borne witness to what he sees by including himself

63

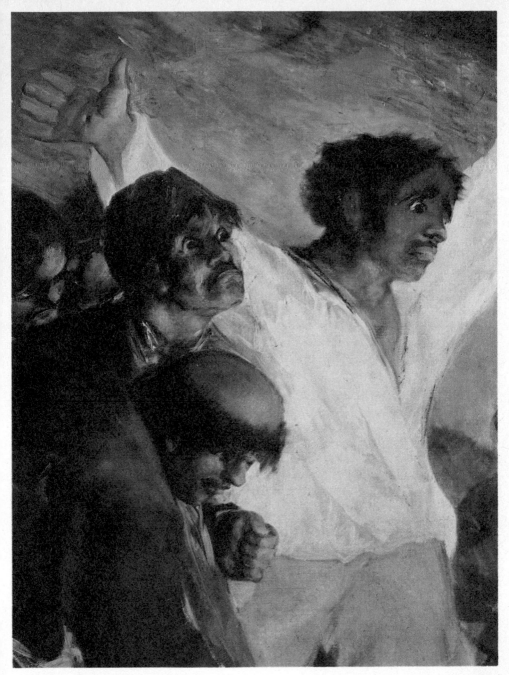

64 GOYA *Third of May* (detail) 1814

at his easel in the background, no doubt as a tribute to Velazquez's *Las Meninas*. But whereas Velazquez introduces himself to enhance the informal and domestic atmosphere of his royal group, Goya lurks as a disconcerting presence behind the glittering display.

The sheer lack of flattery in this work makes it hard to believe that the artist was not being sarcastic. Yet it does not seem to have caused displeasure. It was accepted and paid for; and, although it was the last official portrait he did for Charles IV, he remained court painter and later painted Ferdinand. Those satisfied with their own appearance and gestures have no reason to see their repetition as character assassination.

Above all the picture is a triumph for Goya's integrity as a reporter in an artistic field in which this is not normally encouraged. This gift was to be tested to the full during the years 1808–14, when Spain was ruled by Napoleon's brother Joseph, and was in a state of continuous and brutal insurrection. Goya himself took no active part in the struggle. He remained in Madrid, swore allegiance to Joseph, painted French officers, and even received Joseph's award, the Royal Order of Spain, in 1811. However, he witnessed enough of the atrocities, enough murder, rape and senseless butchery, to feel compelled to make his own record. As with the *Caprichos*, his chosen medium was etching; though this time the resulting prints, the *Disasters of War*, were not published. Perhaps they represented too deep an indictment of war itself to be acceptable to either side.

For his contemporaries, Goya's view of the war was summed up in two monumental paintings, done in 1814, which commemorate the events that gave birth to the Spanish resistance movement. On 2 May 1808, when French troops were already in occupation of Madrid, the populace in the Puerta del Sol area rioted; in the tumult some of the French were killed. The revenge taken was out of all proportion. During the same night hundreds of civilians – for the most part innocent – were arrested and shot.

Even before Ferdinand returned to Spain, Goya applied to the Regency for financial aid to paint these two great works. No doubt his motive was political; for it was a shrewd move to express such nationalist sympathy at a time when he was being asked awkward questions about that medal he had received from Joseph. Yet they are none the less sincere. Goya was in Madrid when the events took place and, even if he did not witness them, he experienced their consequences. In the *Second of May* he showed a moment of compulsive violence as Spaniards attacked the Mamelukes, the hated Egyptian mercenaries of the French army, dragging them from their horses and stabbing them to death. The expressions on the assassins' faces suggest an act less of heroism than of desperation; and the sharp flashes of colour in the crowd, with the steep perspective of the street, heighten the frenzy.

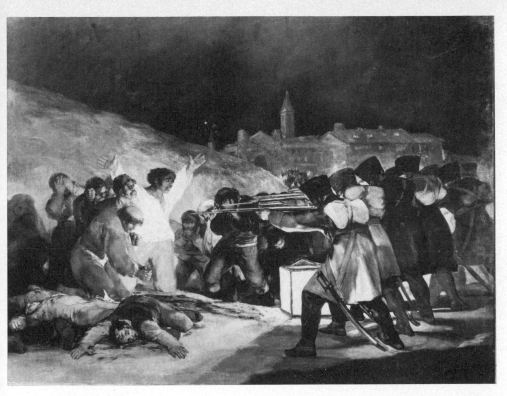

65 GOYA *Third of May* 1814

The *Second of May* is perhaps the finest of all the battle scenes of the
Napoleonic wars; the *Third of May* is beyond classification. No execution 65
scene has ever revealed this extreme moment with such barefaced honesty.
What is described here is the heroism of the final and hopeless gesture; of the
outstretched arms and staring features of the white-shirted victim as he is 64
mown down by a faceless firing-squad. Unlike the *Horatii*, he is not about to 38
save his country. Unlike *Marat*, his death is absurd, and he knows it. 39

Everything hangs on his gesture. The massacre takes place without
witnesses, at the dead of night. There is an unseemly haste in the way the
unfortunates are bunched against a wall, with those already killed on one
side, and those waiting their turn on the other. The colours are mournful and
sombre: black, ochre and olive-green. The only illumination comes from a
crude box lantern, turned to expose the victims. Its brightness is met by that
of the white-shirted man. And while it is enclosed by the mechanical line of
anonymous soldiers, he is the centre of a group of individual people. Some

95

cannot look, some look despite themselves, some stare. But each endures his death in a way that is utterly human.

Goya was reinstated. But by now he was lonely and old, as well as deaf. His wife and many of his closest friends were dead, and he rarely went out in society or painted at court. In 1819 he withdrew to a country house outside Madrid, known, as it happened, as the Quinta del Sordo, 'house of the deaf man'. Here he remained until his departure to Bordeaux in 1823.

66 In a self-portrait of 1815 he examines his features in close-up against a deep brown ground. Both in technique and intention it is close to Rembrandt's portraits of himself in his old age, although what emerges from Goya's face is not ironic resignation but rather a persisting curiosity and energy. Perhaps it is his deafness that makes him stare so hard with his eyes that his mouth hangs slightly open. But the sense of surprise that this conveys is matched by the angle at which he peers round the side of his canvas.

Once more a renewed bout of illness seems to have stimulated his fantasy. 67 *The Disparates* are more curious and dream-like than the *Caprichos*, but also less savagely critical. The themes themselves can often be connected with popular proverbs; Goya was now prepared to accept the force of poetic experience stored up in folk traditions.

66 GOYA *Self-portrait* 1815

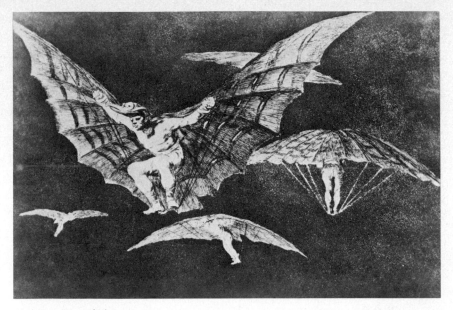

67 GOYA *Way of Flying c.*1820

Goya never attempted to have these plates published. Perhaps he used the etching process for its pictorial rather than its reproductive potential; for he had remarkable sympathy for the special qualities of different graphic media. He was the first artist to appreciate the unprecedented freedom of draughtsmanship allowed by the new technique of lithography, and he used it to capture the movement and excitement of the bull-fight in his illustrations to a history of bull-fighting, *Tauromaquia*. For his imaginative visions he preferred the fine lines and deep grounds that could be achieved through his own peculiar combination of etching with aquatint. In *Way of Flying* he gives his wistful aeronauts an insectile delicacy as they flit about their featureless world. 67

Goya's last visions, in the paintings with which he decorated two rooms of the Quinta del Sordo, are 'Black Paintings' both in their macabre subjects and in their sombre colouring. They are executed with a freedom and power that is achieved by only a few artists in their last years – by such men as Michelangelo, Titian and Rembrandt. 68, 69

There appears to be no precise programme to the strange mythologies that unfold in them; but there are many points of contact between the works themselves. This must have been even more evident before they were removed from their original location in 1874 to save them from destruction.

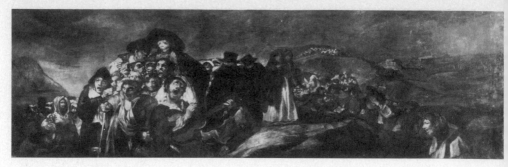

68 GOYA *Vision of the Pilgrims of San Isidro c.* 1820–23

Then one could have seen how the scenes in the upper room have the appearance of hallucinations – one shows two giants battling, sunk to the knees in a mountainous landscape, while another has two figures levitating between a sniper and a group of travellers – and how the ones in the room below are darker, more factual and more savage. It was in the latter that he heightened the impact of his subjects by arranging them in contrasting pendants. At one end a youthful full-bodied woman was set against two aged, groping men. On the long walls Christian ritual was compared with that of witchcraft, as the travellers in the *Vision of the Pilgrims of San Isidro* stared open-mouthed towards a *Witches' Sabbath*; and at the other end was the female treachery of *Judith Slaying Holofernes* and the male brutality of *Saturn Devouring One of his Children*. This last is perhaps the most horrifying of these works. Yet, even as Saturn gnaws a mutilated carcass, one can see in his eyes the fear that drove him to commit the horrible act; the fear of being usurped. Goya is seeking to reach beyond myth to human experience.

The 'Black Paintings' have no counterpart in any of the heroic or prophetic art being produced by his contemporaries: perhaps only in music, in the late quartets (1824–26) of Beethoven, was there a comparable exploration of darkness. In many ways these were Goya's last great statement, yet they were not the conclusion of his career. Even in his exile his curiosity remained undiminished. His friend and fellow émigré in Bordeaux, the poet Leandro Fernández de Moratín, described him as 'deaf, old, slow and weak, not knowing a word of French, and so desirous of seeing the world'.

Goya's endurance, like that of Blake, was central to his achievement. For both preserved a sense of humanity that could survive disillusion. With their prophetic and ironic insight they were the first to face a world of passion and absurdity before which conventional heroic art was powerless.

69 GOYA *Saturn Devouring One of his Children c.* 1820–23

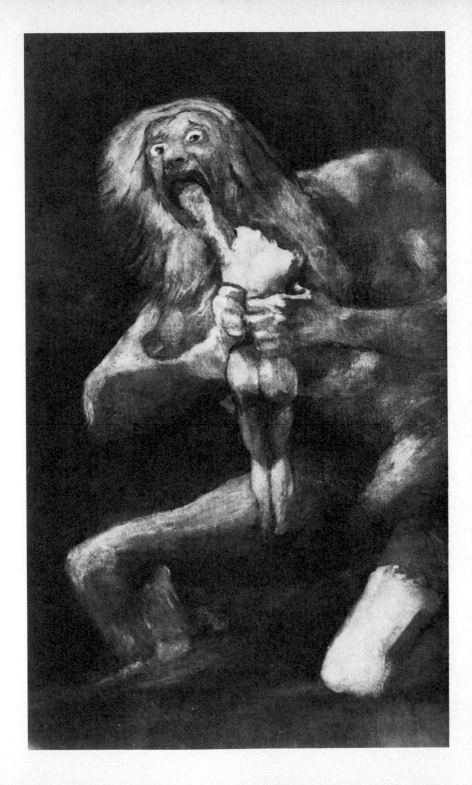

The medieval revival

Dreams and fantasies

By their very name, the Romantics professed a fascination for the Middle Ages. The old romances – censured by the prudish heroine of Samuel Richardson's novel *Pamela* as 'calculated to *fire* the *imagination* rather than to *inform* the *judgement*' (1740) – became a powerful symbol for those who were seeking to replace rules and taste with inventiveness and enthusiasm; and in the visual arts the fantasy of Gothic and the colourful naïveties of illuminated manuscripts and ancient paintings seemed to offer a comparable release.

This renewed appreciation of the Gothic world bears a superficial resemblance to the growth of interest in other cultures of the past or of distant lands – such as that for Greece or for the Orient. But it was always distinguished from these by its marked ethnic concern: it was presumably for this reason that the medieval was always strongest in Northern Europe. Already by the middle of the eighteenth century, the perennial curiosity of the antiquarian for medieval remains was being supplemented by an

70 BERTHÉLEMY *Retaking of Paris from the English* 1787

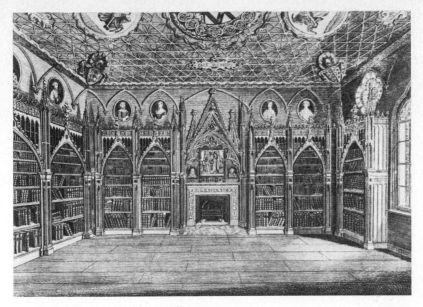

71 CHUTE *Library at Strawberry Hill* 1754

enjoyment of their evocative qualities. These early Gothicists were perfectly prepared to invent where the materials were not to hand. There was no need for the mock ruins that they built in the wilder parts of landscaped parks – such as Sanderson Miller's castle at Hagley (*c.* 1754) – to bear more than a passing resemblance to the real thing. Indeed, the very knowledge of the artifice could heighten the poignancy.

It was in such a mood that Horace Walpole, the dilettante fourth son of the famous British Prime Minister, began to Gothicize Strawberry Hill, his villa at Twickenham, in 1748. The move was a bold one, for he brought the asymmetry and picturesqueness of garden furnishings into his very living quarters. With mounting enthusiasm he and his band of amateur advisers turned his home into a thorough-going medieval domain. And, as they proceeded, so their desire for authentic detail increased. In the library of 1754, for example, the form of the book-cases was scrupulously copied from a tomb in Westminster Abbey.

However arbitrary Walpole's Gothic might seem today, it fulfilled a need for his contemporaries, and his house became a regular tourist attraction. It is equally appropriate that his skill at providing a fanciful alternative to mundane existence should also have led to his revival of the literary romance. His *Castle of Otranto* (1765), the earliest of 'Gothic' novels, opens with the inexplicable appearance of a gigantic gauntlet which, typically, he

72 BLAKE *Angels Watching over the Tomb of Christ* *c.*1806

claimed was inspired by a dream. And his assertion in defence of such irrationalities, that in the modern novel 'the great resources of fancy have been dammed up, by a strict adherence to common life' might have been intended as a riposte to Pamela's strictures on romance.

In these activities Walpole prefigured the Romantic pursuit of new sensations – though with considerably more light-heartedness. He shared none of the sense of tragedy that can be felt in William Beckford, who was to outpace him both in the drama of his mansion at Fonthill and in the excesses of his own book *Vathek* (1782). Nor, indeed, did he approach the insights of some later Gothic novels, such as Mary Shelley's masterly exploration of aberrant personality in *Frankenstein* (1818).

26

Greek and Gothic

The enjoyment of make-believe also enriched such contemporary medieval subject paintings as West's *Death of Bayard* (1772) or the French artist Jean-Simon Berthélemy's (1743–1811) *Retaking of Paris from the English*. These works evoke an age of chivalry and adventure but reveal scant interest in the styles of medieval art.

70

73 INGRES *Mlle Rivière* 1806

It was in fact the enthusiasts for Greek art who first responded to a similar archaic quality in the Gothic. When John Flaxman came to Rome to study in 1787 he fell in with such connoisseurs as Humbert de Superville and William Young Ottley, who were beginning to document the art of the Italian Middle Ages. His own famous *Outlines* show the results of such contacts in their engaging eclecticism; they enliven the succinct outlines of the Greek vase with a flowing Gothic linearity.

His friend William Blake – who possibly first influenced him in this direction – was soon to take the Gothic more seriously (*see* p. 80). It was the 'spirituality' of the Gothic that absorbed him; and his most overt reinterpretations of medieval forms are in specifically Christian subjects, such as the *Angels Watching over the Tomb of Christ* from the series he painted for Thomas Butts. The beautiful rhythm that flows down the arch of the angels' wings in perfect symmetry completely releases the design from the anthropocentric bias of Greek art: it is like some vibrant hieroglyph of the Divine.

Blake's understanding of the Gothic was unique; his religious attitude to it can be compared only with that of the German Romantics (*see* p. 106).

Elsewhere, artists with a taste for the archaic came nearer to the position of Flaxman. In France, the Primitifs of David's studio expressed a sympathy for the culture of the North; while there were other pupils of the master – notably Ingres, Girodet, Richard and Granet – who had an undisguised enthusiasm for medieval methods. Indeed, when Jean-Auguste Dominique Ingres (1780–1867) exhibited his portrait of Napoleon as Emperor and the three portraits of the Rivière family at the Salon of 1806 he was roundly condemned by the critics for being 'Gothic'.

73

Blake was responding to Gothic art with the spiritual sensuousness of the mystic; but Ingres could find in it the means for a subtle eroticism. Nowhere does he use this more tenderly than in his portrait of Mlle Rivière. The fifteen-year-old girl is viewed in a simple three-quarter pose beneath an arched frame, like some virgin saint. Her innocence is echoed in the pure tone of her white dress and the limpid landscape beyond. But its coolness sends a shiver of premonition through the scene. It is early spring, and just as the trees are in their first leaf so she too is awakening. Her lips are already full, there is a sharp accent to her mustard-yellow gloves, and the undulations of her soft swan's-down boa anticipate her emerging femininity. It was never to be fulfilled, for Mlle Rivière died later the same year.

Despite the attacks on Ingres's style, this brilliantly successful young artist – who had won the Prix de Rome in 1801 at the age of twenty-one and had now painted Napoleon twice – was in fact following a vogue. The reaction that succeeded the excesses of the Terror had led to a widespread yearning for tradition. It was a mood inflamed by a prominent returned exile, the writer Chateaubriand, when he published his *Spirit of Christianity* (1802), an impassioned plea for the rehabilitation of the historic faith that had been undermined by republicanism. It was this feeling that had been so well gauged by Napoleon in 1801 when he made his peace with the Pope and restored Christianity as the official religion of France. Mocking the 'mere dreamers who think that a Republic can be made out of an old monarchy' he had himself crowned with the ancient title of Emperor three years later in a magnificent ceremony in the Cathedral of Notre-Dame. Nor is he likely to have been displeased when, in 1806, Ingres depicted him with a 'Gothic' technique that reminded the critics of Van Eyck, and in a hieratic pose that they considered more appropriate for the representation of *le bon roi* Dagobert.

Napoleon's appeal to the past was calculated; the artists who responded to it had come into contact with medieval art more haphazardly. It had been a fortunate accident that the Museum of French Monuments that had been set up by the National Assembly in 1790 to house the works pillaged from the churches should have been entrusted to Alexandre Lenoir. For it was this

scholarly and imaginative artist who established the pattern for all modern museums, arranging works according to chronology and type. An English visitor, the Reverend William Shepherd, noted how the 'dim religious gloom of the apartments destined for the reception of the recumbent figures of the saints and warriors of the Middle Ages, lends to rude efforts of art an interest which they do not in themselves possess'; while the 'more exquisite productions of the time of François I and Louis XIV' were displayed in 'lightsome halls where their beauties will best be discerned'. Lenoir's dim religious gloom is also reminiscent of the atmosphere in the subject pieces of Fleury Richard (1777–1852) and the darkened cloister paintings of Ingres's 74 friend François-Marius Granet.

74 RICHARD *Louis IX Showing Deference to his Mother* 1808

Lenoir's sculpture collection was soon to be supplemented by a much grander project; the opening of the royal collections in the Louvre to the general public. Eventually this became the Musée Napoléon, and was swelled by the booty that the Emperor brought back from his campaigns. Undoubtedly the main attractions here were the stupendous masterpieces of the Renaissance and antiquity, such as the Vatican treasures, Raphael's

2 *Transfiguration* and the Hellenistic *Laocoön* group. Yet there were also valuable examples of early Italian and Northern art, including the central panels of Van Eyck's *Adoration of the Mystic Lamb*. This collection, the sight of which inspired Friedrich Schlegel to proclaim the virtues of 'Christian' art to his fellow Germans in his magazine *Europa* (*see* p. 110), also provided a source book for Ingres and for all his colleagues up to its dispersal in 1816.

The incipient medievalism of this period is felt most pervasively in the gentle *intimisme* of Fleury Richard. Basing his art on illuminated manuscripts, Dutch interiors and the monuments in Lenoir's museum, he retold anecdotes from the history of France with simple rhetoric and a naïve

74 fascination for historic detail. Such works as *Louis IX Showing Deference to his Mother* found approval in the upstart Napoleonic court, and many, including this work, were acquired by the Empress Josephine. Ingres himself occasionally painted essays in what Théophile Gautier was later to name the *style troubadour*; yet his response to the Gothic was on the whole much less overt. He never needed to resolve the stylistic conflict between Greek and Gothic: for the constant tension between irreconcilables – simplicity and exaggeration, intellectual purity and sensuous abandon – is one of the sources of his art's eternal ability to amaze.

National character and devotion

By the first decade of the nineteenth century, the reappraisal of medieval art was widespread throughout Europe. It was among German artists, however, that it first led to a systematic revival, when a group of young students at the Vienna Academy banded themselves together into a 'Brotherhood of St Luke' in 1809 with the intention of restoring the spirit of the Age of Faith in both their art and their lives.

The reasons behind this move lay not so much in any great familiarity with the art of the Middle Ages as in the attitudes that had been adopted towards it by the German Romantic writers and critics. The concept of art as the expression of the character of its creator had already been emphasized by the writers of Storm and Stress. Indeed, this had been the basis of the earliest German defence of the Gothic, Goethe's essay on Strasbourg cathedral, *On German Architecture* (1773). Like contemporary writers in England – and equally incorrectly – Goethe assumed that the Gothic had originated in his

own country. Yet this assumption did not take on its full significance until the idea of national character was developed by his friend Gottfried Herder over twenty years later in his *Letters for the Advancement of Humanity* (1793–97). Here Herder argued that nations, like individuals, had a 'character'. Like some great plant, this would gradually unfold through history in accordance with the features that had existed in embryo at the time of its origin. This concept of innate national identity was, in Germany, to become the first step on a tragic path; but Herder's own views were a plea for tolerance. He saw no reason why the Indian should be made to imitate the European; nor, for that matter, why the modern European should have to emulate the ancient Greek.

The relationship between art and national identity had been suggested by Winckelmann, when he had accounted for the supreme qualities of Greek art; but his interest had been in prevailing social and climatic conditions, rather than in any innate 'Greekness'. For the German Romantics, however, inheritors of Herder's doctrine, there was a living German soul, and it was this that Gothic architecture and 'Old German art' expressed uniquely. In much the same way it led in literature to the emulation of the folk-tale and the ballad, and in music to the popularity of the *Lied*.

This attitude was encouraged by the fact that the late Middle Ages actually could be looked upon as a kind of German golden age. For this was the time when Germany had enjoyed a measure of unity under the Holy Roman Empire, before the centuries of political, religious and cultural disintegration that accounted for its present disarray. And it was also the highest point of German art; for it was then that the genius of Albrecht Dürer had flourished.

Convinced that great art was the expression of over-all greatness, the Romantics found that the paintings of Dürer represented (in the words of Wilhelm Wackenroder) 'this upright seriousness and strength of German character faithfully, not only in their faces and external traits, but in their inmost spirit'. And it was taking his rugged forms and obsessive naturalism as their guide that they hoped to encourage the blighted plant of German national character once more to flower. Wackenroder, a sickly and soulful youth, died in 1798 at the age of twenty-five, after having published no more than one slender volume. Yet his *Outpourings from the Heart of an Art-loving Monk* (*Herzensergiessungen eines kunstliebenden Klosterbruders*) (1797) did more than any other work to stimulate a yearning for the Middle Ages. Indeed, it is a proverbial starting-point for histories of German Romanticism.

Although the climax of Wackenroder's book is the section in praise of 'our venerable ancestor Albert Dürer', he was no more a chauvinist than Herder was: the other great hero of his book was the 'divine Raphael'. His

75 OVERBECK *Franz Pforr* 1811

point about Dürer was rather that this artist had succeeded by developing his own qualities rather than by striving to emulate those that were foreign to him: 'He was not made for the ideal and the noble serenity of Raphael. His delight was in representing men as they really existed all around him, and in this he succeeded admirably.'

It was the sentiment of Wackenroder's book (rather than its information, which was taken from standard sources) that was so influential. This sentiment was not so much one of nationalism as of religious adoration. Wackenroder asserted that there was no hierarchy of styles, but only a truthful expression of the self. All works of art were nevertheless united inasmuch as they were hymns of praise to the Creator: 'Art can be considered as the flower of human feeling. From the different parts of the earth it rises towards Heaven in an everlasting variety of forms, and to our father.'

In his emphasis on emotion, his love of dreams, and above all his view of art as a religious act, Wackenroder came close – as Crabb Robinson noted – to the outlook of William Blake; but there is a crucial difference. Where Blake speaks of vision, Wackenroder speaks of devotion. His is a gentle world; he believes in self-expression, but he is no revolutionary.

This change of mood is one that separates the heroic independence of Blake's generation from the communal yearning of the medieval revivalists. Just as the emphasis had slipped from individual to national character, so the image of struggling genius had given way to the concept of the artist craftsman, working in quiet harmony with the world around him. It was the need for a sympathetic environment that caused the founding of the Brotherhood of St Luke. And if the Brethren could never quite realize their dreams, at least they could share them, as when one of their leaders, Friedrich Overbeck (1789–1869), depicted his friend Franz Pforr 'in a surrounding in which he would perhaps feel happiest'. Pforr sits in his medieval garb at a Gothic window. Beside him is his cat, whose meek pose is echoed by that of the young girl devoutly knitting and reading in the chamber behind. Outside is a fairy-tale town, that leads down to the sea. One can well believe that this is a portrait of the youth who declared: 'I feel that I am unfit for the unquiet, large life. A small room, my easel, a few friends, and the necessities of existence satisfy all my wishes. I must confess to you that I should like to achieve something in art, but this is best done in the midst of a quiet retiring life.' 75

Christian Romanticism

In the decade between the death of Wackenroder and the formation of the Brotherhood of St Luke, the medieval revival reached endemic proportions in Germany. Wackenroder's friend Ludwig Tieck continued the evocation of the past in a series of popular novels and plays, such as *Franz Sternbald's Wanderings* (1798) – an 'artistic romance' about the life of a mythical pupil of Dürer's. A more inspired view was that of the poet Novalis, whose *Christianity, or Europe* (1802) described a vision of a Europe united by the Christian faith and blessed by a harmony of Church and State through the Pope and Holy Roman Emperor. Published in the same year as Chateaubriand's *Spirit of Christianity*, it made a similar plea for a return to tradition. Napoleon, whose opportunist support of the revivalist cause soon disillusioned Chateaubriand, became a virtual Antichrist for the German medievalists, especially after he invaded German territory in 1806. From this time they became actively identified with the German nationalist movement which culminated in the War of Liberation of 1814.

Such events provided a positive context for the revival, which was matched in the theoretical sphere by the assertions of the critic Friedrich Schlegel. Schlegel's rigid defence of medieval art and the Christian religion (he converted to Catholicism in 1808) seems something of a retreat from the days in which he had hailed the 'progressive universal poetry' of Romanticism (*see* p. 9). Yet it was also an attempt to preserve something of

positive value from that time of high enthusiasm which – after the death of Novalis in 1801 – could never return.

Schlegel not only brought a greater dogmatism to the revival: he also discussed early Italian and Northern art and its significance for the modern painter in far more specific terms than Wackenroder had. And, once he had seen the Musée Napoléon in 1802, he realized that here lay the spiritual source he had been seeking. With characteristic fanaticism he filled his magazine *Europa* with a lengthy series of 'Descriptions of Paintings from Paris and the Netherlands' (1802–4).

Beginning with the statement 'I am exclusively attuned to the style of the earlier, Christian painters', he goes on to praise these for their positiveness and simplicity: 'No confused heaps of men, but a few isolated figures . . . severe forms, contained in sharp and clearly defined contours; no chiaroscuro or dirt, muck and shadow, but pure relationships and masses of colour.'

Such definiteness seems far removed from any romantic sense of mystique. But Schlegel preserves this, too, contracting his earlier love of indefiniteness and the infinite into the static mystic image: 'A hieroglyph, a symbol of the divine – this is what every worthwhile painting must be.' It is this quality that is missing in Greek art which, despite its simplicity, describes no more than the 'perfection of organic form'.

Friedrich Schlegel, his brother August Wilhelm and Ludwig Tieck were great polemicists. And in the widening circles of their travels these survivors of the *Athenaeum* circle implanted the revised doctrine of 'Christian' Romanticism throughout Germany: in Berlin, Frankfurt, Heidelberg, Dresden and Vienna. Everywhere there seemed to spring up collections of 'Old German' and pious art, the earliest being that of the brothers Sulpiz and Melchior Boisserée in Cologne. The work of the contemporary painters who responded to the Schlegels' exhortations is disappointingly bereft of the spirit of the Middle Ages. Perhaps it was Friedrich Schlegel's cautious qualification that they should 'copy only the truths of the Primitives and not their imperfections' – 'the emaciated hands, the Egyptian position of the feet, the tight clothing, garish colour, squinting eyes or the lapses of draughtsmanship' – that encouraged them to leave all but the surface detail of their academic trainings intact.

No doubt it was the smallness of the step represented by Gottlieb Schick's 76 (1776–1812) *Sacrifice of Noah* that made it seem such a satisfactory synthesis to A. W. Schlegel and Madame de Staël when they saw it exhibited at the Pantheon in Rome in 1805. Schick had travelled far from the art of David (under whom he had studied in Paris); but he had travelled almost exclusively in the direction of the High Renaissance, making a brief stop at

76 SCHICK *Sacrifice of Noah* 1805

Poussin on the way. Yet no one could doubt his good intentions, which Schlegel described as 'the feeling of devotion which had been totally absent from contemporary painting'. It is a picture about piety, not just in the way the figures take up their simple poses like actors in a tableau, but also in its subject; the moment when God renewed his promise to man with that great and natural hieroglyph, the rainbow.

The Brotherhood of St Luke

Only the Brotherhood of St Luke took the emulation of the Primitives to an extreme. For this alone its members would earn an important place in any history of nineteenth-century revivalism. These students of the Vienna Academy may not have been the first to form a breakaway group to challenge official teaching methods and standards; that honour seems to belong to the French Primitifs (*see* p. 104). But they were certainly the first to take secession to the point of establishing an alternative mode of existence.

Their involvement with the spirit of the past became so great as to compel those who could afford it – and some who really could not – to make in 1810 the pilgrimage to Rome, their sanctum of Christian art; and to establish themselves there in the disused Monastery of S. Isidoro, where they lived in monk-like seclusion, grew their hair long and dressed in archaic costumes.

Their inspiration stemmed from the person they called their 'leader', Franz Pforr (1788–1812). It was his passionate friendship for Friedrich Overbeck (1789–1869) – who was to be known as the 'priest' of the group – which had been celebrated on the anniversary of their first meeting by the founding of the Brotherhood on 10 July 1809. (The other four original members were, one feels, largely a make-weight.) And it was Pforr's death in 1812, at the age of twenty-four, that precipitated the break-up of their communal monastic existence. Only after this did the appearance of the survivors and their imitators lead the curious Romans to dub them 'Nazarenes', the name under which they returned to conquer the German official art world and dominate religious painting throughout Europe for half a century.

Not long after Pforr's death there began a distinct decline in the emotional pitch of the work of the Nazarenes. Perhaps even the paintings of the leader would not always have retained their sense of wonder, for this depended above all on a pure and unaffected feeling for the naïve.

77 REHBENITZ
Self-portrait
1817

78 PFORR *Shulamit and Maria* 1812

Although the motifs of Pforr's pictures are largely derivative, his manner is unmistakable. Nothing shows the personal nature of his art more clearly than *Shulamit and Maria*. For this allegory on his friendship with Overbeck (the names come from a 'legend' written by Pforr himself) was the culmination both of his life and his artistic career. Shaped like a private devotional diptych and presided over by the evangelist St John, it symbolizes the different characters and fates of the two artists. On the left is the ideal of Overbeck, the Raphaelesque Shulamit, seated in a peaceful garden; while on the right Pforr's Maria combs her hair in a darkened chamber, reminiscent of the one depicted by Dürer in his engraving of St Jerome. The allusion was not simply because the Brethren were in the habit of calling the tranquil Overbeck their Raphael, and the passionate Pforr their Dürer. It was also to evoke the eternal yearning of the North and the calm fulfilment of the

78

South. And, more personally, it implied that Overbeck, who is seen entering the garden of Shulamit, would achieve his desire while Pforr, already mortally sick as he painted the work, would not. Despite this note of tragedy (suggested more urgently by the differing tonalities of the two sides), the picture reveals an almost childlike love of simple forms and bright colours, and a fascination with the magic of natural light. Both these interior and exterior worlds are recorded with a feeling for detail and individuality that Pforr described as 'definite character'; and shows how far his ideal of naïveté was from the Neo-classicist's search for pure form.

As Pforr's work suggests, the Nazarene technique was best suited to those who still found painting simply a genuine revelation. It was a young man's art; and, although the original Brotherhood soon drew away from it, other young artists gained inspiration from it as its ideals became known throughout Germany. The meticulous drawing technique, which discarded the easy shading effects of chalk drawing for a network of fine lines, could even coax such minor talents as Theodor Rehbenitz (1791–1861) into rare moments of achievement. For when this artist drew his self-portrait soon after coming into contact with the Roman Nazarenes he recorded every detail and nuance of the head with an almost fanatic persistence. And in doing so he achieved that state of hyper-realism in which the familiar suddenly becomes an awesome revelation, and the minutest feature bears intimations of the infinite.

Monumental art

Overbeck, deeply shaken by the death of Pforr, virtually ceased painting for a year. Then, with the aid of religion (he was to convert to Catholicism in 1813), he gradually returned. Surviving until 1869, he became the 'Prince of Christian painters', as Pugin put it, the representative of the pictorial ideals of the Catholic revival.

The Nazarenes were also to develop in a more secular direction under the influence of Peter Cornelius (1783–1867), who joined them in 1812. He was already familiar with the medieval revival through such acquaintances in his native Rhineland as the Boisserée brothers. Indeed, he had already begun a series of illustrations to the recently published *Faust*, Part 1, of Goethe, in a terse, Dürer-like grotesque. These were little to the taste of Goethe, who became so disturbed by such leanings in young artists that a few years later, in 1817, he persuaded his collaborator, the artist J.H. Meyer, to write an article attacking 'Neo-German Religious-Patriotic Art' in their magazine *Kunst und Alterthum*. In the case of Cornelius, however, he need not have worried. For, when he reached Rome, the artist soon began to revert to the academic training of his youth and produce works in his own severe version of the

79 CORNELIUS *Faust and Mephisto on the Brocken* c.1811

High Renaissance. More than anyone else he was responsible for turning the Nazarene painting from the naïve to the didactic. In 1816 it was he who persuaded the newly appointed Prussian Consul-General in Rome, Jacob Bartholdi, to have the reception-room in his lodgings decorated with murals illustrating the story of Joseph. With characteristic high-mindedness the Nazarene artists involved – Cornelius, Overbeck, Schadow and Veit – insisted on learning the rigorous and archaic technique of pure fresco; and succeeded in mastering it perfectly. In Overbeck's contributions, notably the *Sale of Joseph to the Ishmaelites*, there is still an echo of the fairy-tale world of the Brotherhood of St Luke. Cornelius' main subject, *The Recognition of Joseph by his brothers*, on the other hand, is composed in the standard classical manner, with central dramatic event and chorus of onlookers in a rigid frieze-like arrangement.

80

It was this series that established the Nazarenes' international fame; though when one reads remarks like that by the English painter Charles Lock Eastlake, 'They have dignified their style by depriving the spectator of the power of criticizing the execution', one wonders whether they were not being praised as much for their intentions as their achievements. In any case the Nazarenes began to be employed as mural painters on a large scale. In Germany their pious, high-minded and strongly traditional art seemed a perfect propagandist organ for the reactionary governments that had become established following the expulsion of Napoleon.

The first German monarch to view the Nazarenes in this light was King Ludwig I of Bavaria, who as Crown Prince came to Rome in 1819, and invited Cornelius to Munich to paint frescoes in the new public buildings he was having erected there. Ludwig was determined to have his capital transformed into an 'art-city', both for reasons of international prestige, and to keep his subjects in a state of sated docility. To contemporaries he seemed to have succeeded; and foreign observers were full of amazement not only at the sumptuous museums, churches and palaces that were going up in Munich, but also at the way in which the peasantry would use the vast frescoes of the exploits of the Wittelsbach dynasty to instruct their children in national history. Despite all this, Ludwig was one of the monarchs whose rule failed to survive the 1840s.

Cornelius spent twenty uneasy years in Munich, during which time he saw his dreams of painting a great religious cycle gradually vanishing as he was first employed on the decoration of museums and then allowed to paint no more than the apse of the Ludwigskirche, the very church where he had set his heart on fulfilling his plan. For Ludwig had soon tired of the Master's ascetic style. He preferred instead the pupils of Cornelius, who, despite their rigorous training, were prepared to paint with all the sensationalism and

80 OVERBECK *Sale of Joseph to the Ishmaelites* 1816

bravura that the Nazarenes had sought to destroy. Finally, in 1840, Cornelius accepted an offer from the Prussian King to come to Berlin and decorate a Campo Santo, a mausoleum for the Prussian royal family. But within a decade of his commission the project had been rendered obsolete by the political changes which followed the uprising of 1848.

Cornelius' ultimate failure to paint his great cycle can be seen as tragic. But what is more tragic is his failure to recognize his own potential for dramatic narrative, which is so clear in early works like *Faust*. Only occasionally does the sheer imaginative force of some theme break through his schematized arrangements, as in his cartoon of the *Four Horsemen of the Apocalypse*, one of 82 the designs for the Berlin Campo Santo. Here Cornelius has become so absorbed with the confusion and panic of figures, as the celestial horsemen wreak vengeance on humanity, that he has barely managed to check the diverse movements with his customary symmetry. It is true that the design

117

has little of the Gothic fantasy of the woodcut by Dürer on which it is obviously based; yet as a large-scale mural design it has a powerful and convincing rhetoric.

Even at its least convincing, Cornelius' work displays draughtsmanship; and, indeed, the Nazarene movement as a whole was more vigorous in its graphic art than in its painting. It is not surprising, therefore, that they should have made such a fine contribution to book illustration. Cornelius' *Faust* was one of many volumes in which archaic interests did not dull the imagination. Lithography – an invention of the Bavarian Alois Senefelder – was used at this time in Germany primarily to imitate the freedom and complexity of 'Old German' penmanship. Strixner's reproduction of Dürer's border illustrations to the *Prayer Book of the Emperor Maximilian* (1808) precipitated a whole range of Ballad Books with fantastic decorative borders. But it was the growing vogue for wood engraving that led to the finest German production in this genre. For the 1840 edition of the *Nibelungenlied*, illustrated by the Düsseldorf artists E. Bendemann, J. Hubner and Alfred

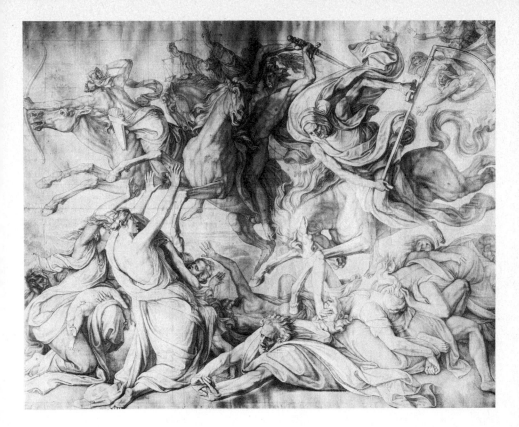

Rethel, drew directly on the woodcut style of the sixteenth century. And
Rethel, at least, achieved designs which were to become a source of
inspiration for the English Arts and Crafts movement.

Influences abroad

Above all, the Nazarenes impressed their contemporaries with their good
intentions. They appealed to those who wished to counter the alarming
social and economic changes of the nineteenth century with the image of
faith and innocence. For such revivalists the return to the conventions of the
Primitives was as much a theological as an aesthetic issue; for Overbeck and
his followers had banished all the pagan corruptions – like *putti* for angels –
which had crept into religious art during the Late Renaissance and the
Baroque.

It was the influence of the Nazarenes that encouraged a strict orthodoxy in
nineteenth-century Church art. Even Ingres abandoned his customary
ambivalence when fulfilling such commissions as the *Christ Giving St Peter*

83 FLANDRIN *Procession of Virgins*

the Keys for SS. Trinità dei Monti in Rome; while pupils of his like Hippolyte
Flandrin took an active part in decorating churches with all the 'Primitive'
conventions.

Nazarene art was equally effective on the level of political didacticism.
The developments in Munich made a profound impression on those who
were responsible for the decoration of public buildings elsewhere. When it
was decided in England in 1840 to decorate the new Houses of Parliament
with allegorical and historical murals, the outcome was a positive craze for
Teutonic art. In the next few years scores of aspiring history painters made
the journey to Munich to learn the techniques of fresco and that hieratic
symmetrical method of designing that the Pre-Raphaelite painter William
Holman Hunt was later to refer to disparagingly as 'the German Balance of
composition'.

Art, however lofty its intentions and however sound its theoretical basis,
still does not convince by argument, but by the evidence of the eye; and, for
the nineteenth century, descriptive accuracy remained the standard of
pictorial excellence. Indeed, revivalists had always insisted that the
Primitives had observed more truthfully than later generations, whose
vision had become clouded by conventions and meaningless displays of
expertise. Yet they could not deny that these later generations had also made
concrete advances in the interpretation of natural appearances – in the
understanding of perspective and anatomy, for example; and their desire to
correct the 'faults' of early art while preserving its 'truths' led all too often to
a bland and meaningless compromise.

120

84 NASH Luscombe, Devon, begun 1799

Architecture and revivalism

The revivalist movement in painting was closely paralleled by developments in architecture. There is a similar evolution from the colourful evocations of the generation of Berthélemy and Walpole to a distinct nationalist and religious concern around 1800, and finally to an interest in functionalism in the 1840s.

Behind the inventiveness and irregularity of the first stage lay the idea of the Picturesque. By the late 1790s the taste for actually living in a fantastic environment was sufficiently widespread to support a strictly commerical partnership like that of the landscape gardener Humphrey Repton (1752–1818) and the architect John Nash (1752–1835) between 1795 and 1802. Both specialized in popularizing the irrational. While Repton – who, in the course of his career, improved over four hundred estates – would provide an exciting but well-mannered wilderness, Nash would design a house that was the last word in eccentricity, but nevertheless comfortable in a way that Fonthill can never have been. Houses like Luscombe, Devon, 84 built for the banker Charles Hoare, run Perpendicular-style windows down to the ground to provide a light and airy verandah, have octagons that contain spacious rooms, rather than dank halls and stair wells, and altogether give the suggestion of a castle within the scope of a villa. Nash was equally at home with irregular styles that suggested other Utopias distant in time or space: such jaded tastes as that of Nash's most illustrious patron, the Prince Regent, could be titillated by a bizarre Orientalism, like that in which the Brighton Pavilion was refurbished (1815–21).

Nash was above all a planner of façades; a skill he used to full effect in the masterly classical terraces of Regent's Park. To him the Gothic was a means of achieving a special effect; but there is an appreciation of lighting and surprise throughout his work that suggests that the qualities people found in the medieval were beginning to have a more general application.

The relationship between Greek and Gothic is no less ambiguous in architecture than it was in painting. For both had equal claims to being natural and archetypal. The creation myth that lay behind the reappraisal of Greek architecture was that of a French writer, the Abbé Laugier. In his *Essay on Architecture* (1753) he suggested that the Greek Doric style was still directly connected with the very first type of building, the simple primitive hut with its bare posts supporting a straight cross-bar or lintel. On the face of it, the creation myth surrounding the Gothic seems similar. For it was widely held in the eighteenth century that the Gothic arch was derived from the shape formed by the interlocking of two branches of adjacent trees. Yet, although both these myths refer to the 'naturalness' of Greek and Gothic, they are in fact talking about very different things. The naturalness of Greek architecture is the naturalness of using logical deduction to discover the basic module for construction. In Gothic it is the imitation of forms as they actually can be found growing in nature. Nothing could illustrate Blake's distinction of Greek as 'mathematical' and Gothic as 'living' form more clearly.

But if the rationales behind the naturalness of Greek and Gothic were thus opposed, there was nevertheless a practical appreciation of the qualities of both. Even Laugier could admit to an admiration for the loftiness and lighting effects of the Gothic, and proposed a combination of such a feeling with Greek construction in churches – a synthesis that was attempted by Soufflot when building the Parisian Basilica of Sainte-Geneviève, now the Panthéon. Time and again, architects like Boullée and Sir John Soane express an interest in the Gothic, not in the forms they use, but in the way they stage their buildings. Soane (1753–1837), the finest English architect of his generation, was consistently disparaging about the purely decorative quality of his rival Nash; yet although his own eclectic classicism shows an integrity and care of a quite different order, its effect still depended upon the evocation of a mood and for this, as Sir John Summerson has pointed out, he leaned on the Gothic. In such interiors as those of the Bank of England or the Court of Chancery, Westminster, he may use the overhead lighting of a Roman bath; but the massiveness of form and lighting is broken up by lantern openings, hanging arches and a slenderness of features that creates an intricate and ethereal atmosphere quite unknown to classical antiquity. Soane was a great admirer of the 'bold flights of irregular fancy' of Sir John Vanbrugh, the

85

85 SOANE Court of
Chancery, Westminster, 1823

86 SCHINKEL *Study for a
Monument to Queen Luise*
1810

great successor to Wren who had not only brought English architecture closer to the exuberance of European Baroque, but had also delighted in a fanciful Gothicism. And just as Vanbrugh had created a castellated façade for his own house at Greenwich (1717), so Soane indulged in some harmless Gothic fun in his London home in Lincoln's Inn Fields, building himself a medieval 'monk's cell' and casting himself in the role of its mythical occupant, 'padre Giovanni'.

The ethnic interest in the Middle Ages that crystallized into nationalist movements on the Continent during the Napoleonic period concerned Gothic architecture every bit as much as it did 'Primitive' painting. Indeed, Chateaubriand's *Spirit of Christianity* (1802) had been considerably more concerned with the former, associating the Gothic not just with spirituality, but also with the French past. In Germany the Gothic was intimately bound up with the national liberation movement, and the great Neo-classical Berlin architect Karl Friedrich Schinkel (1781–1841) turned during the years of the French occupation of Germany to the design of Gothic buildings, both in his evocative landscape paintings and in such unexecuted projects as the mausoleum for Queen Luise. Schinkel's view of the Gothic, that it 'represents something ideal, in that it blends symbol and reality', fits in completely with the thinking of the Christian Romantics. Yet when he became active as the Chief Architect of the Prussian Department of Works

86

87 KEMP The Scott
Monument, Edinburgh, 1836

88 SALVIN Harlaxton Hall, Lincolnshire, 1835

after 1815 he reverted – with the exception of a few churches – to an exclusive exploration of classical radicalism. Perhaps Schinkel sensed that the moment of Gothic idealism had passed in Germany with the dispersal of the liberation movement. In any case, such Gothic as did get built during this period was most uninspired. With a certain amount of disingenuousness the 'Rundbogen' or 'round arch' style became equally accepted as having a national origin; although most of the works that were built in it, such as Friedrich Gärtner's Ludwigskirche in Munich, have as much to do with the Italian Renaissance as they do with any indigenous version of the Romanesque. Like the Nazarene frescoes they so often housed, these round-arched buildings represented the transformation of a medieval dream into a schematized traditionalism.

In Britain, on the other hand, the interest in Gothic as a national style was still gathering steam. Perhaps it was inspired to some extent by the immensely popular medievalizing novels of Sir Walter Scott. Certainly this writer turned his own home of Abbotsford (1812) into a virtual Gothic reliquary, and is appropriately commemorated in the splendid shrine by G.M. Kemp in Edinburgh (1836). In any case, the Gothic of this period is 87 marked by much the same fascination for somewhat forced historical detail as is evident in Scott's novels. No doubt inspired by views of what constituted an English golden age, the Elizabethan style became acceptable as a national style on a par with Gothic, and was as frequently used in the rebuilding of the country houses of the revivalist Tory landowners of the 'Young England' faction. It was for such a society that historical fantasias like Harlaxton Hall, Lincolnshire, were built by the gentleman architect 88 Anthony Salvin (1799–1881).

125

89 CHARLES BARRY The Houses of Parliament 1840–64

But the greatest event in the establishment of the national styles was undoubtedly the competition for the building of the new Houses of Parliament, launched after the old Houses had been burnt down in 1834. For in this the rules stated quite explicitly that this building for the most important of all British institutions should be in the national styles of either 89 Gothic or Elizabethan. The resulting building by Sir Charles Barry (1795–1860) certainly fulfilled this requirement, although only because he employed the Gothicist Pugin to provide the detailing.

The building is rooted in the Romantic period, for Gothic is being used here as a pure evocation. Pugin himself, with characteristic extremism, dismissed the building as 'pure Grecian'; and he was right to the extent that the Gothic detailing has been grafted on to a plan of classical symmetry and a façade of regular interval. The fact that the design is also a masterpiece of picturesque movement is largely due to a fortunate force of circumstances; for while Barry could be as regular as he pleased with the river façade, he had to adjust the other sides of his building to accommodate the ancient Westminster Hall, which was on a slightly different axis. The style of Gothic chosen for the detail – the Perpendicular – was one that enhanced such movement by the shimmering intricacy of its surface. Although Pugin used it here with great fidelity, it was a style that he was later to tire of as he became more obsessed with the functional aspects of Gothic.

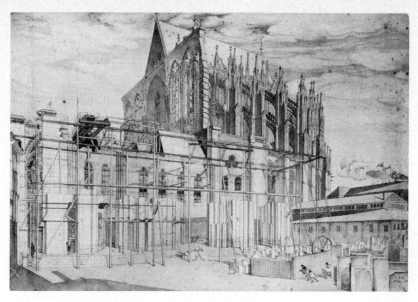

90 RAMBOUX *The Construction of Cologne Cathedral* 1844

Creative archaeology

Barry's use of a specialist to provide the detail for his Houses of Parliament is an indication of the growing seriousness with which the Gothic was being taken. A generation earlier this classically trained architect would, like Soane or Nash, have tried it himself, have got it quite wrong, and few would have been any the wiser. Now, however, the publications of a number of distinguished archaeologists and antiquaries had made people aware of how complex and specific the various styles of the Gothic were. Works like John Britton's *Cathedral Antiquities of Great Britain* (1814–35) had provided a detailed pictorial account of the appearance of Britain's greatest medieval monuments, while John Carter's *Ancient Architecture of England* (1798 and 1807) and Thomas Rickman's *Attempt to Discriminate the Styles of English Architecture* (1817) established the historical sequence of styles. Rickman's book was so popular, indeed, that there does not seem to be much likelihood even today of superseding his divisions of 'Early English', 'Decorated' and 'Perpendicular'.

On the Continent the nationalist interest in Gothic had led to independent investigations. In Germany the rediscovery of the plans for the remainder of the incomplete Cathedral of Cologne led to the most remarkable feat of archaeological reconstruction in the century. Championed with great dedication and enthusiasm by Sulpiz Boisserée, it even aroused the interest of

127

90 Goethe. The actual rebuilding began in 1824, and took three generations of architects to complete. It was viewed from the start as a symbol for the rebirth of Germany, and perhaps it was this that maintained interest in the project over such a long period. And by the time it was completed in 1880 German unification had been achieved.

In France, too, it was largely through such creative archaeology that the Gothic Revival made its contribution; for while Catholic writers such as Charles Forbes de Montalembert strongly supported the Gothic style, most of the Neo-Gothic churches erected were unimaginative. The finest French architect of the movement, Eugène Viollet-le-Duc (1814–79), devoted most of his energies to restoration work. The results he achieved in such famous buildings as the Sainte-Chapelle and Notre-Dame in Paris show a sensitivity that puts most restoration work of the period to shame. Even when he made
91 additions – such as the chapter-house to Notre-Dame – he managed to heighten the picturesqueness and fantasy of a building without noticeably jarring with the original work.

91 VIOLLET-LE-DUC
The Chapter
House, Notre-
Dame, Paris, 1847

92 PUGIN Frontispiece to *An Apology for the Revival of Christian Architecture* 1841

A. W. N. Pugin and functionalism

It seems to have been largely through French writers that Augustus Welby Northmore Pugin (1812–52) enhanced his detailed knowledge of the Gothic with its moral and historical rationale. In view of his origins – he was the son of a French émigré – this seems a natural enough bias; and it was strengthened by his conversion to Catholicism in 1835. His *Contrasts* of the following year cast the whole of the English Gothic Revival into a different light. For whatever vague associations had been made previously between the Gothic religion or nationalism, Pugin now equated artistic style unequivocally with a society's moral condition. He really saw the Greek style as the instrument of paganism, and its employment in churches as a sin. So obsessive was his religious perspective that he considered the contemporary evils of British social life to be due to Protestantism rather than to the Industrial Revolution. Like the Nazarenes – whom he greatly admired – he turned his house into an enclosed Catholic world, and even wore medieval clothes when at home. Not even Cornelius could have matched his boundless energy and irrepressible fanaticism, and it almost

8, 9

seems inevitable that he should have died as he did of nervous exhaustion at the age of forty.

Work on the Late Gothic detail of the Houses of Parliament continued all Pugin's life; but in his own work the emphasis shifted from the Perpendicular of 1350–1500 to the Decorated of 1250–1350, and from the evocative properties of Gothic to its structural fitness for purpose. In this, Pugin was pointing to a stage of the revival to which he himself hardly belonged. He could still convey his Romantic, mystical view of the Middle Ages through the brilliant polemics of his writing and etchings; but his actual buildings were another matter. They do not appear as the magnificent, shining assembly he presented in his *Apology for the Revival of Christian Architecture* (1841) but as sober reconstructions, historically impeccable but dull.

It is in the *True Principles of Pointed or Christian Architecture* (1841) – the published lectures that he originally gave at the Catholic seminary at Oscott – that Pugin emerges most fully as a functionalist. For here he appealed to practical sense rather than religious enthusiasm. He gave cogent reasons for the fitness of Gothic to the building requirements in England, emphasized the logic of its construction, and the need to use ornament to enhance, but not to obscure, the form of the building. Above all, he emphasized that planning should be governed, not by aesthetic fashions, but by utility. He stated that 'the external and internal appearance of an edifice should be illustrative of, and in accordance with, the purpose for which it is designed'.

This was intended as an attack both on the Picturesque and on classical symmetry; for he loathed equally the false façades of Neo-Greek and the 'Castellated' style. His call for functional design was soon felt outside Catholic circles. Among the Anglicans, the High Church Ecclesiological Society adopted a similar view of the Gothic. When its magazine, the *Ecclesiologist*, declared, 'The true picturesque derives from the sternest utility', it was sounding the death knell of that movement whose very essence lay in evocation and reverie.

No doubt it was the soundness of these principles from a structural point of view that led to the immense influence of English Gothic throughout Europe and the English-speaking world. Certainly buildings like Richard Upjohn's Trinity Church in New York (1846) show how rapidly the ideas of the *Ecclesiologist* spread to the New World. In England the new aesthetic reached its most positive expression in William Butterfield's (1814–1900) All Saints, Margaret Street; virtually a show church for the Ecclesiologists. There could be no sterner utility behind the irregularity here, conditioned, as it is, by the need to cram a clergy house, a school and a church on to a tiny site in central London. Even the soaring height of the spire had a purpose.

93 UPJOHN Trinity Church, New York, 1846

94 BUTTERFIELD All Saints' Church, Margaret Street, London, 1849–59

Apparently the 'tallest feature of the mid-century London skyline', it served to guide the faithful (or lure the sinner?) to it through the dense mass of urban squalor. Nor could there be anything less ethereal than its 'structural polychrome', the strident patterning of the rich red and slate-grey bricks with which it is built.

In the same year that Butterfield was taking the ecclesiastical revival of Gothic to its logical conclusion, the brilliant if bigoted young critic John Ruskin published *Seven Lamps of Architecture* (1849), the first of his architectural writings which were to provide the Gothic Revival with a deep sense of moral and social commitment and to stimulate the widespread use of Gothic in domestic architecture. Following Pugin, Ruskin emphasized the utility of Gothic using the persuasive rhetoric that gained his writings an international following. The significance of this stand was summed up by the great historian of the Gothic, Paul Frankl, who explained with admirable partisanship that Ruskin's 'recommendation of Gothic as rational was for that day a *good* recommendation; in the Romantic period Gothic was championed because it was irrational'.

Transcendent landscapes

The status of landscape

During the early nineteenth century landscape painting, which had previously been considered one of the 'lesser' genres, emerged as a principal means of artistic expression. No mode of painting contributed more to the radical changes that took place in art in the succeeding century. For it was paradoxically through constant study before nature, the noting of effects of atmosphere and light, that artists gradually moved away from descriptive painting towards the communication of pure visual experiences – a development that culminated in the emergence of abstract art shortly before the First World War.

It was the Romantic artists who first asserted the supreme importance of landscape. When Philipp Otto Runge exclaimed in 1802, 'everything is becoming more airy and light than before, . . . everything gravitates towards landscape', he seemed to be predicting the dominant theme of the century; just as Turner adumbrated it in the way his own art ranged from the precision of his first topographical watercolours to the misty evocations of his last oils.

The Romantic landscape thus suggested a new direction; but it was itself concerned with the more traditional problem of the limitations of the genre. The standard argument given by academic theorists for considering landscape painting to be subordinate to historical painting had been that it was in itself incapable of representing ennobling events or ideas. Titian and Poussin were admired for the way they used nature to articulate some classical, religious or allegorical subject; but those great Dutch painters of the seventeenth century who became engrossed in the simple depiction of a locality were felt to offer little more than a light diversion.

It would be hard to find a painter of the early nineteenth century who would not have asserted the importance of 'content' for landscape: even Constable talked of its 'moral feeling'. The point at issue was whether the representation of the forms of nature could in itself have such deep significance. And it was by asserting that it could that Constable and the other major landscape painters of his generation established the basis of their art.

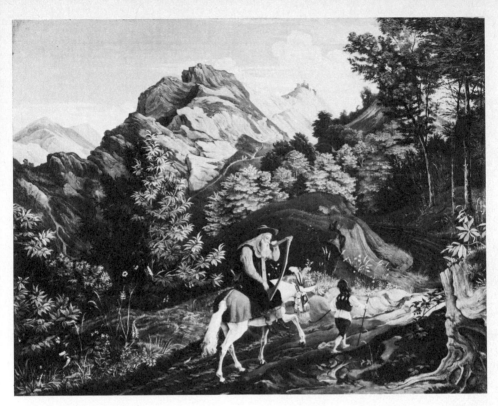

95 RICHTER *The Harper's Return* 1825

Man and nature

At its simplest, this assertion involved a straightforward challenge to the subordination of nature to man implicit in traditional classical landscape. The Dresden artist Adrian Ludwig Richter (1803–84) – as guileless as the delightful illustrations to ballads and folk-tales by which he is now chiefly remembered – certainly understood this to be the Romantic approach to landscape when, as a student in Rome, he wrote in his diary in 1824: 'For the first time I am going to venture into the romantic field, where man and nature dominate equally, each giving meaning and interest to the other.'

The resulting *Harper's Return* is certainly an instance of this. Both the Harper and the landscape have an autumnal air; yet it would be hard to say which provides the principal theme. The figures – clad in russets and greens similar to those of the surrounding countryside – are certainly in the extreme foreground, yet they are no more prominent than the carefully drawn foliage of the plants and trees. Furthermore, they do not in themselves

95

133

provide a subject for the picture. Rather, as Richter suggested, their journey complements that of the landscape, as it rises to the barren mountain peaks and the castle beyond.

Richter's demonstration of the Romantic approach introduced the key issue: that of how far insensate nature could convey thoughts and emotions: how far it could go beyond the custom, familiar in Western art since at least the time of Homer, of using natural imagery to reflect man's actions. It was no coincidence that the members of the generation that became concerned with the expressive potential of landscape were the successors to a philosophy that had completely revolutionized the understanding of perception. For in his *Critiques* Immanuel Kant had drawn attention to the way in which our experience of the world comes only through our faculties of awareness and the organization which already exists in the mind. There is no way of coming to terms with the ultimate reality of the 'thing-in-itself'; all we can know is our impression of it. And this, being conditioned by our own particular situation, is necessarily subjective. It is only in our minds that mountains are distant and blue, or meadow plants small and fragile.

Although Kant himself was insistent that there really was an external reality, an objective world to stimulate our subjective impressions, he had followers who could question this: J. G. Fichte, in particular, felt that there was no world that could be separated from the perceiver, that our awareness was in fact an act of creation. As Coleridge put it:

> O Lady, we receive but what we give,
> And in our life alone does nature live:
> Ours is her wedding garment, ours her shroud.

Such thinking provided an exciting rationale for the subjectivity and sensationalism of the Romantics: their concern with direct sensory experience. And although Kant was opposed to the liberties that were taken with his theories, he was well aware of the close link between perception and inner being. He provided a highly personal example of this when, in the *Critique of Practical Reason* (1788), he talked of looking up in amazement at the vastness of the starry firmament above him and feeling at the same time the existence of a moral law within himself. He acknowledged here not just that the qualities we recognize in nature are ones that are inherent within us, but also that the contemplation of nature can provide the deepest moments of self-discovery.

For Kant, the self-knowledge thus achieved was the means of intimating an ultimate reality behind our subjective impressions; and, like Kant, the Romantics could find in such experiences the knowledge not just of a moral law, but also of the Divine. This was certainly the case for William

Wordsworth, with his 'God in Nature', and the philosopher F. W. J. Schelling, with his 'Nature-Philosophy'.

The events that stimulated such intimations had to be approached through an actual sense of revelation; and the landscape painters who explored the relationship between man's understanding and the world around were all concerned with those thresholds of awareness at which the imagination becomes most excited, whether these were of scale, space, distinctness or motion. The important English critic William Hazlitt took up this point in his essay 'Why Distant Objects Please' (1821–22), tracing the motions of the mind as it contemplates such features as 'the misty mountain tops that bound the horizon': 'Our feelings, carried out of themselves, lose their grossness and their husk, are rarified, expanded, melt into softness and brighten into beauty . . . We drink the air before us, and borrow a more refined existence from objects that hover on the brink of nothingness.'

And, indeed, it is their atmospheric indistinctness that lends such fascination to the late landscapes of Turner. Hazlitt went on in his essay to associate this allure with distances of all kinds, with far-off lands and the past. Yet the commonplace could be equally mysterious, if examined intently enough. For the poet Novalis, as for Blake, a leaf or a twig could create 'epochs in the soul', as they do in the seemingly endless explorations that Friedrich Olivier made of some withered leaves that he gathered on a winter day in 1817.

96

96 FRIEDRICH OLIVIER *Withered Leaves* 1817

Each artist, in seeking to present this heightened awareness, showed a leaning towards one of two polarities: either to intensify or to overwhelm; to present the contemplation of nature as a visionary or a dramatic experience.

Visionary landscape: allegory and sensibility

It was in Scandinavia and the north of Germany that attempts were first made to infuse landscape painting with a sense of the spiritual. For here the sensibility to nature, awakened by Rousseau and such English poets as Thomson and Gray, became combined with a native mystic tradition. The outcome can be seen in the writings of such poets as L. T. Kosegarten, the Protestant pastor who found in nature the direct revelation of Christ's message, and sought in plants, the weather and the changing seasons resonances with man's spiritual progress.

The practice of painting on such themes appears to have begun in Copenhagen, at the Academy, where the major German symbolic landscape painters Runge and Friedrich were to receive their early training. Even the leading history painter there, Nicolai Abraham Abildgaard (1734–1809),

97 ABILDGAARD
*The Meaning of
Life c.* 1780–90

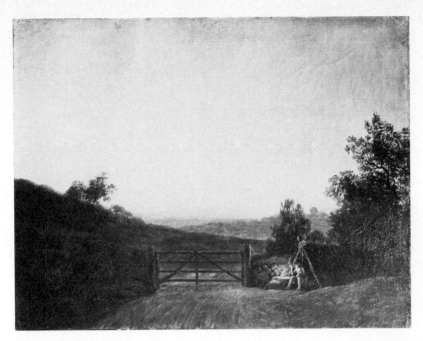

98 JUEL *Northern Lights c.*1790

attempted to present such allegories as *The Meaning of Life* by these means. 97
The imagery is heavily dependent on traditional emblems, but Abildgaard
has placed these in an actual landscape setting, so that their meaning is
expressed in terms of the spatial progression from the seated lady at the open
gate to the pyramid and cypresses in the background. The landscape is of the
most rudimentary kind. There is little attempt to evoke a mood that would
infuse the parable with life.

While Abildgaard was exploring the symbolic use of landscape elements
from the starting-point of classical allegory, his colleague Jens Juel
(1745–1802) was feeling his way towards a more emotive understanding of
nature. Juel was a popular portrait painter who placed his figures in open-air
settings with something of the lyricism and intimacy of Gainsborough, who
seems to have influenced him directly through his portraits if not through his
pure landscapes. Juel's *Northern Lights*, however, shows a hint of some 98
further meaning. The centrally placed closed gate is part of a barrier that
firmly separates the tangible foreground from the ethereal light beyond.
And beside the gate sits a man in the shadows, illuminated only by the
meagre light of a lamp.

Two north German students of the Copenhagen Academy, Philipp Otto Runge (1777–1810) and Caspar David Friedrich, sought to combine sensibility with allegory, to communicate the intense feelings that they experienced in the presence of nature so clearly that 'this emotion of our soul should become as palpable as a handshake and a glance'.

Of the two, Runge was certainly the more ambitious, for he set out to develop a totally new art of symbolic forms and colours. This he referred to as landscape, although it ranged far outside a conventional use of the term to include a combination of childlike genii and flowers arranged in hieratic symmetry. Nature for Runge was a manifestation of the Divine, and he was really seeking to communicate 'this sensation of our kinship with the whole universe': the sense of ecstasy when 'everything harmonizes in one great chord'.

He planned to express the 'great chord' in a cyclical group of paintings, *Times of Day.* These four vast designs would have brought together many complex layers of meaning. They would also have provided a unity of the arts, for he intended to house them in a special building where poems by Ludwig Tieck would have been recited to the accompaniment of music by their friend, Ludwig Berger.

Runge died at thirty-three, with no more than a fragment of his scheme completed. His intense vision can only be glimpsed in the disparate array of portraits, symbolic compositions and detailed studies that he left behind. Yet his writings, published by his brother Daniel thirty years later, leave no doubt about his originality or his mystic awareness of nature: '. . . my soul rejoices and soars in the immeasurable space around me, there is no high or low, no time, no beginning or end. I hear and feel the living breath of God Who holds and supports the world, in Whom everything lives and acts'.

Despite the fragmentary nature of Runge's art, it shows a clear growth of expertise, particularly in the ability to communicate effects of light. As a painter he started late. The son of a self-made merchant in the small Pomeranian town of Wolgast, he did not begin his formal training until he went to study at Copenhagen at the age of twenty-two. Before that he had met the religious approach to nature through the poet Kosegarten, who was for a time his schoolmaster, and who later commissioned him to paint an altarpiece for a shore chapel that he wished to erect for the fishermen in his care, in a small village on the island of Rügen.

Despite the sympathetic relationship that developed between him and Jens Juel, Runge soon tired of the Academy at Copenhagen, which he left in 1801. Nevertheless, he did acquire there the precise linear draughtsmanship that enabled him to record his designs and observations with such care and

99

99 RUNGE *Morning* from the *Times of Day* 1803

exactitude. It was not until he moved to Dresden in 1801 that he began to feel sure of his direction. His lack of success, in that year, at the annual competition held by Goethe at Weimar for a design on some classical theme, precipitated a reaction in him against conventional subject painting: and this was further augmented when he met the poet Tieck, who introduced him to the ideas of the Schlegel circle. He accepted with enthusiasm the view that art was 'the flower of human feeling' and determined to make his own sensations the centre of his art. By 1803 he had completed a series of outline designs for the *Times of Day* cycle, and two years later he had them engraved. Meanwhile, Tieck, now a firm advocate of medieval revivalism, had become deeply suspicious of Runge's highly personal symbolism. By 1803 Runge had left for Hamburg, where he was supported for the last seven years of his life by his brother Daniel.

99
At first sight, the outlines of the *Times of Day*, with their rigid symmetry and obscure imagery, seem little more than arcane diagrams. As the central image for *Morning*, Runge chose to show a lily rising above the surface of the earth. While the lower buds scatter roses downwards, the opening flower supports three pairs of genii. Above them is a 'trinity' of further figures, and the design culminates in Venus, the morning star. This mixture of classical and Christian mythology is repeated in the border, where the serpent of eternity triumphs over the downturned torches of death at the bottom, and the name of Jehovah is written across the sun at the top.

In his last years Runge was seeking to turn this synthesis of allegory, mythology and folklore into an expressive painting. He modified but he did not discard the basic imagery, for it was fired by his own personal convictions. He felt flowers to be the natural form to which humans responded most completely: 'inwardly we always connect an emotion with the flower'. His genii – the human figures which mark the meeting-points at which our emotions become one with natural creation – always take the form of young children, for Runge accepted the Romantic notion of childhood as the moment when feelings are still genuine and spontaneous. Yet he was no sentimentalist. In his portraits of children he observes them with an obsessiveness which, far from idealizing them, threatens to distort
100
them with primal energy. In *The Hülsenbeck Children*, Runge has attempted to approach the world of the child by choosing a low viewpoint. The baby emerges from behind the sunflowers as a totally self-absorbed being, instinctively clutching a nearby leaf. The little boy, too, is heedless as he rushes forward. Only the girl, who looks backward and gestures anxiously at the baby, has reached the age of self-consciousness and care. The conception behind this is naïve, but the work shows the most sophisticated understanding of the bright lighting effects and reflections of the open air.

In the first version of the *Times of Day* he had been principally interested in the symbolism of colour: the evening, for example, was represented by a deep red, which also stood for Christ's Passion. But by the time he painted *The Hülsenbeck Children* in 1806 he was already observing the effects of colour and light with painstaking naturalism, and in his book on colour theory *The Colour Sphere* (*Die Farbenkugel*, 1810), symbolism is far less evident than such phenomena as colour reflections and the different properties of opaque and transparent hues.

When he came to paint the final version of *Morning* he still preserved its altarpiece-like symmetry. But what had previously been presented as an idea was now expressed as an event. The globe of the earth had been replaced by an actual landscape; the symbolic lily of light had become infused with a tangible feeling of illumination, to become the mystic source of the picture.

100 RUNGE *The Hülsenbeck Children* 1806

Unfortunately the work, not quite complete when the artist died, was cut up in later years; but one of the fragments remains the culmination of Runge's career. For in the image of the infant lying in the meadows at dawn, with his hands opening before the light like the leaves of the shrubs, naturalism and symbolism become perfectly fused. For once, emotion and idea are one; and Runge's complex mysticism is conveyed, as he wished it to be, as pure feeling.

Caspar David Friedrich

Runge, in his sense of the infinite and the universal, in his boundless enthusiasm, his fragmentary achievement and his early death – even in the compulsive self-exposure of his writings – was the perfect Romantic artist. It seems impossible that such a man could communicate his limitless sensations through the finite means of the material world. Yet Runge had striven to express his vision in concrete terms precisely because he believed in the continuum of all things. If he could not describe the full range of his experience, he could at least intimate the point of confrontation between the visible and the non-visible.

Caspar David Friedrich (1774–1840), who shared Runge's pantheism, never attempted a similar encyclopaedic programme. 'Every true work of art must express a distinct feeling', he declared. Runge's most effective picture is a detail, an extract from his cosmology; Friedrich's pictures are single moments. The woman who stands before the rising sun opens her hands to the light as Runge's child does. We see the woman's gesture of ecstasy, even how the light transforms her into a ghostly silhouette. But in Friedrich's vision she is not one with it. She stands forever rooted in the foreground, hiding its source from our gaze. Friedrich painted precisely the paradox Runge wished to resolve: man's yearning for the infinite and his perpetual separation from it.

Friedrich's art, unlike Runge's, began with an intimate knowledge of nature. He first made his name as a topographical draughtsman and only gradually moved to more ambitious work. Throughout his life he remained a faithful student of nature, and never allowed abstractions to replace experience. For, as his friend Dahl said, 'Friedrich saw in a particularly tragic way . . . the limits of what can be represented in painting.'

Born in the Pomeranian harbour town of Greifswald, the son of a prosperous soap-boiler and candle-maker, Friedrich had a material background very similar to Runge's. He, too, came under the influence of Kosegarten through his first drawing-master, J.G. Quistorp.

Kosegarten saw the barren landscapes of the North as being the most spiritual; in particular, he regarded Rügen as the 'land of the soul', once

101 FRIEDRICH *Procession at Dawn* 1805

occupied by prehistoric, Ossian-like heroes. He also discerned a specifically Christian message in the revelations of nature, and this, too, underlies Friedrich's outlook.

In the four years that Friedrich spent at the Academy in Copenhagen (1794–98), his progress was slow, but he did absorb a precision of outline and a refined sense of tonal gradation. He also painted a number of watercolours of sentimental park-like landscapes, full of evocative images like those of his teacher Juel. He settled in Dresden in 1798 and remained there – with a number of prolonged visits to Pomerania – until his death in 1840. At first he worked mainly in the purely tonal technique of sepia which was then in vogue. His subjects – the wild Baltic coastlands – also appealed to current taste. Gradually, however, he moved towards more provocative themes, under the influence of the Dresden Romantics, Tieck, the Schlegels and their group. Catholic tendencies began to find a resonance in his art, as natural images were placed in juxtaposition to crosses, monks, Gothic buildings and religious processions.

It was with a pair of such sepias that Friedrich achieved his first public success, when he was awarded a prize by Goethe at the Weimar art

143

102 FRIEDRICH *Woman in the Morning Sun* c.1811

exhibition of 1805. Goethe, who had abandoned his idea of restricting his annual competition purely to classical subjects, made it clear that he admired the prize-winning works for their technical expertise and careful observation rather than for their religious and medievalizing subjects. He continued to value Friedrich as a naturalist even as late as 1816, when he asked him to make some cloud studies for his meteorological investigations. It was only when Friedrich refused that Goethe fully appreciated the gulf that lay between the artist's spiritual intimation of the moods of nature and his own analytical approach.

It was not too difficult for Goethe to choose to ignore the iconography of the *Procession at Dawn*, for the subject of a procession taking a monstrance to a wayside cross is discreetly set within a conventional landscape composition. Even the reference to Gothic architecture in the arch formed by the linked trees through which the priests are about to move is not insisted upon.

101

144

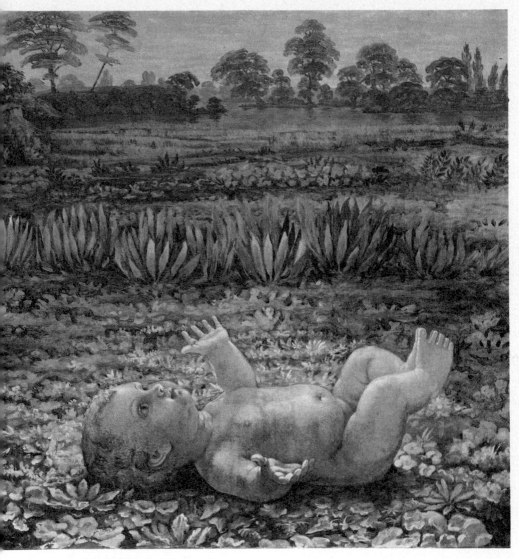

103 RUNGE *The Child in the Meadow* 1809

However, no one could have doubted the intentions behind the next work with which Friedrich drew attention to himself. For, in the large oil, *The* 105 *Cross in the Mountains*, the artist took the unprecedented step of using a pure landscape for an altarpiece. The commission was a private one – it was destined for the chapel of Count Thun's castle at Tetschen – but Friedrich made his achievement public by exhibiting the work in his studio at Christmas 1808.

As might be expected, this gesture provoked protests, notably from one local critic, Freiherr von Ramdohr, who accused Friedrich of sacrilege for making 'landscape creep on to the altar'. Ramdohr was equally disturbed by the way that Friedrich attempted to force landscape to express an explicit allegory and by the liberties that he took with the conventions of landscape composition.

While Friedrich, like Runge, adopts the symmetry and much of the symbolic imagery of conventional altarpieces, his compositional methods are very much his own. He has taken care to use a scene that could actually exist. For what is shown on the top of the mountain is not the Crucifixion, but a wayside crucifix, of the kind that was commonplace in the mountains around Tetschen; the fir trees and rocks are based on studies that he made near there. This is not an allegory in the accepted sense that a number of independent symbols are brought together to represent an abstract idea – as 97 they are in the frame, or in Abildgaard's *Meaning of Life*: it is the representation of a coherent landscape. And if the scene suggests an ulterior meaning (in this case Christ as intercessor between man and God the Father), it is because the artist has viewed it in such a way as to concentrate on those ambivalences in representation that provoke reflection. He has abandoned the conventional spatial arrangement of landscape. Instead of the foreground introduction, we are led straight to the central image. And this, too, blocks any further recession, throwing up instead a contrast to the evening sky beyond.

In this organization of the composition, Friedrich has at last found a way to heighten the drama of a landscape so that it no longer requires the presence of some human event to make its meaning explicit. The forms of nature themselves have become the protagonists.

Like Ruisdael and the other great Dutch masters of the seventeenth century, whose work he knew from the famous Dresden Gallery, Friedrich achieved in his mature works a powerful and elemental sense of nature; and his most radical designs appeal on the deepest level through archetypal forms and relationships.

This concern is reflected in the way he worked. His friend the artist and doctor Carl Gustav Carus records how Friedrich would stand before his bare

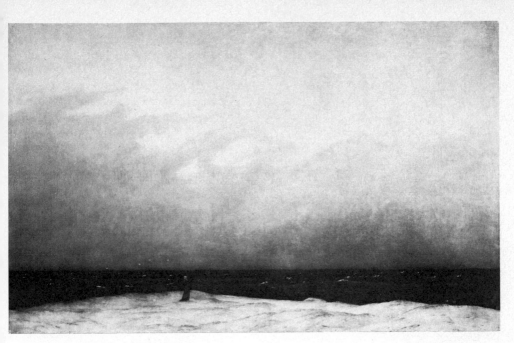

104 FRIEDRICH *Monk by the Sea* 1809

canvas, waiting until the image of what he was to paint 'stood life-like before his soul', and how he would then immediately sketch it out, and proceed to paint directly. He himself advised the artist to: 'Close your bodily eye, so that you may see your picture first with the spiritual eye. Then bring to the light of day that which you have seen in the darkness so that it may react upon others from the outside inwards.'

The *Monk by the Sea* is one of the few compositions by Friedrich in which alterations can be discerned. In this case, two boats were removed from the sea, leaving the picture dominated by the single unbroken line of the horizon. The monk who stands on the foreground headland thus literally sinks beneath it. Each element, land, sea and air, has become distinct. There is nothing to unite them. Each is endless and without solace. Its starkness is unavoidable, and the writer Heinrich von Kleist, who did not pretend to understand it, could still sense its uncompromising radicalism when he wrote: 'because of its monotony and boundlessness, with nothing but the frame as a foreground, one feels as if one's eyelids had been cut away'.

On its own, this picture seems to suggest a positively existential loneliness, yet it takes on a less modern aspect when one learns that it has a pendant which shows the monk's burial and his reunion in death with the infinite.

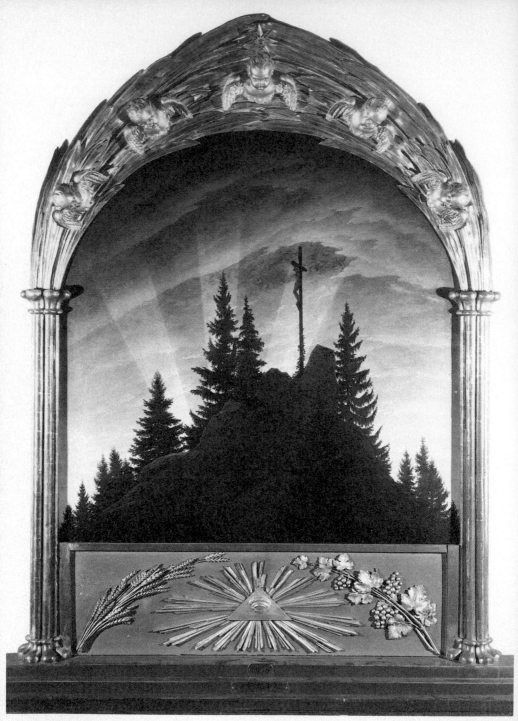

105 FRIEDRICH
The Cross in the Mountains 1808

106 FRIEDRICH *Meadows before Greifswald* c.1825

107 FRIEDRICH *The Large Enclosure* 1832

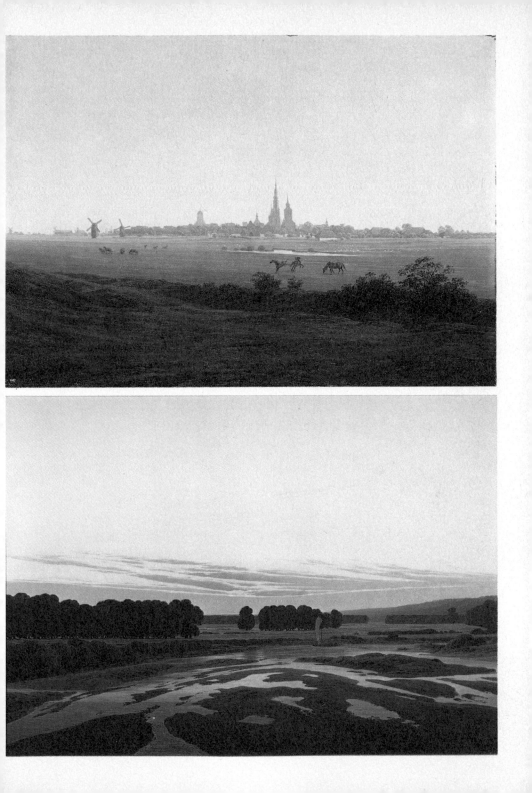

Up to the end of the Napoleonic wars Friedrich frequently painted works in which explicitly nationalist themes can be found. And, just as he had used a landscape to proclaim salvation through Christ, so he celebrated the defeat of the French in 1814 with a picture which showed a French dragoon lost in a German forest of evergreens.

The succeeding years – with his election to the Dresden Academy in 1816 and his marriage in 1818 – were a time of tranquillity. There was a gentler mood in his art as well. Through such younger friends as J.C.C. Dahl, he became aware of the growing naturalist movement. His handling of paint became freer and thicker, and he even made a number of sky studies. His stark contrasts gave way to less dramatic arrangements.

These later works still convey an intense contemplation. His *Arctic Shipwreck* may be less arresting in its colouring and lighting than *The Cross in the Mountains*. Yet it is still dominated by a central pyramidal structure, which separates the relentless motion of the ice, as it crushes the trapped ship, from the open spaces beyond.

Right through his life he maintained a distinction between the study of individual forms in nature and the fusion of these into a moment of 'distinct feeling': he often combined sketches from different localities in one picture, and made use of studies by other artists of places he had not visited; his annual sketching tours never took him outside central and north Germany.

Friedrich's limited range of experience seems to have helped to preserve his intimate feeling for nature. Certain sketches he used again and again, as though turning to them as mnemonics to recapture some experience. And if his subjects were often melancholy, he could also paint such works of tender intimacy as *Meadows before Greifswald*, a memory of his native town, glinting in the evening light, with two horses frolicking in the foreground.

Among his contemporaries Friedrich achieved a reputation for silent melancholy. This seems to have been a cloak for shyness in his early days, for those who knew him well told of his gentleness and his humour. Yet as his art fell out of favour and began to seem forced and contrived to a generation with different standards of realism, he became embittered. A series of illnesses, which left him nearly paralysed by 1835, added to his misery, and in his last years physical weakness forced him to end as he had begun, as a painter of small sepias. The mock-Gothicism of his early works returned, too, though this time with a grimmer accent.

Up to the time of his physical disablement, his powers as an artist in no sense diminished. *The Large Enclosure*, a view over a marshy stretch of land near Dresden, plays on the poignancy of evening light. In the after-glow, everything is changing. The waters, still reflecting the sky, stand out from shady earth, while the dense rows of trees behind are already nocturnal

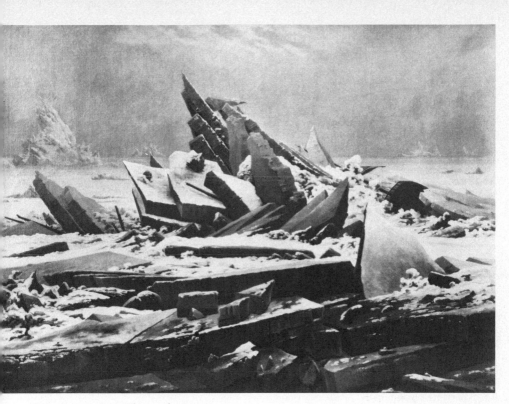

108 FRIEDRICH *Arctic Shipwreck* 1824

silhouettes. Before them is the pale, solitary sail of a small craft, moving near to the dark centre of the composition, where our eye is held by the insistent curves of the sky and foreground. Here, as in all his best works, Friedrich has touched some pure communication of forms that awakens a new and unsuspected level of awareness.

Devotion and tradition

For both Runge and Friedrich, the study of nature, God's creation, was a religious act. Yet both of them remained rooted in their Protestant upbringing, and neither countenanced a return to the simple piety of medieval art. However, Wackenroder, too, had considered nature to be the language of God, and the Nazarenes (*see* p. 112) insisted on its careful study. There were some of their followers who found in landscape a means of expressing their enthusiasm and devotion.

151

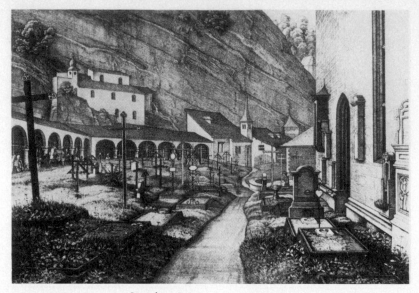

109 FERDINAND OLIVIER *Saturday* 1818–22

In Vienna, there was a brief flowering of inspired landscape in the wake of the medieval revival. Here the central figure was Ferdinand Olivier (1785–1841), an artist from Dessau who arrived in Vienna in 1812 with his younger brother Friedrich (1791–1859). Ferdinand Olivier was far from being an innocent, having previously studied in Paris and encountered the art of Caspar David Friedrich in Dresden.

Once in Vienna, the Oliviers were inspired by such older revivalists as Koch to paint religious subjects in landscapes that lean heavily on the Danube school and other Old German Masters. But in their drawings they preserved a more personal world. Friedrich Olivier, the less original of the two, could raise imitation to the level of revelation in his studies of withered leaves. Ferdinand recorded the humblest of views with clear-eyed piety. His lithographs, *The Days of the Week*, are like a series of meditations on Holy Week. Each day is represented by a view of the neighbourhood of Salzburg which sets off the appropriate mood. *Saturday* shows the cemetery of St Peter in Salzburg. Viewed close to the ground, the scene is described in a delicate mesh of lines which lays bare the plainness of stone surfaces and captures the delicacy of each plant in the foreground shadows. There is a note of disturbance and grief, heightened by the irregular recession of the pathway and the slight tilt of the shadowed cross on the left. And these prepare one for the funeral that is eventually discovered by the arches at the foot of the mountain.

109

152

The fate of the Oliviers' art was similar to that of other German Revivalists who did not die young. Friedrich Olivier went to Rome, Ferdinand stayed in Germany; both drifted gradually into the web of official art, and the heartfelt intimacy of their drawings vanished.

Samuel Palmer and the Ancients

The response to nature as a means of self-discovery, awareness of the infinite and the Divine, was common to the Romantic movement throughout Europe. However, in landscape painting outside Germany, it tended to remain an undercurrent, implicit rather than explicit. Thus, in England, there was among painters a more selfless sensibility, a more outgoing fascination with the moods and multiplicity of nature for their own sake. And although this moved the artists further from the intensive centre of Romanticism, it left them with a more communicable achievement.

In England it was only among the immediate followers of William Blake that spiritual revelation became the explicit theme of landscape painting. No more than a handful of drawings from nature by Blake himself are known; for landscape was to him a matter of synthesis, an inspired transformation of the visible. His own pure essays in the field were the result of a commercial commission. In 1819 he was engaged by Dr Robert Thornton to provide twenty-three of the 232 small wood-engraved illustrations to the third edition of his school version of Virgil's *Pastorals*.

110

Thornton was himself horrified by the results; some he had re-engraved, and others he could bring himself to include only after encouragement from such sane members of the artistic establishment as the President of the Royal Academy, Sir Thomas Lawrence. That Blake received such distinguished support shows how his vision could appeal even to those who lacked the innocence to emulate it.

The peculiar impact that Blake's landscapes, as opposed to his prophetic works, made on his followers was a matter of content: his pure visions they

110 BLAKE *Cottage by a Stream* from Virgil's *Pastorals* 1820

could only admire, while his re-creation of nature was something they could emulate. The young Samuel Palmer could recognize with joy in the 'visions of little dells, and nooks' a transformation of the world that had become for him all too mundane: 'There is in all such a mystic and dreamy glimmer as penetrates and kindles the inmost soul, and gives complete and unreserved delight, unlike the gaudy daylight of this world.'

These illustrations to Virgil, and the pastoral scenes in the Book of Job, became a kind of talisman for Palmer during his most inspired years. They did not simply lead him to find his own nooks and dells in the rolling countryside of Kent; they actually showed him how to magnify textures and intensify features in his own drawings. At times Palmer's world is so close to that of Blake that it is as though they were speaking with one voice.

Blake's pastoral vision drew sustenance from the growing interest in the northern Primitives among English painters and connoisseurs. The English revivalist movement possessed its own Boisserée in Charles Aders, an Anglo-German merchant who built up a collection of Flemish and German Primitives after the Napoleonic wars. Aders, the friend of Flaxman and Crabb Robinson, was always willing to show his collection to those interested; and in the 1820s they included Blake and such younger admirers as Palmer, John Linnell, Edward Calvert and George Richmond, who thus came to hear of the Nazarenes and see lithographs after their works.

113 Some of these artists, in particular George Richmond, were tempted to follow the modern Germans in their close imitation of the subjects and styles of art before Raphael; and the decision to form a group known as the 'Ancients' and retire to the rural seclusion of the village of Shoreham may have been encouraged by their knowledge of the Brotherhood of St Luke. But for the most part their response to ancient art was more independent and creative.

Samuel Palmer actually came into contact with this movement before he got to know Blake. The artist who first provided him with the impetus to work from nature 'with a child's simple feeling and with the industry of humility' was Linnell, whom he met in 1822. By this time, Linnell had known Blake for four years, was a familiar of Aders, and a strong admirer of Dürer's and Lucas van Leyden's engravings. Like Wackenroder, he responded to Dürer as an unfettered realist, and his own conversion came after more than a decade of wide-eyed observation that bordered on the naïve. For Palmer it was Linnell's injunction to look at Dürer and van Leyden that plucked him 'from the pit of modern art'. Two years later Linnell did Palmer an even greater service by introducing him to Blake.

The tragic destruction of much of Palmer's early work by his son has deprived us of the record of his first excitement at his discovery of the

111 PALMER *Early Morning* 1825

112 PALMER Sketchbook 1824

'Primitives'. But this prodigious young painter – who as a fourteen-year-old in 1819 had already exhibited at the Royal Academy under the influence of such English naturalist watercolourists as David Cox – had by 1824 fully accepted the hard lines, clear forms and vigorous textures of Dürer and Lucas van Leyden.

112 Like Blake, Palmer was as strongly fired by the written word as he was by the visual image. His sketchbook of 1824 – the only one from this period to survive – contains such exhortations to himself as 'look for Van Leydenish qualities in real landscape, and look hard, long and continually'; in other outcries he goads his pictorial imagination with poetic metaphors, seeing a cornfield as a 'waving sea of plenty', or noting how 'the rising moon seems to stand tiptoe on a green hill-top to see if the day be gone and if the time for her vice-regency is come'.

111 The outcome of this interchange is clear in six finished sepia compositions, embellished with quotations from Milton and the Bible, which encase an abundant and fertile earth with thick, vigorous lines. It is a pastoral vision of fulfilment, a world of magic and fable, in which a young rabbit can be encountered, unafraid, on a morning walk.

113 RICHMOND *Christ and the Woman of Samaria* 1828

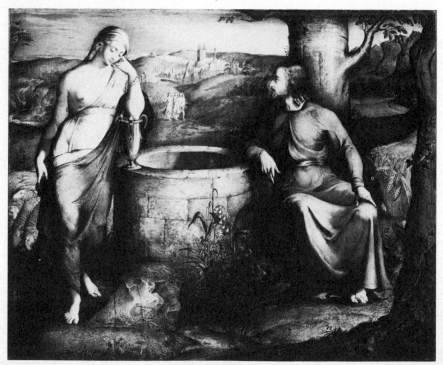

114 PALMER *Self-portrait* 1827

Palmer's vision, like Blake's, was highly sensuous – at times his imagery is
frankly sexual. Yet he did not possess the heroic independence of the older
man. A self-portrait of 1827 suggests more a youth filled with the 'negative 114
capability' described by Keats – that receptiveness to every fleeting nuance:
overflowing with excitement in the moment, but passive and visionless
when it has passed.

In 1827 he lost his mentor with the death of Blake. Earlier in the year he
had already decided to settle at Shoreham, aided by a legacy from his
grandfather. He was to remain here for nine years, but only in the first five
was his inspiration fully sustained. A townsman by birth, he had always
enjoyed an idyllic view of rural life, and the Reform Bill of 1832, which
threatened the conservatism of the English countryside and was preceded by
outbursts of rick burning and social agitation, appears to have come to him as
a final disillusionment. In 1837 he married Linnell's daughter, and fell under
the spell of his awkward and autocratic father-in-law. The man who had
once been his guardian angel was now the demon who urged him to paint in
a way that would be profitable. The outcome was a style of nostalgic
gentleness, frequently sensitive, but totally lacking in excitement.

The paintings of Palmer's early Shoreham years were more than a continuation of Blake's vision. He had learned to grasp the detail of each individual form, to delight in the large ungainliness of horse-chestnut leaves, the pendulousness of fruits and the roughness of tree-trunks. Often he would work with a mixture of watercolour, pen, tempera and varnish, and achieve thereby a deep luminosity that makes his picture glow like a stained-glass window. In *A Hilly Scene* there is an unearthly illumination, far more pervasive than any that could be cast by the sickle moon.

115

Palmer himself constantly found difficulty in reconciling what he saw with what he envisaged, in bringing together the 'lovely gentleness' of nature with the 'ponderous globosity of art'. It was only his sense of religion – symbolized in the *Hilly Scene* both in the 'Gothic' arch of the tree branches and the church at the picture's centre – that convinced him of the union which underlay all the visionary landscape of the Romantic period; the pure emotion generated through the awareness of nature remained the deepest and closest intimation of God.

J. M. W. Turner

A sense of divinity may be implicit in the whole of Romantic landscape painting. But the fascination with nature need not always linger on this single theme. The exploration can be extensive as well as intensive: the sheer presence and variability of the natural world can become overwhelming.

It was the extensiveness of the universal that obsessed the greatest landscape painter of the age, Joseph Mallord William Turner (1775–1851). In sixty years he explored every genre of landscape then conceived, always pushing towards some extremity. His most powerful advocate, John Ruskin, made an observation that could stand for Turner's work as a whole when he remarked that his sea pictures embodied either 'the poetry of silence and calmness' or 'turbulence and wrath'; 'of the intermediate conditions he gives few examples'.

Turner's art was one of extremes, but not of exaggeration. For exaggeration is no more than a shorthand way of alluding to the extraordinary; Turner entered fully into the events themselves. He recorded what he had witnessed, not so much by description as by the creation of pictorial equivalents. There is an actual delicacy and luminosity in his glazes, an actual force in his impastos, an internal cohesion to his compositions and colour harmonies. The literary sources, allegorical references and rhetoric of his subjects are like footnotes to the central fact of paint. The pictorial achievement was to make his art an object of admiration for the Impressionists and their followers – artists for whom the symbolism and subject matter of Romanticism had little meaning.

158

Although Turner's art was largely a source of consternation for his contemporaries, his expertise was constantly acknowledged. At twenty-four he was an Associate of the Royal Academy, and he became a full member in 1802, at the earliest possible age of twenty-six. Yet these honours were by virtue of his painting skill alone. A London barber's son, he had no social graces to help him on towards such coveted 'public' honours as a knighthood or Presidency of the Royal Academy.

Turner was both ambitious and miserly; and yet neither passion could override his art. The fortune he amassed by it was used in his later years to support him while working on pictures that were largely unsaleable, and to buy back examples of his earlier achievements. It would also have financed the establishment of a 'Turner Gallery', in which his work would have been on show for the public in perpetuity, had not the terms of his will been set aside by relatives as avaricious as himself. Devoted only to his father, he established no personal ties that would interfere with his art.

Turner's fascination with his own early productions during his last years reflects the underlying continuity of his career. His style certainly changed radically during his life, but this was a cumulative effect, the result of a gradual building up of experience. Already in his earliest watercolours one can detect the preoccupation with atmosphere and luminosity that was to dominate his last paintings; and his celebrated 'vortex' composition, in

116 TURNER *Light and Colour (Goethe's Theory) – the Morning after the Deluge* 1843

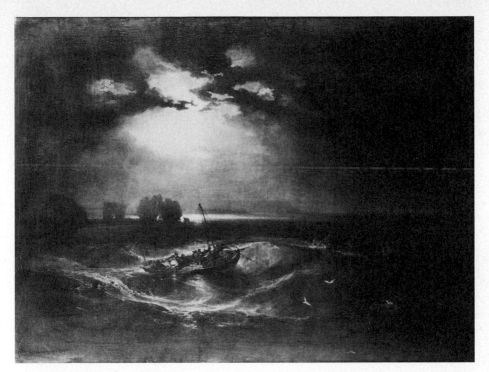

117 TURNER *Fishermen at Sea* 1796

which all the features of a picture become swept up in a whirling centrifugal mass, is already implicit in his first exhibited oil, *Fishermen at Sea*. 117

Yet there does seem to have been one moment of crisis in mid-career. This was around 1815, when he seemed to have achieved the height of his ambition, to have outpaced all contemporaries, and emulated the Old Masters to perfection. It was a vital but daunting moment. From then on Turner was learning lessons that only he could teach himself. And, indeed, it took him some years to adjust.

The emulation of the works of other masters was an accepted practice in a society that still believed in a single scale of excellence in the arts, and still felt that the young English school had much to catch up on and learn from the Old Masters. Turner began at the very bottom of the hierarchy, as a colourist for other people's engravings and drawings. From the start his approach was pragmatic; and at much the same time as he entered the Royal Academy School in December 1789 he also began working for the architectural draughtsman, Thomas Malton. There can have been no finer training in

accuracy of observation than to work for a man whose métier was the exact depiction of buildings. And, as Ruskin noted, the sense of precision never left Turner. It is this that makes his exploration of atmospheric effect so telling.

Turner trained as a watercolourist at a time when the technique itself was taking on new importance. The growing fascination with the moods of nature among topographers brought out the special advantages of this fluent and sensitive medium for capturing the feeling as well as the features of a place. It was a quality that had already distinguished the work of John Robert Cozens, and Turner came into close contact with this artist's work when he was set to copy watercolours in the possession of Dr Thomas Monro. For this doctor and amateur painter had Cozens, and many of his works, in his care during the artist's last years of insanity (1794–97). Monro seems to have established a kind of informal academy for young watercolourists, in which they had the advantage of working from his collection and he of acquiring their copies. Turner worked there with the only artist of his generation to rival his expertise in the medium, the short-lived Thomas Girtin. Girtin responded to the way Cozens carefully built up the tone of his pictures with structured layers of small brush-strokes, whereas for Turner Cozens' overall mastery of effect was a stimulus to experimentation. In 1799 he told the Academician and diarist, Farington, that 'he had no systematic process for making drawings . . . By working and occasionally rubbing out, he at last expresses in some degree the idea in his mind.'

It was part of the watercolourists' challenge to oil painters to demonstrate that the medium was powerful enough to sustain a large finished composition. By 1799 Turner was also a master of this type of work, which remained highly popular among his patrons for many years. His five 'picturesque' views of Beckford's Fonthill Abbey show the extent to which a sense of the momentary had invaded topography. The *Evening* scene, for example, frames the Abbey with a wooded glade where a glinting rivulet provides a moment of quiet charm to set against the drama of the distant building.

As Turner graduated in the favour of the Academy he also began to adopt the dominant medium of oil, and to emulate the great seventeenth-century masters of landscape. Even at the end his sense of rivalry never left him, for he stipulated in his will that two of his early works should hang beside two Claudes in the National Gallery.

It had been a recommendation of Sir Joshua Reynolds that the artist should assimilate the qualities of some famous work by designing a pendant for it: and Turner was engaged to paint pendants to a number of masterpieces. For Turner, however, such a commission was also a challenge

118 TURNER *Wreck of a Transport Ship* 1805–10

to improve on the original; and improvement in contemporary terms meant the demonstration of additional expertise in the rendering of atmosphere and drama. Above all it was the virtuosity of such fashionable artists as De Loutherbourg that Turner emulated at the expense of earlier painters.

It seems hard to believe that the *Wreck of a Transport Ship* was actually the culmination of a series of stormy sea pictures that had begun with a commission from Lord Bridgewater to paint a pendant to his Van der Velde *A Rising Gale* in 1801. In that commission Turner had grasped the way the Dutch master made a keynote out of the dominant tilt of a foreground sail to set up the motion of the wind. In the *Wreck of a Transport Ship* this gale has grown into a storm. Everything now is at the mercy of the sea. Even we are engulfed in it, for our point of view is from the depths of a trough between the waves.

Disaster pictures – particularly shipwrecks – were part of the stock-in-trade of Romantic art, and Turner certainly exploited their sensationalism to the full. Yet the action is conveyed through the presence of the medium.

119 TURNER *Slavers Throwing Overboard the Dead and Dying – Typhoon Coming On*
(detail of 126)

120 TURNER *Interior at Petworth c.*1837

121 TURNER *Rain, Steam and Speed* 1844

Contemporaries were baffled by what they felt was Turner's lack of realism and, in particular, by the lack of transparency in the water. Ruskin could answer that waves really do become weighty and opaque when whipped up by a storm. For Turner, it was only through such tangibility that the force of a tempest could be given an analogue in paint.

While transcending the naturalism of the Dutch, Turner set out to outdramatize the historical landscape. Initially, his first-hand knowledge of such works had depended on the holdings of those private collections to which he had access. But in 1802 he was one of the several British artists who profited from the year and a half of peace with France to make a tour of the Continent. With characteristic astuteness he rushed first to see the most sublime of Europe's natural sights – the Alps – and then returned via its greatest collection – the Musée Napoléon. In the few weeks that he was in Paris he copiously noted the works of Ruisdael, Poussin, Rubens and Titian: all those, in fact, who had explored the association of human drama and nature. Already he had made essays in Biblical disaster in the manner of Poussin; he now came to understand how carefully this master gauged the tonalities of his pictures to accord with their content.

In a sense, this relationship between landscape and event remained the dominant preoccupation throughout Turner's career, though it deepened into a more basic investigation of experience and representation. And any

122 TURNER *Hannibal Crossing the Alps* 1812

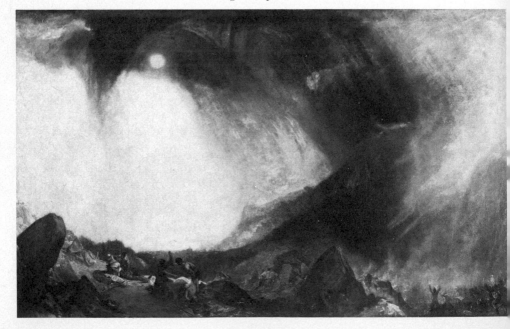

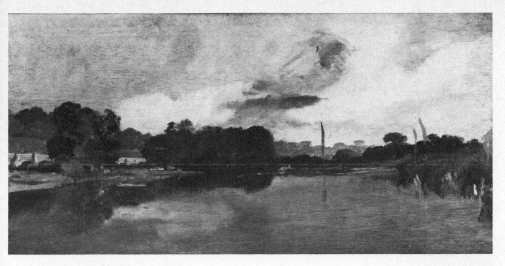

123 TURNER *Walton Reach* c.1810

temptation to subordinate landscape to subject had become fully controlled by the time he created *Hannibal Crossing the Alps* in 1812.

122

As a subject this could not have been more to the purpose of historical landscape. For in it nature resounds with human import. The snowstorm that sweeps down on to the Carthaginians as they skirmish with local tribesmen threatens to blot out the image of the fertile plains beyond. Nor did Turner leave the reflection on this portent to the spectator's imagination; for when he exhibited the work at the Royal Academy he appended some verses to the catalogue entry which concluded:

> *Still on Campania's fertile plain he thought*
> *But the loud breeze sob'd 'Capua's Joys beware'*

The verses themselves were portentous. Written by Turner himself, they mark the first appearance of those extracts from his epic *The Fallacies of Hope* which were to accompany so many of his exhibited works. The very title of this poem reveals the morbid fatalism of Turner's thinking. Turner valued the use of poetry to enrich and expand the mood and import of a picture; but it was no more than an extension. There is no reason to suppose that there was ever more to *The Fallacies of Hope* than the 'extracts': that is, small pieces of verse concocted to fit the occasion. The image came before the poem.

If tradition is to be believed, the image also came before the subject. For it was the experience of a snowstorm while staying with a patron and close friend, Walter Fawkes, in Yorkshire in 1810 that is supposed to have been the

167

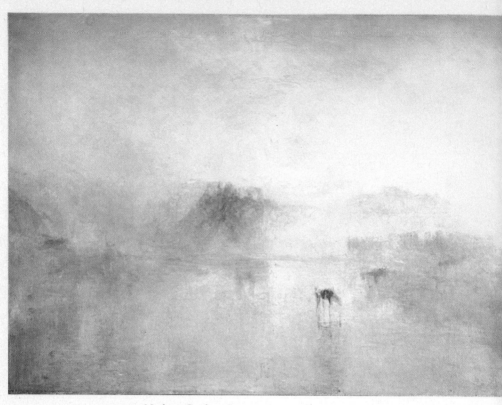

124 TURNER *Norham Castle* c.1840

starting-point of the picture. Fawkes' son recorded Turner as having said to him: 'in two years' time you will see this again and call it "Hannibal Crossing the Alps".'

In any case, the storm is evidently the central event of the finished work. Hannibal's men and the tribesmen squabble in the folds of the foreground, their gestures almost indistinguishable among the rocks. And these in their turn are no more than markers for the tremendous sweep of snow-laden air as it arches over our heads, already half-obscuring the sun. It is a war of the elements, deep-toned and massive, with the palette knife freely used to lay on the impasto of snow clouds.

Hannibal Crossing the Alps brought Turner to the brink of hyperbole: although a glance at the work of an emulator like John Martin will show how far Turner remains from the mere multiplication of effect. He did not attempt a scene of similar violence for more than twenty years; and then it was in terms of the revolution he had achieved in the use of colour.

128

Even while painting the most dramatic of themes, he had never ceased to explore the lyrical tranquillity of Claude and such Dutch masters as Cuyp. The recordings of moments of movement and excitement must, by the very nature of the circumstances, be allusive; the silent and static can be investigated with more care. It was in the quiet English countryside that he turned to the practice, usually associated with Constable and other naturalists, of making direct studies in oils. *Walton Reach*, one of a number of 123 sketches made in the Thames valley, has all the freshness of Constable's open-air sketches, yet its purpose is somewhat different. For, whereas Constable searched for the individual and the momentary, filling his sketches with those little flecks that suggest the passing light and wind, Turner has reduced his forms to broad, evenly applied areas of paint. It is a landscape virtually devoid of narrative, and one of the first works in which his sense of organization comes to the fore.

After the Napoleonic wars Turner became an inveterate Continental traveller; and while he found in France, the Rhineland, the Alps and Central Europe a vast fund of new material, it was Italy that did most to develop his vision. For here he was to trace the light in Claude's pictures to its source, and to find a very different kind of experience.

125 TURNER *The Campanile and Ducal Palace at Venice* 1819

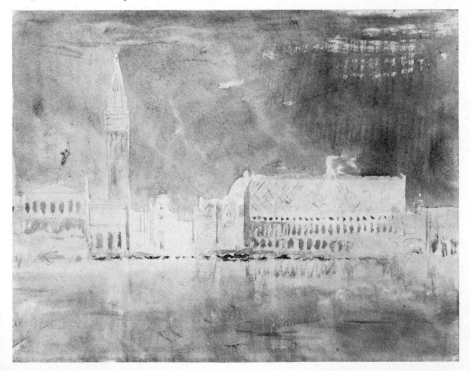

Turner spent most of his six months' journey in Rome and southern Italy, but he visited Venice on his way, and there the freshness of the experience inspired some of his earliest essays in pure colour. Just as the study of *Walton Reach* had brought out a sense of the organization of shapes on the picture plane, a watercolour like *The Campanile and Ducal Palace at Venice* combined a similar sense – evident in the radical frontality of the composition – with the use of almost pure primary colours.

In this sketch one can see the dawning of that approach that was to characterize the great works of his later career. Painting, the application of colours on a flat surface, cannot actually copy a three-dimensional world illuminated by light; all it can do is suggest equivalent sensations. And it was by concentrating on the creation of equivalents that he achieved combinations of colour and form of unprecedented force and directness. At the same time as he made his sketch of the Campanile he was beginning the habit of making the kind of compositional studies of pure colour areas since known as 'colour beginnings'. Such watercolours are not 'abstract', for they always move towards the evocation of an atmospheric effect; yet they indicate how the starting-point of his pictures was shifting to the properties of the medium in which they were created.

By the 1830s the practice of making 'colour beginnings' was also firmly established in his oil paintings. There are numerous contemporary accounts of how he would send his works to the Academy 'only just rubbed in' and how he would then work them up into a recognizable subject in the few days set aside for 'varnishing' just before the exhibition opened. Such works as *Norham Castle* are now believed to show the state before this final stage.

If colour harmonies could re-create the brightness of Italian light, they could also reveal the subtler luminosity of shady interiors. A series of prolonged stays in the spacious and relaxed atmosphere of Petworth, the country seat of his patron Lord Egremont, between 1828 and 1837, seems to have stimulated his curiosity in this direction. It was accompanied by a deeper understanding of the inner vibrancy of Rembrandt's pictures. Turner, in such studies as the *Interior at Petworth*, depends much more on the relation of colours than does Rembrandt. But there is some hint of Rembrandt in the way the shapes of red and yellow and green dissolve and float before a changing background of warm and cool tonalities. And there is an almost mystic force to the column of light that bursts through the central arched opening and scatters in the atmosphere. There is a sense, both in the power of effect and in the density of paint, of light as a force superior to material forms.

Turner was deeply concerned with the theoretical side of his art. Between 1807 and 1837 he occupied the Royal Academy's Professorship of Perspective – a surrogate, in his eyes, for a teaching post in landscape. As a

lecturer he was a disaster – the only fully appreciative member of his audience being the painter, Thomas Stothard, a deaf man, who came solely on account of the magnificent diagrams that were used. Yet Turner prepared his material with great care. Not only did he include a résumé of the development and significance of the use of landscape painting in history painting, but he fully explored the problems of light sources and the nature of reflections. After 1830, when he had abandoned lecturing, many of his exhibited paintings contain explicit references to colour theories – notably *Watteau Study by Fresnoy's Rules* (1831), and *Light and Colour (Goethe's* 116 *Theory) – the Morning after the Deluge.*

The latter picture concerns a further dimension in Turner's use of colour: its emotive potential. Turner had read and carefully annotated Goethe's *Theory of Colours* (*Zur Farbenlehre*) when it appeared in the English translation of his friend, Eastlake, in 1840. He was scornful of the poet's anti-Newtonian bias, although he admired the acuity of his observation of optical effects. *Light and Colour* concerned Goethe's speculation on the associative properties of colour, according to which the 'cool' tones of the spectrum – blue, blue-green and purple – were 'negative', producing 'restless, susceptible, anxious impressions'; while the 'warm' tones – red, yellow and green – suggested 'warmth, gaiety and happiness'.

Light and Colour is a pendant to a picture entitled *Shade and Darkness* which shows the Deluge about to descend, and is painted in 'negative' blues and purples. Yet, although *Light and Colour* is based on the morning after the Deluge and is painted in 'positive' tones, it is not so much a celebration of God's salvation of Noah as a sceptical comment on it. For Turner has conceived the whole scene as encapsulated within a bubble, on whose spherical surface can be seen prismatic refractions of colour – a substitute for the rainbow which occurs in the Biblical account as a symbol of 'God's Promise'. And in the accompanying lines from *The Fallacies of Hope* Turner made it clear that these effects show the falseness of this promise. For the bubble is no more than

> *Hope's harbinger, ephemeral as the summer fly*
> *which rises, flits, expands and dies.*

Turner's disagreement with Goethe is not an attack on colour association so much as an affirmation that it, like every other form of perception, is dependent on the frame of mind of the observer. Goethe saw the power of light as benevolent; Turner saw it as indifferent. The force that gave life was also the force that destroyed.

Light and Colour was essentially a demonstration picture. But Turner had already produced works in which colour association is integral to the

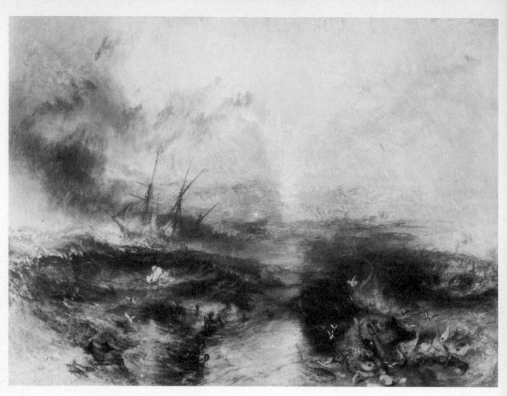

126 TURNER *Slavers Throwing Overboard the Dead and Dying – Typhoon Coming On*
1839

119, 126 structure. *Slavers Throwing Overboard the Dead and Dying – Typhoon Coming On* showed the moment when in 1783 the captain of the slave ship *Zong* had diseased slaves thrown overboard so that insurance could be claimed on them for being lost 'at sea'. No picture by Turner is more lurid than this horrifying image, made even more unbearable by the foreground carnage, where the discarded slaves are being devoured by monsters of the sea. Ruskin, who thought it 'the noblest sea that Turner has painted', revelled in the gaudy exposure of '. . . the guilty ship as it labours amidst the lightning of the sea, its thin masts written upon the sky in lines of blood, girded with condemnation in that fearful hue which signs the sky with horror'.

Certainly the bruised, angry feeling of the storm-tinged sunset is unmistakable. Yet there is something disconcerting about the fact that Turner could create out of such a moment so magnificent a discord. Like
189 Delacroix's *Death of Sardanapalus* it betrays an all too voluptuous morbidity.

Even where there is no such explicit symbolism the emotive power of colour in Turner's late works continues to set up associations. In his famous

172

celebration of that new and revolutionary mode of travel, the railway, there is something satanic about the black fuming engine as it rushes towards us over the viaduct: especially when it is contrasted with the limpid river scene with its peaceful floating boat on the left. Critics like Théophile Gautier could see the work as a positive manifestation of evil; yet there is every bit as much in the title and details of the work to enable one to see it as a panegyric on progress. This ambiguity leaves the central image of the work intact; the metallic intransigence of the train, passing through shimmering mists of pale blue and gold.

It is not difficult to see how Turner's outlook – his fatalism, love of the elemental, of grandeur and decay – accord with contemporary Romantic preoccupations; but his way of painting, that indistinctness which in a moment of defiance he called his 'forte', seemed to be the epitome of arbitrariness, a brilliant subjectivity only appropriate for those evocative and imaginative subjects known as 'romantic'. When seeing a view of the prosaic town of Dieppe so treated, Crabb Robinson exclaimed: 'If he will invent an atmosphere and play of colours all his own, why will he not assume a romantic *name*? No one could find fault with a Garden of Armida or even Eden *so* painted.'

Robinson was being too neat in tidying the romantic experience away from the commonplace. It was actually a harsher critic who came nearer to the heart of the matter. The most quoted remark the essayist William Hazlitt made about Turner, his dismissive 'pictures of nothing, and very like', was said in the context of a critique that chided Turner for producing paintings that were 'too much abstractions of aerial perspective and representation not properly of the objects of nature as of the medium through which they were seen'.

What is truly extraordinary is that a year later in 1816 Hazlitt wrote an article for the *Encyclopaedia Britannica* in which he praised Rembrandt precisely for his handling of 'nothing': 'His landscapes we could look at for ever, though there is nothing in them.' For Hazlitt, still a defender of the importance of 'content' in art, the magic of Rembrandt's light saved the inconsequential material of his pictures. And in trying to find a category for this supreme achievement he concluded: 'Rembrandt is the least Classical and most romantic of painters.'

This approach to Rembrandt seems to have been increasingly in Turner's mind during his latter years. Already in 1811, in his perspective lectures, he had made a distinction between the lowliness of Rembrandt's matter and the 'veil of matchless colour' with which he clothed it, so that the eye 'as it were thinks it a sacrilege to pierce the mystic shell of colour in search of form'.

It is the privilege of painters to concern themselves most with that which accords with their own interests in the works of their predecessors. And if Turner looked at Rembrandt above all for his 'veil of matchless colour', a later generation of French artists were similarly selective in praising the English master's chromatic harmonies while condemning the 'exuberant romanticism of his fancy'. Nevertheless, even such tranquil moments as 124 *Norham Castle* have nothing to do with the Impressionist dissection of light. The chance appearance, under certain conditions, of haystacks, façades and ponds, may have provided simply a felicitous visual occasion for the creation of the pure colour poetry of Monet's late works; but Turner could not be so dispassionate. The event still lurks behind the veil, is still at the core of the pictorial equivalent. Colours for Turner are not even the release of pure emotions, as they were to be for the Symbolists. They are the vehicles of an ineffable attitude to being; of the curiosity, wonderment, despair and psychological naïveté of an age which still sought to grasp an intimation, however abstracted or indefinite, of some totality behind the enigma and inconsequence of existence. There was no other artist in that age who could make this so purely visual.

Landscape and melodrama

Any sequel to Turner must have the air of anti-climax. Yet it did not seem so to his contemporaries. Few ventured to follow him in his journey beyond simple descriptiveness; and there were many artists who claimed to have improved on Turner when they had merely exploited and vulgarized the lower reaches of his art.

There was, for example, a whole range of marine painters who negotiated 118 the well-charted regions between *The Transport Ship* and the seascapes of the Dutch. First among these was Clarkson Stanfield (1793–1867), an ex-seaman, who gained his apprenticeship in 'effect' painting working as a scene-painter at the Drury Lane Theatre. His skill in handling atmospherics certainly took in Ruskin, who rashly declared 'one work of Stanfield alone presents us with as much concentrated knowledge of sea and sky, as diluted, would have lasted one old master his life'. But there was a definiteness in his allusions that was far more satisfying to the Victorians than the confusing ambivalences of Turner's themes. And, although an occasional critic of this period could decide that a work like Turner's *The Transport Ship* 'exhibited in a high moral sense the excitement and action of the tempest in its wrath', no one 127 could miss the pathos of Stanfield's *The Abandoned*. This was unequivocal enough for an engraving of it to be used to set the scene in a series of paintings on the consequences of marital infidelity, *Past and Present* (1858, Tate Gallery), by that master of Victorian moral genre, Augustus Leopold Egg.

127 STANFIELD *The Abandoned* 1856

128 MARTIN *The Great Day of His Wrath* 1851–54

The principal heir to Turner's historical holocausts – a field he left wide open after his *Hannibal* of 1812 – was John Martin (1789–1854). This artist came from a Northumbrian family of eccentrics: one brother ended up in a lunatic asylum after having attempted to set fire to York Minster, and another walked the streets of Newcastle as self-styled 'Philosophical Conqueror of All Nations', wielding a home-made gong and wearing a tortoise-shell hat. His own nickname of 'Mad Martin' may have been undeserved; but his pictures made their impact through their extension of scale and effect beyond all probability.

Martin was a self-made man who remained on the fringes of artistic respectability. He became a violent opponent of the Royal Academy, which he felt had slighted him. The antipathy soon became reciprocal, as the men of taste began to witness the mounting popular success of his 'vulgar' art. For such Biblical fantasies as *Joshua Commanding the Sun to Stand Still* (1816) or *Belshazzar's Feast* (1821) became show-stoppers wherever he chose to exhibit them. The latter, for instance, caused the exhibition at the British Institution to be extended three weeks, and then immediately attracted a further five thousand paying visitors when it was shown privately. And if Martin sometimes had difficulty in finding an actual purchaser for his vast canvases, he certainly made a killing out of entry-fees to see them and the mezzotints of them he engraved.

Martin's ingenuity ran to practical suggestions for the much-needed improvement of London's sewage disposal and water supply. His pictures, too, are full of calculations; and the explanatory pamphlets that he wrote for them provided not only full descriptions of the multitudes of people and stupendous buildings in them, but also the actual heights of the towering mountains. Like a modern spectacular or science-fiction film, Martin's fantasies enthralled through their detailed account of the barely believable. In a pre-Darwinian age such accuracy in the description of Biblical holocausts was no mere matter of make-believe. Indeed, the recent discoveries of fossils and buried cities seemed to many scientists actually to confirm the Bible. One such believer, the palaeontologist Cuvier, visited Martin and praised the scientific exactness of his *Deluge*.

It was this fundamentalism that inspired Martin's last great creation, his *Last Judgment* in three gigantic canvases which follow the Book of Revelation to the letter. In *The Great Day of His Wrath* the mountains and rocks actually fall, as bidden in the Bible, on those who seek to hide from the Lord. Some of them take whole cities – already viewed upside-down – into the abyss. It is hardly surprising that such faithful accounts of What Is To Come were on constant tour throughout Britain and America for twenty years after Martin's death.

129 ALLSTON *Elijah Being Fed by the Ravens* 1818

The American Sublime

In America Martin exerted a strong influence, but he is far from being a major reason for the flourishing of a school of imaginative landscape painting there. Since Independence, American painters of talent tended less to seek their fortune – as West and Copley had done – in England. Painters like Washington Allston and Thomas Cole travelled extensively in Europe, but returned to America to establish their careers.

Although there was already at the beginning of the century a strong impetus to depict the native American landscape, artists still leaned heavily on the culture of Europe in their imaginative work. Nathaniel Hawthorne's complaint in *The Marble Faun* of 'the difficulty of writing a romance about a country where there is no shadow, no antiquity, no mystery, no picturesque and gloomy wrong, nor anything but a common prosperity' seems also to have been echoed by painters; neither they nor Hawthorne seem to have thought of the Indian civilizations that provided such a fertile source of romance for European writers and painters.

In one sense this feeling of separation was an advantage. For it intensified the isolation of the Romantic artist. The bizarre fantasy of the stories of

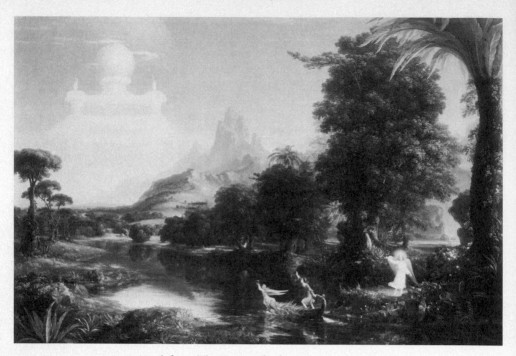

130 COLE *Youth* from *The Voyage of Life* 1840

Edgar Allan Poe, for one, fed upon this distance from the source of their narratives, and this also gave an edge to the art of Thomas Cole.

Washington Allston (1799–1843), a Harvard graduate, spent two prolonged periods in Europe, from 1801 to 1808, and 1811 to 1817. The respect he acquired for historical art was the bane of his life, and the last twenty-five years of it were dogged by his inability to complete the vast Biblical subject *Belshazzar's Feast*. In landscape painting, however, he could give expression to more personal obsessions; and even when he moved into the field of historical landscape, fully equipped with a profound enthusiasm for Titian's 'gorgeous concert of colours', there was little left in it of Old World reticence. *Elijah Being Fed by the Ravens* is in many ways a pastiche of Titian and Rosa; yet no European artist would have conceived so haywire a pair of trees, or such a blatant mimicry of the arched back of the Prophet.

Thomas Cole (1801–48), the leading landscape painter of the early nineteenth century, was equally drawn by the 'gigantic associations of the storied past'. Yet he tried to filter this through an American experience. Born and reared in England, which he left at the age of eighteen, he found the sheer freshness of 'primeval forests, virgin lakes and waterfalls'

129

131 CHURCH *Landscape with Rainbow* 1866

exhilarating after the sights of Europe, 'hackneyed and worn by the daily
pencils of hundreds'.

Despite the unrivalled success of his American views, Cole could never rid
himself of the old belief in the supremacy of content in a picture. A trip back
to Europe in 1829–32 – during which he actually occupied Claude's old
studio in Rome – confirmed his respect for historical landscape. For the rest
of his life he loved nothing more than to find the occasion for creating
landscape cycles on human destiny, such as *The Course of Empire* (1836) and
The Voyage of Life. The latter, a sequence of four pictures in which a man
passes in a boat along a river and reaches his apotheosis as his battered vessel
comes to rest in the sea, is like a fairground ride come real, each turn
presenting a new stupendous sideshow. The subject apparently came to Cole
as he made a journey along the Genesee, and the spring-time *Youth*, for all its 130
Claudian staging and Martinesque vision in the sky, has an unprecedented
sense of newness in the bright, almost metallic, depiction of luxuriant
verdure and manifold plants.

Cole's pure landscapes, usually viewed panoramically in dramatic
atmospherics, were full of what his public could readily identify as 'true

American feeling'. His most successful pupil, Frederick E. Church (1826–1900), travelled throughout North and South America in search of

131 spectacular scenes which he endows with a symphonic totality that is positively Wagnerian. His all-embracing harmonies of colour, light and atmosphere, handled with breathtaking expertise, at last turned historical landscape into a truly popular art. And the sense of drama and the heroic that emerges here is already close to that of Hollywood.

Dramatic landscape in Europe

There was no full-scale Continental equivalent to the Anglo-Saxon nature drama. Rome had been the earliest centre of the revival of 'heroic' landscape; and it was there that the French painter Girodet (1767–1824) first proclaimed landscape the 'universal genre of painting' in 1793. Yet the artists who worked there rarely ventured to extremes. Girodet's own landscape compositions are charged with poetry, but they never stray far from Gaspard Poussin. The Tirolese painter Joseph Anton Koch (1768–1839) became the dominant representative of 'heroic' landscape in Rome in the

135 decade after he settled there in 1793. His *Schmadribach* certainly conveys something of the *terribilità* that he so admired in Michelangelo, and accords with his own desire to convey a sense of the elemental in landscape similar to that imagined when reading the Bible or Homer. Yet this 'universal picture', with its mighty sweep through the strata of nature from the foreground stream to the snow-capped mountain tops, is above all a feat of control. Each form is embedded in its plane, there is no mystery to the lighting or atmospherics; everything is organized and classified. And, although Koch was often hailed as the reviver of German landscape, the cautious archaism of his later works did as much as anything to dampen the youthful enthusiasm of artists like Fohr and the Oliviers.

This heroic art did develop a more expressive concern in the 1820s. In France Paul Huet (1803–69), the friend of Delacroix and Bonington, painted lowering landscapes, full of deep gorges, darkened woods and silent lakes, which struck Théophile Gautier as 'Shakespearian'. His early scene of a

133
95 lonely wanderer returning at evening beneath a stormy sky is very much the pessimistic corollary to Richter's sentimental *Harper's Return*. However there is a world of difference between Richter's Koch-inspired inventory of features and Huet's painterly atmospherics. Like Turner and Stanfield, Huet made a speciality of studying the powerful and mutable in nature, and was most admired for his treatment of waves.

Like the followers of Turner, Huet constantly ran the risk of becoming over-theatrical. For it was all too easy to upset the delicate balance between observation and expression on which the Romantic revelation through

132 NUYEN *Ruin by a River* 1836

133 HUET *Landscape with a Lake at Evening (The Storm)* 1840

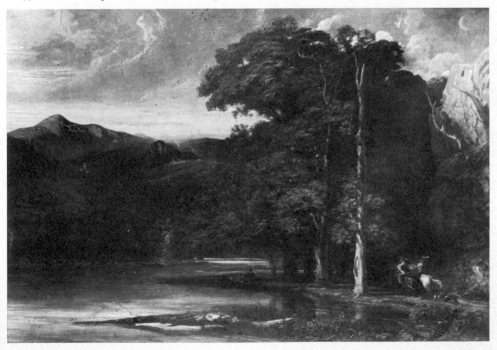

134 BLECHEN *Galgenberg* c.1832

nature depended, to replace empathy with simple histrionics. Romantic landscape, as it spread through the academies of Europe, became no more than a set of stock conventions, which even a young artist of talent like the Dutch Wijnandus Josephus Johannes Nuyen (1813–39) could do little to revive.

132

This dilemma can be felt clearly in the works of the brilliant Berlin painter Carl Blechen (1798–1840). Blechen was aware both of Friedrich and of Turner. A skilled scene-painter, he became fascinated with the study of light effects after a visit to Italy in 1828–29. Yet more often than not the lyricism of his scenes is dispersed by irony, much as his contemporary the poet Heinrich Heine, in his early verses creates idyllic moods only to destroy them. In such spirited landscape studies as *Galgenberg* there is a fatal lassitude, a falling off of attention from the fearful gallows and the impasto of the slaty sky to the aimless strips of colour on the horizon. Romantic landscape painting had become a cliché for Blechen, yet elsewhere there was nothingness: either the nothingness of Turner's formless light, or the nothingness of the naturalists, whose paintings had no subject. In the end, Blechen was drawn, like so many other painters of his generation, towards naturalism.

134

135 KOCH *Schmadribach* 1808–11

'Natural painture'

Plein-air painting

'For these few weeks past, I believe I have thought more seriously of my profession than at any other time in my life.'

When the twenty-six-year-old John Constable (1776–1837) wrote thus to his friend Dunthorne on 29 May 1802, he had just taken a momentous decision: he had refused a post as a drawing master in order to devote himself fully to his art.

From now on he was determined to work directly, and on his own. He would return that summer to his native village of East Bergholt, 'where I shall endeavour to get a pure and unaffected manner of representing the scenes that may employ me. *There is room enough for a natural painture.*'

Although the word 'painture' was an innovation of Constable's, it soon became clear enough what he was referring to. And indeed, the long and arduous struggle he had in setting aside preconceptions about landscape painting in his pursuit of a 'pure and unaffected' representation of the English countryside has since become one of the heroic legends in the history of naturalism.

136 Constable's representation of rural England in such mature paintings as *The Haywain*, seems so effortless and self-explanatory that it is hard now to credit the difficulties that he faced. Yet it is precisely the appearance of naturalness that is the measure of his achievement. Each scene was in fact the product of a mind keen to trace the workings behind the surface of events; each demanded a skill in understanding that led the painter to declare that the art of seeing nature was 'as much to be acquired as the art of reading the Egyptian hieroglyphs'. He knew, too, of the unbridgeable gulf between what is seen and what can be recorded; he saw that 'natural painture' was above all a matter of suggestion.

Both these problems, of understanding and of presentation, were to be Constable's constant concern. Yet they lead to an even more basic problem. For if natural painting involves interpretation and selection, how can it be 'pure and unaffected'?

The dominant feature of 'natural painture' was the desire to observe directly. And it was this that led Constable to lay such importance on the oil

136 CONSTABLE *The Haywain* 1821

sketch made in the open air. Yet he was hardly the inventor of this method. Claude himself is supposed to have finished the distances in his pictures outside in the Campagna, and by 1750 the making of oil sketches in the open appears to have been a well-established activity among landscape painters in Rome. It certainly seems to have been practised there by Claude Joseph Vernet (1714–89), that French master of dramatic atmosphere. The habit may have been introduced among British artists by Richard Wilson (1714–82), who, after his sojourn in Rome around 1750, returned to paint historical landscapes and local views which are notable both for their command of a Claudian vocabulary and their mastery of light effects.

There may seem to be a world of difference between Wilson's reinterpretation of the British landscape in such large-scale compositions as *Holt Bridge on the River Dee* and Constable's 'six-footers'. Yet it was Constable's appreciation of the observation in such works that led him to describe Wilson as 'one of those appointed to show the world the hidden stores and beauties of nature'. Envisaging him 'walking arm in arm with

22

137

185

137 WILSON *Holt Bridge on the River Dee c.*1762

Milton and Linnaeus', he saw him as one of those artists who combined a scientific investigation of natural phenomena with deep poetic sensibility.

No actual oil sketches before nature by Wilson can now be traced, but his pupil Thomas Jones (1743–1803) left behind a large number. Like other painters of the time who adopted the practice, Jones used it as a means of making records, but not as a basis for large-scale compositions.

Jones' rapid studies, painted on paper, have considerable vigour. Yet they also reveal the problems for eighteenth-century artists of using oil as a sketching medium. For the method of building up effects of luminosity through the careful application of layers of glazes – common in the studios – could hardly be applied when working in the field. In *Pencerrig* Jones lets the brown tone of the paper show through to give a warmth to his Welsh hills. But there is little else to lighten their forms, and the solid green land seems hardly related to the bold clouds above. It was only when more varied forms of handling were introduced that oil became an effective means of recording direct impressions of atmospherics.

138

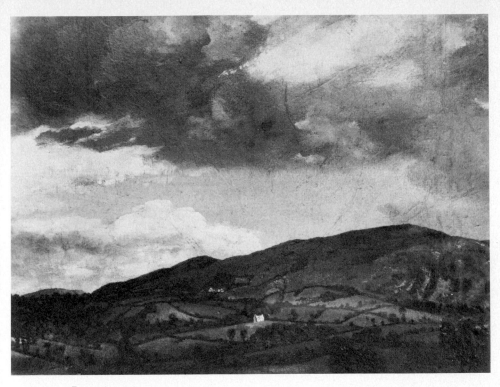

138 JONES *Pencerrig* 1772

Watercolours and local atmosphere

The light and transparent washes of watercolour, on the other hand, could capture such effects more readily. The paintings of Paul Sandby (1725–1809) demonstrate the way this quality gradually began to be exploited by the professional topographers. The *Distant View of Leith*, a study made while the 140 artist was working as a military map-maker in Scotland, may have been intended first and foremost as reconnaissance, but the medium has at the same time allowed a swift and deft laying on of washes to capture the tonal subtleties of the shadowed foreground and the luminosity of the estuary beyond.

Watercolour painting also had its idealist side, evident in the Rubensian fancy of Sandby's later woodland views. It was in the imaginative views of John Robert Cozens, moreover, that light first became the dominant feature 28 in a watercolour.

Turner and Thomas Girtin (1775–1802) brought together these two traditions in their works. During the period when they were both copying

187

the Cozens in Dr Monro's care, their use of layers of blue-grey washes to build up tones was virtually identical. But it was Girtin who continued to explore the subtle gradations that captured every nuance of a place and moment.

Girtin's search for structured luminosity led him to abandon many of the conventions of landscape composition. In his *White House*, a watercolour that even Turner felt he had not equalled, he gave the most unexceptional of scenes, a bend in the River Thames by Battersea Reach, an air of expectancy by emphasizing a single house and its reflection. There is nothing mystical about this magical achievement. It is a perfect demonstration of how the discovery of an atmospheric effect – in this case the way white, in certain conditions, stands out from its surroundings – can become an event in itself.

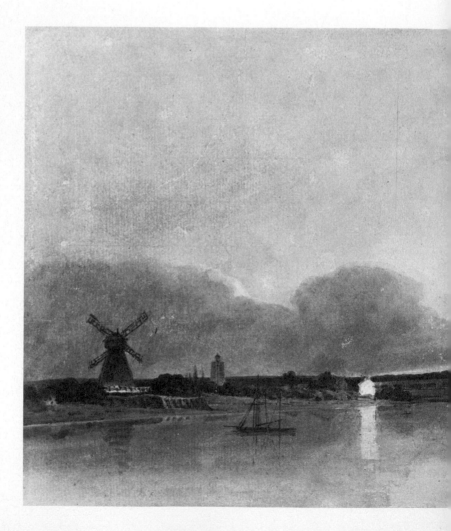

139 (left) GIRTIN *The White House* 1800

140 SANDBY *Distant View of Leith* 1747

141 COTMAN *Chirk Viaduct* c.1804

142 GIRTIN *La Rue Saint-Denis* 1802

It is quite in keeping that, while Turner was moving towards the description of vast holocausts, Girtin's most ambitious scheme should have been the creation of a panorama of London, a monumentalization of mere locality. His *Eidometropolis*, probably painted around 1800, but exhibited in the summer of 1802, only a few months before his death, is now lost; but surviving studies show the fidelity of his record. There is in them the same interest in the sheer presence of the city as there is in the street scenes of Paris he painted as a result of his visit there of 1802. Possibly the sketches he made there were first undertaken with a panorama in mind. In any case, there is a remarkable objectivity to such watercolours as *La Rue Saint-Denis*.

142

No other watercolourist ever matched the totally unassuming luminosity of Girtin's last works. Later artists like Bonington (*see* p. 248), Samuel Prout (1783–1851) and Thomas Shotter Boys (1803–74) were influenced by his Paris scenes – published in 1803 – but could never adopt similar views without resorting to a more obvious drama. More generally, Girtin opened the eyes of a whole generation of watercolourists to the freshness and intimateness of locality. When the young Norwich painter John Sell

Cotman (1782–1842) came to London in 1798 it was Girtin's example that
led to the development of his own rigorous manner. A watercolour of Chirk 141
Viaduct is a masterpiece in the presentation of the incidental. A chance
section of the viaduct is viewed from the shrubland and pools it spans. All
temptations towards Piranesian grandeur are avoided as this motif becomes
the starting-point for a rhythm of lucid intervals, articulated by the clearly
marked, but closely balanced, tonal areas. There were few among his
contemporaries to appreciate such an eventless art. For, as Cotman himself
explained, 'three quarters of mankind, you know, mind more *what* is
represented than *how* it is done'.

East Anglia and the Dutch

If watercolour painters were more precocious than oil painters in developing
the treatment of the intimacy and atmosphere of locality, their art could
suggest less of the weight, the force of earth, light and wind in the
countryside. It was this sense that comes over in the finest of the seventeenth-
century Dutch painters, such as Hobbema and Ruisdael; and it is perhaps not

surprising that the naturalist movement in English oil painting should have received its strongest impetus from that part of the country, East Anglia, which had the strongest traditional commercial and cultural links with Holland.

Although it was the Norwich school who turned most fully to the art of the Dutch, the early work of Gainsborough bears witness to the survival of a taste for Dutch art in that part of the country. A native of Sudbury, Suffolk, Gainsborough was first active as a landscape painter. In later years, his Arcadian vision of nature – fired by his sense of restriction at being 'confined *in Harness* to follow the track' in his profession as a portrait painter – led to the depiction of wistful autumnal pastorals readily described by contemporaries as 'romantic'. But his earliest works have quite a different effect.

Gainsborough was later to be rather apologetic about these 'first imitations of little Dutch landskips' and regarded his *Cornard Wood* as having 'very little idea of composition'. Nevertheless, he did concede that the picture, despite lacking the broad sweep of his later style, was equal to it in 'the touch and closeness to nature in the study of the parts and *minutiae*'.

Gainsborough was to leave this style behind him when he moved from his Suffolk practice in Ipswich to Bath in 1759. But these Anglicizations of the

143

144 CROME *Moonrise on the Yare* 1811–16

Dutch were to become an inspiration for Constable, whose maternal uncle, David Pike Watts, was at one time the owner of this particular painting.

The last flowering of the Dutch influence was in Norwich in the early nineteenth century. No doubt the extreme conservatism and isolation of this region at that time helps to explain the emergence of so independent an artistic community, complete with its own exhibiting body, the Norwich Society, founded in 1803. Certainly local patronage does not seem to have been a cause, for even the leader of the school, John Crome, had to subsist on teaching, while Cotman had a hard time making a living even by this.

Yet John Crome (1768–1821) – who was born in Norwich and lived there all his life – was dependent for his artistic instruction largely upon the collections of local connoisseurs. And it was through these that he gained such a close knowledge of Dutch landscape and, to a lesser extent, of Wilson and Gainsborough.

While Crome's horizons were later to be expanded by visits to London, and even Paris in 1814, his work can still virtually be classified according to Dutch prototypes; but if his pictures are strongly traditional in outlook, they do nevertheless have a vigour that is the artist's own. *Moonrise on the Yare* 144 may be a tribute to the moonlight scenes of Aert Van der Neer, yet the Dutch master never treated any of his scenes in terms of such bold silhouettes.

193

143 GAINSBOROUGH *Cornard Wood* 1748

Constable can be seen as part of an East Anglian tradition; but what made him stand out from the others was the scope of his ambitions and his persistence in pursuing them. He steadfastly refused to dissipate his energies by acting as a drawing master, as Cotman and Crome did, or by painting the type of landscape calculated to bring success. Unlike Turner, he rarely painted lucrative views of gentlemen's country seats or famous places, or the dramatic imaginative scenes that would flatter the pretensions of a collector.

It is probable that when Constable declared his intention of achieving a 'natural painture' he had no more than the vaguest idea of what the outcome would be. For even when he painted *The Haywain* nineteen years later, he himself noted its 'novel look'. In his early years he was struggling hard enough simply to keep painting. Born the second son of a wealthy miller in the Suffolk village of East Bergholt, Constable had to contend with opposition when he decided to become an artist. Finally, in 1799, he settled in London and became a student at the Academy at the age of twenty-two.

Like the other young painters of the day, Constable was largely dependent upon the benevolence of collectors for gaining a knowledge of the works of the Old Masters. And while he was soon to remonstrate against 'running after pictures, and seeking the truth at second hand', he never ceased to use the works of others as a guide and stimulus. If he was opposed to mindless imitation, he nevertheless told the engraver John Burnet that 'he seldom painted a picture without considering how Rembrandt or Claude would have treated it'. He was fortunate to find in the local collection of the connoisseur Sir George Beaumont examples by both these artists as well as Rubens' landscape *Château de Steen* and watercolours by Girtin; all these works were to have a formative influence upon him.

Throughout his career Constable copied pictures that particularly attracted him, and one of the first works that he copied was Beaumont's small Claude *Hagar and the Angel*, which is now in the National Gallery. Certainly the 'amenity and repose' he admired in Claude can be felt in his first painting of Dedham Vale, where the view to his favourite local church is framed by harmonious banks of trees in a manner similar to those in the *Hagar*. Yet this is already combined with a freshness in the colouring, the frank admission of the greenness of the Suffolk countryside, that shows how he has already moved away from any suggestion of mere imitation.

Any tendency that he might have had towards idealizing was balanced by his admiration for the early landscapes of Gainsborough, and of the Dutch themselves. 'The Dutch painters were a *stay-at-home people*, – hence their originality', he later declared. He valued them also on account of the similarity between the scenery they painted and his. Ruisdael, whom he was

145 CONSTABLE *Dedham Vale* 1802

also copying in his first years in London, he later praised for the way he 'has made delightful to our eyes, those solemn days, particular to his country as to ours, when without storm, large rolling clouds scarcely permit a ray of sunlight to break the shades of the forest'.

In later years Constable was to be dismissive of the Picturesque movement, but in 1806 he was still sufficiently uncertain of his direction at this time to take up an offer from his maternal uncle David Pike Watts to 146 finance a visit to the mountainous Lake District. For the next three years he was to use the studies he made there for the oil paintings he sent to exhibitions. But after that he abandoned such topics altogether. Later he was to tell his biographer Leslie that the 'solitude of mountains oppressed his spirits. His nature was peculiarly social and could not feel satisfied with scenery, however grand in itself, that did not abound in human association.' Certainly his finest works abound with the image of man peacefully gaining his living from the land.

Constable's deep involvement with the act of painting can be seen in his persistence in using oil painting as a sketching technique, unlike Turner, Linnell and other landscapists of the period. He was not deterred by the clumsiness of the medium when compared with watercolour, but revelled rather in the vigour of effect that it could achieve. Habitually using panel or millboard for these open-air studies, he would dab separate areas of paint 147 over a unifying warm brown ground. In *Flatford Mill from a Lock on the Stour*

146 CONSTABLE *Borrowdale* 1806

147 CONSTABLE *Flatford Mill from a Lock on the Stour c.*1811

his handling has ranged from bold impasto in the sky to the thin striations on the water. Each form, each effect, required something different.

Constable felt keenly the individuality of each phenomenon. 'No two days are alike' he once declared, 'not even two hours; neither were there ever two leaves alike since the creation of the world.' But if this essentially Romantic attitude led other painters of the period, such as Palmer or Olivier, to the minute elaboration of detail, Constable chose rather to observe individuality in movement, light and atmosphere. He sought – as he later said in the introduction to Lucas' mezzotints after his works *The English Landscape* (1833) – 'to arrest the more abrupt and transient appearances of the CHIAR'OSCURO IN NATURE . . . to render permanent many of those splendid but evanescent Exhibitions, which are ever occurring in the endless variety of Nature, in her eternal changes'.

However bold Constable became in his pursuit of the momentary, he still had to face the problem of how to retain such effects in finished compositions. To a certain extent he was already investigating this in his oil

197

sketches. It has been noticed by Michael Kitson that the composition of *Flatford Mill from a Lock on the Stour* is similar to that of one of Claude's

145 *Seaports*. But, while in *Dedham Vale* he fully accepted the Claudian device of viewing a distance through a clearly defined foreground, he has rethought the design here so that the distance is almost completely blocked and attention is being held in the middle ground. Devices are being rearranged to accommodate experience.

149 It was in *Boat Building on the Stour*, which he claimed to have painted entirely on the spot in the summer of 1814, that Constable appears to have attempted first to bring together sketch and completed picture. As can be seen by comparing the work with a surviving pencil study for it, he did no more than rearrange a few of the boatbuilders' implements and deepen some shadows in the foreground to soften the uneasy presence of the barge's hull. One can sense in the result the constraints that Constable placed upon himself to achieve such rigid authenticity in the handling. For the broad and variegated treatment of his oil sketches has now become smoothed down to gain an overall unity of surface. If there is much sunlight in this picture, the 'chiar'oscuro in nature' is but tamely present.

There was little in this small work, in fact, to make Constable's contemporaries suspect that it was more than a fresh and diverting piece of rural genre when it was shown at the Academy in 1815. Nor can Peter de

148 Wint's (1784–1849) *Cornfield*, exhibited at the same time, have helped to dispel this view. Superficially, at least, De Wint recorded the rural economy of Lincolnshire with every bit as much fidelity and freshness as Constable did that of Suffolk. And the fact that De Wint found that such large-scale treatments of these scenes did not sell, and was obliged to pursue instead the career of a watercolourist, did not augur well for Constable's future intentions.

Constable's exploration of the surrounds of East Bergholt had in fact been paralleled by a similar search for authenticity elsewhere. In London the watercolourist John Varley (1778–1842) had been influential in encouraging his brother-in-law William Mulready (1786–1863) and his pupils William Henry Hunt (1790–1864) and John Linnell (1792–1882) to 'go to Nature for everything'. For Mulready the advice had been far from satisfactory: his two scenes of the area around Kensington Mall (1811, 1812) were rejected by the Academy and considered 'too literal' by the man who had commissioned them.

Literalness was the keynote of the open-air studies made by this group.

151 Linnell soon developed a detailed *intimisme* in his finished oils which readily explains his fascination with Dürer. It is hardly surprising that it was in this circle that a mechanical device for transcribing detail, the Graphic Telescope,

148 DE WINT *Cornfield* c.1815

149 CONSTABLE *Boat Building on the Stour* 1814

was invented by Varley's brother Cornelius. A last and brief flowering of such interests can be found in the works painted by George Fredrick Lewis (1782–1871) before 1820. A friend of Linnell's, he proudly recorded in the catalogue of the 1816 exhibition of the Society of Painters in Oil and Watercolour that his *Hereford, from the Haywood, Noon* was 'painted on the spot'. If, as Leslie Parris believes, this work is the one now in the Tate Gallery, it shows how little the sketching or painting in oils before nature need lead to the exploration of atmospherics and light. For, if Lewis' work is remarkable for recording the data of British farm life with an objectivity far removed from Constable's rosy view of rural activity, it shows none of the Suffolk artist's meteorological concern. Noon, for Lewis, is more a time when farmhands take a rest and a swig of ale than one of those 'splendid but evanescent Exhibitions . . . in the endless variety of nature'.

There seems to be no clear reason why Constable should, in his mid-forties, have suddenly embarked upon the series of large exhibition canvases, the 'six-footers', for which he is now chiefly remembered. The first of the series, *The White Horse*, still shows the difficulties Constable had in magnifying his freshness of vision to the scale of the big academy showpiece,

150 LEWIS *Hereford, from the Haywood, Noon* 1815

151 LINNELL *Study of Buildings* 1806

the *grande machine*. But in *The Haywain* he resolved this, having mastered the habit of painting first a full-size sketch of the work, in which he could lay out the whole effect with great boldness, and then elaborating on this in the final work.

Unlike *Boat Building*, these large canvases are not exact records of a place. *The Haywain* may show a well-known place, the cottage in which a local character, Willy Lott, spent the whole of his life, but Constable has made alterations to the shape of the river, and the extent of the banks, in order to create a design with greater breadth. Above all, it was the immediacy of a particular time that he was seeking to convey, and it is as well to remember that when Constable first exhibited the work at the Academy in 1821 it was simply entitled *Landscape: Noon*. 136

It is this sense of a moment that creates the centre of the picture's excitement. Like the landscapes of Rubens, which he so admired, it is full of rhythm, colour and movement. The whole surface is alive with incident, the smoke rising from a chimney, the sun shining through leaves, making them translucent and brown, a fisherman emerging from the rushes. Yet everything is held in the most careful and tranquil of balances. The

152 CONSTABLE *Study of Clouds* 1821

movement is the slight but constant change of a breezy summer's day; and just as this movement can be suggested without threatening the harmony of the whole, so the individuality of each object is asserted without creating conflict.

This does not seem to have struck critics at the time. At the Academy it created no stir. But three years later, when exhibited at the Paris Salon, it created a furore. Yet this, too, seems to have gone wide of the mark. For in their excitement about the freshness of the whole work, the way it had captured the movement of clouds and painted green upon green without becoming tedious, the critics ignored the completeness of the work's content, and referred to it as a 'sketch'.

Nothing governs the movement in *The Haywain* more than its sky. Constable was far from being the first landscape painter to make skies 'an

effectual part of the composition'. Indeed, he himself recognized this as a common practice when, defending the implication that the sky was obtrusive in his pictures, he stated: 'It will be difficult to name a class of landscape in which the sky is not the key-note, the standard of scale, and the chief organ of sentiment.'

Yet here, as elsewhere, Constable established a new standard. He may have taken as a starting-point the *Cloud Compositions* in Alexander Cozens' treatise on landscape; but he took pains to make studies in the 1820s that emphasized above all the specific. This one, for example, has on the back the 152 inscription 'Hampstead/Sept 11 1821 10 to 11 Morning/Clouds silvery grey on warm ground/Light wind to the S.W./fine all day – but rain/in the night following'.

However, if Constable's concern is for accurate observation, he is not interested in classification. He compiled no inventory of clouds and his studies were largely devoted to those kinds of cumulus associated with changeable weather. He sought only to gain a close knowledge of those transient moments that attracted him.

In his combination of scientific enquiry and emotive response, Constable was fully of his age. Perhaps at no time since would it have been possible for an artist to write both 'Painting is a science, and should be pursued as an inquiry into the laws of nature' and 'Painting is for me but another word for feeling' without any sense of contradiction. Like Coleridge, whose poetry he greatly admired, he felt the attentive perception of nature in itself to be spiritually uplifting.

Constable also shared something of Coleridge's dark and troubled temperament, and it was not necessarily his intention that he should go down in history as the painter simply of rustic tranquillity. In 1821 he wrote of his wish that 'it could be said of me as Fuseli says of Rembrandt, "he followed nature in her calmest abodes and could pluck a flower on every hedge – yet he was born to cast a stedfast eye on the bolder phenomena of nature"'. Many of his sky studies are of stormy effects and sunsets, and after *The Haywain* he attempted to heighten the drama of his 'six-footers'. *The Leaping Horse*, exhibited in 1825, takes its cue from a moment of rapid action. 153 It shows the moment when one of the barge horses makes its customary leap over one of the barriers set up along the Stour towpath to prevent cattle from straying.

Constable himself was clear about his interest in the 'bustle incident to such a scene' and felt anxious that the finished work had not completely conveyed the effect he wished. Certainly the full-scale sketch for it contains more sense of drama; and the violence of its impasto has made it a favourite work for Francis Bacon.

153 CONSTABLE Study for *The Leaping Horse* 1825

The death of his wife, and a continued lack of serious recognition, served to deepen his inner pessimism. In such later works as the full-scale sketch for *Hadleigh Castle* the paint is laid on almost savagely with a palette knife, and the whole surface is flecked over with those white highlights that became known as 'Constable's snow'. Constable fully accepted that it was an inner turmoil that was being expressed in these canvases: 'How for some wise purpose is every bit of sunshine clouded over in me. Can it be wondered at that I paint continual storms – "Tempest o'er tempest rolled"?'

Yet he also saw something therapeutic in the sheer act of this expression: 'Still the darkness is majestic and I have not to accuse myself of ever having prostituted the moral feeling of Art . . . My canvas soothes me into forgetfulness of the scene of turmoil and folly and worse.'

As an image – a ruined castle by the sea – *Hadleigh Castle* is certainly very different from *The Haywain*. But it seems curious that Constable did not vary his subjects more in the late expressive years. He never sought out a wider variety of scenery after the infelicities of his 'picturesque' tours of Derbyshire and the Lake District in his youth. All other views were the outcome of journeys undertaken for personal reasons. He went to Brighton and the South Coast on account of his wife's health, and to Salisbury to visit his friend Archdeacon Fisher.

The range of time and weather in his pictures is not extensive either. His storms are really clouded summer days, and one would be hard put to it to find a Constable painting of a real tempest. Occasionally his pictures have a hint of autumn, but never of winter. There is no snow in Constable's world. Evenings are rare, night-times non-existent.

Even before Constable's personal life had become clouded, the harmony of the countryside had been rent by violent change and economic recession – the consequences of the mechanization of farming that followed on the Industrial Revolution, the shift of productivity in Britain to industry and the slump that followed the wars with France. Suffolk, a highly organized farming community, was hit by these changes particularly badly, and Constable, the relative of farmers, millers and landowners, was well aware of it. In 1822 he considered the 'state of things in Suffolk' to be 'as bad as Ireland'.

Yet there is no more unrest in the subjects of his pictures than there was in the nooks and dells of Samuel Palmer. Constable's labourers go about their business peacefully, the fields are full of corn, there is not a burnt hayrick in sight. For a member of the landowning classes to paint such scenes of rural harmony in Suffolk in the 1820s virtually amounts to propaganda. It hardly needs to be added that Constable, like Palmer, was opposed to the Reform Bill of 1832. For this would 'give the government into the hands of the

154 CONSTABLE Sketch for *Hadleigh Castle* 1829

rabble and dregs of the people, and the devil's agents on earth – the agitators'.

Constable's revolution was a pictorial one. He painted the greenness and movement of the English countryside, and in doing so sacrificed the conventions of distancing, tonality and finish that were traditionally thought to make a landscape pleasing. But if he made nature appear more immediate, his image of it was still that of the pastoral.

Naturalism is a standard that changes with every generation. Constable certainly brought about a new understanding of the effects of atmosphere and light; but he was not a naturalist in the sense that these effects alone were sufficient cause for painting. There was still the 'moral feeling of art'. His freshness was the means of bringing to life his memories of a harmonious world, a peaceable land of summer weather: and it is the Suffolk of his boyhood that still lingers beneath the agitated surface of his last pictures.

Towards naturalism

In France the search for a pure and unaffected manner was to lead to the consideration of the *effects* of nature − of light, colour and atmosphere − in themselves. But this was not before painters there had received an impetus from Constable. Previously the depiction of common nature had been upheld by Georges Michel (1763−1843), a Parisian John Crome. Absorbing the lessons of Ruisdael and Rembrandt, this artist settled at Montmartre, and found among the windmills and the heathlands the moodier moments of the Dutch.

It was the artists who began to move to the Forest of Fontainebleau to surround themselves with the marshes and woodlands in the neighbourhood of the village of Barbizon after 1830, who set up a more contemporary standard of naturalism. It is one that is only partially related to the notions of Romanticism. It is true the artists' 'flight to nature' to immerse themselves in an idyllic primal world has much of the Rousseauian vision about it. But their response to the forest scenery they surrounded themselves with was on the whole less charged than that of Constable to his native Suffolk. It is perhaps for this reason that their pictures remind one more readily of the more placid Dutch masters of the seventeenth century. They are best remembered today for extending the habit of painting directly out of doors,

155 MICHEL *The Storm*

156 THÉODORE ROUSSEAU *A Marshy Landscape* 1842

blurring the distinction between 'sketch' and 'finished picture' in a way that Constable had never done, and becoming a direct inspiration for the Impressionists. Only Théodore Rousseau (1812–67), the strongest 156 personality in this loosely knit group, allowed his subjective emotions to emerge in the actual manner that he painted. From the time that he first exhibited at the Salon in 1831 this artist became notorious for the challenging vigour of his naturalism. As such he shared something of the sensationalism of the *romantiques* – although, unlike them, he was not favoured by the regime of Louis-Philippe. Only after 1848 did he achieve official acceptance. Prior to his first visits to the Barbizon area in 1830 Rousseau had absorbed the principles of the classical 'universal landscape' from his teacher Lethière. When he saw *The Haywain* in 1833 it made a deep impression on him; but he 136 found nothing in its treatment to go against the emotive approach to landscape. And if he encouraged his followers to keep in mind the impression of 'virgin nature' he also understood composition to be the means by which 'that which is within us' enters into 'the external reality of things'. Within him there was a feeling for grandeur and passion that came to the fore when he confronted a mighty tree or a marshy expanse.

209

157 DAHL *Rising Clouds in the Mountains* 1826(?)

158 COROT *Geneva, Quai des Paquis* 1841

A less impassioned – and also less Constable-like – naturalism can be found
in the works of Jean-Baptiste-Camille Corot (1796 1875). During his first
visit to Rome (1825–28) he found among the practitioners of the classical
landscape a concern for *plein air* effects, evident in the open-air oil sketches of
the major French classical landscape painter Valenciennes. In his own works
there is a calm and unpretentious insistence on the exploration of pure tonal
values that was to become a model for later generations. The distinction
between this quiet art and the more impassioned work of Rousseau was
admirably brought out by Baudelaire in his Salon review of 1859: 'If M.
Rousseau – who, for all his occasional incompleteness is perpetually restless
and throbbing with life – if M. Rousseau seems like a man who is tormented
by several devils and does not know which to heed, M. Corot, who is his
absolute antithesis, has the devil too seldom within him.'

Yet Corot's art is not wholly without emotion. There is something of the
Franciscan in his simplicity, and one contemporary at least could feel that 'he
does not so much paint nature as his love for her'. In later years this love

158

159 DURAND *Kindred Spirits* 1849

mellowed and took on a wistful poignancy, which was far more successful with the Salon-going public than his fresher earlier paintings had been. At this popular level, at least, Romanticism eventually caught up with him.

The charting of the gradual shift from emotive response to dispassionate description is an uncertain business, but there can be no doubting the strength of the movement. Throughout Northern Europe there sprang up movements and individuals who sought to set both idealism and subjectivity behind them. Such a man was Ferdinand Georg Waldmüller (1793–1865) whose fresh and immaculate views of Austrian mountains and pastures were as much of an affront to the Academy in Vienna as anything by Constable and Rousseau was to the art establishments of London and Paris. Another was the Norwegian Johann Christian Clausen Dahl (1788–1857). After a visit to Italy Dahl settled in Dresden in 1823 and became the intimate of Friedrich. Yet, although he would at times adopt the imagery of his sombre friend, and would also depict scenes of his native Norway in terms similar to those of Everdingen, his pictures reveal a blander interest in sheer description. A genial, even-tempered man, he felt no urge to probe too far beneath the surface either of appearance or of his own personality.

157

160 DURAND *Study from Nature – Rocks and Trees* c.1855

In America, too, there developed a less excited interest in the wonders of the New World. Thomas Cole himself had, in his later years, moved towards the investigation of a less stupendous scenery. But the figure who led the 'Hudson River School' towards a Barbizonian appreciation was Cole's successor, Asher B. Durand (1796–1886). In 1849 Durand painted a picture in Cole's memory, *Kindred Spirits*, showing the artist and the poet Bryant standing on a rock, above a deep gorge, contemplating the hazy expanse. But within a few years he himself had turned towards the *plein air* study of the rocks and trees in that same area.

159

160

Intimism and luminism

As the English Pre-Raphaelites were later to show, the search for natural truth did not always lead in the direction of atmospherics: there was also a more naïve impetus to record facts rather than effects.

From the start this tendency was connected with an admiration of 'Primitive' art, whether this was the 'unprejudiced' investigations of the fifteenth century or the simple directness of folk-art. Even Constable cast a wistful eye on those artists prior to the High Renaissance who supposedly went to nature without having to contend with the influence of others' impressions. And if he felt the need to come to terms with a knowledge of

161 BEWICK *The Blackbird (Black Ouzel)* 1797

162 LINNELL *Canal at Newbury* 1815

nature that went beyond such innocence, such naturalists as John Linnell found their own studies before nature to accord with the detailed accounts of Dürer and the Flemish. In his *Canal at Newbury* this sharp-eyed attentiveness has produced a record that is as appropriate to the hardness of early spring as Constable's rippling fullness is to midsummer. 162

Such literalness, too, was closer to the kind of art that sought to make records for the naturalist, the precise drawings required by the botanist, zoologist and geologist. Thomas Bewick (1753–1828), the Newcastle artist who revived the use of wood as an engraving medium, used this archaic medium to grasp the markings and features of animals and birds in his popular books on natural history. And if his precision owed little to the old masters of woodcut, he was nevertheless reviving a medium that had sunk, since the Renaissance, to the level of a popular art and which seemed to him to be most appropriate for expressing his own deep affection for his native region. 161

Conscious naïveté and provincial primitivism in fact constantly intermingle in the type of art that often goes under the name of 'intimist'. Yet whichever it is, the precision does seem to be deliberate in an artist like

215

163 DANBY *Clifton Rocks from Rownham Fields* c.1822

Francis Danby (1793–1861). For when this Irish artist wound up in Bristol between 1813 and 1824, after having failed to make his fortune immediately in London, he seems to have readily adopted a detailed manner for local work while sending more extravagant pictures to London exhibitions. Such
163 scenes as *Clifton Rocks from Rownham Fields* provided an account of every leaf of every tree that was certainly well appreciated by patrons who had a special interest in local topography. It was out of a similar concern for natural history that the Swiss animal painter Jacques-Laurent Agasse (1767–1849), who settled in England in 1800, could bring a fresh charm to such genre
164 scenes as *The Playground*.

The kind of faithful and unpretentious record that can be found in such works accorded well with the kind of small-town intimacy that goes in Central Europe under the name of 'Biedermeier'. This word derived from the confounding of two fictitious, deeply provincial and Philistine characters

164 AGASSE *The Playground* 1830

– Herren Biedermann and Bummelmeier – who were currently the butt of much journalistic wit. It is certainly a useful term for identifying a tendency in the art and social life of the period 1815–48 – although it has none of the theoretical implications of such associated designations as Romanticism and Realism and cannot in any way be associated with an explicit movement. It should also not be confused with the simpler but equally bourgeois *intimiste* tradition that had existed as a sub-culture throughout Europe since the seventeenth century. Perhaps it is best to be distinguished from this by a certain self-consciousness and sentimental humour that can be seen as the innocent counterpart of Romantic ennui. Used in this way it can have a meaning not only for the art in Central Europe, but also in France, England and America. Thematically it can apply equally well to the description of people's everyday lives as to the nature that surrounded them. It certainly has a relevance for the exquisite interiors of Georg Friedrich Kersting (1785–1847) – a friend of Caspar David Friedrich who eventually became a

168

165 DROLLING *Interior of a Kitchen* 1815

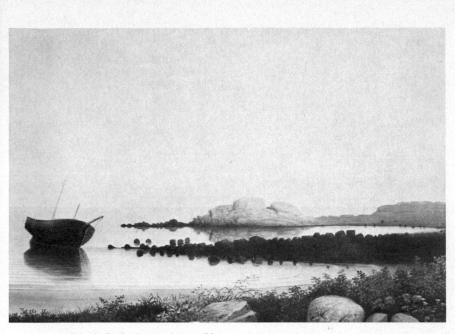

166 LANE *Brace's Rock, Eastern Point, Gloucester* 1863

drawing supervisor at the Meissen china factory – and the meticulous records of the French genre painters Louis-Léopold Boilly (1761 1845) and Martin Drolling (1752–1817).

In both cases there is an obvious dependence on the 'little masters' of the Dutch school. Yet both are of their time in the lyrical sentiment that underlies their enjoyment of domesticity.

In America the relationship between such detailed art and the folk tradition is more complex. The 'luminist' seascapes of the New England painter Fritz Hugh Lane (1804–65), with their careful detail and subtly graded tonalities, seem to belong to both traditions at once. Lane was painting for a highly appreciative local audience, and seems to have shared with other New Englanders a deep involvement with ships and the sea. George Caleb Bingham (1811–79) was more nationally famed for his Missouri genre scenes. There is certainly a most knowing control in the clear organization of these scenes of Middle American life. Yet the smoothly painted luminosity gives an almost magical quality to their realism. In their

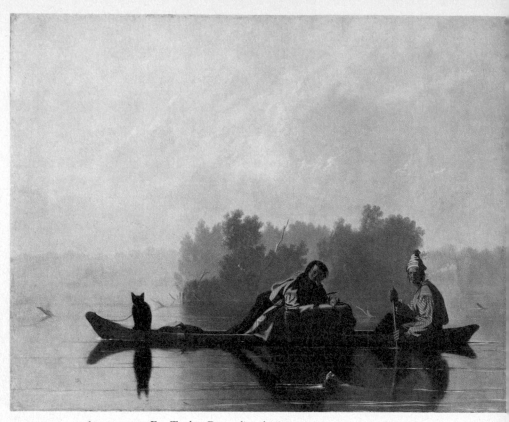

167 BINGHAM *Fur Traders Descending the Missouri* 1845

different ways both Lane and Bingham gave their accounts a precision that
has since become a recurring feature of American realism.

The European search for naturalism had many unexpected reverberances.
And if some of these could be felt in America, others travelled to the Far East.
Landscape painting here was an art of great antiquity, and there was nothing
that Europeans could teach Chinese and Japanese scroll painters about the
spiritual contemplation of nature. It was such masters of the more worldly
Japanese woodblock print as Hokusai (1760–1849) and Hiroshige
(1797–1858) who adapted Western conventions of lighting and perspective
to the Eastern tradition. And it is fitting that this more accessible and popular
art should in its turn have been the one to have the greatest impact on
Western painters when, a few decades later, these sought to reinvigorate
their art by turning to the East.

220

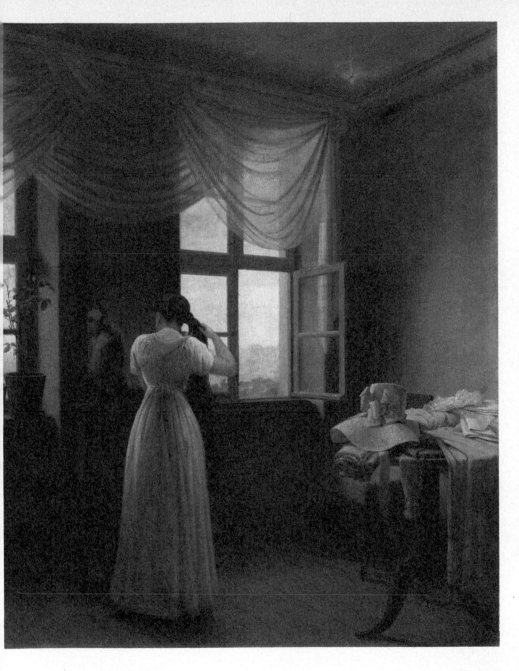

168 KERSTING *Before the Mirror* 1827

Sensation

Romantic versus classic

It was in France that the controversy over Romanticism and classicism became most vociferous. In the time between Stendhal's proclamation of the valour and modernity of Romanticism in *Racine and Shakespeare* in 1823 and 169 the staging of Victor Hugo's *Hernani* in 1830 – where the breaking of a classical convention of verse-making in the opening lines provoked riots in the audience – French Romanticism emerged as a violent and committed *avant-garde*.

The military metaphors that came so readily to those who took part in these skirmishes are symptomatic of the situation in which they occurred. For in post-Napoleonic France, art could be a surrogate for political action. There were many – old soldiers, dreamers, untried adventurers – who felt a stifling boredom and sense of betrayal, as they saw the daring changes of the Revolution and Empire atrophying in the hands of the new officialdom. Classicism – whether in the theatre or the salon – became for these a symbol of mindless traditionalism, the perpetuation of form for form's sake. Whereas an artist like Ingres indicated the 'timeless' values of Greek art, Stendhal could assert that all great art was daring and innovatory when it was made; that the borrowing of conventions from the past was no way to create for the present age.

The classical-Romantic conflict was real enough in the sphere of art politics; but it is less clear how much it meant to the major painters of the time. Certainly Delacroix was hailed as a Romantic leader; yet he himself was disdainful of the movement, and never concealed his respect for tradition and 'permanence'. And although the later works of David's pupils could provide substance to the accusation that classicism was irrelevant and lifeless, there was no doubting the topicality of the paintings of David from the Revolutionary period, or those of Gros and Girodet from the Empire. Géricault and Delacroix were the heirs to a school of painting full of drama and emotional complexity.

By the end of the eighteenth century, in fact, some artists were producing works so aberrant that only the word 'romantic' seemed appropriate to describe them. In 1802, in *The Spirit of Christianity*, Chateaubriand had

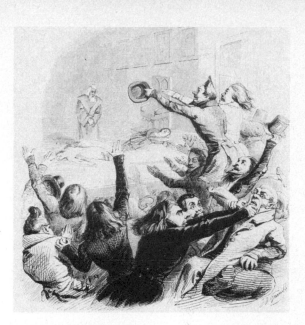

169 GRANDVILLE *The Disorderly Romantics at the Battle of 'Hernani'* 1830

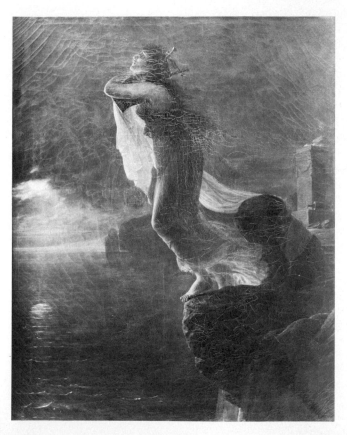

170 GROS *Sappho at Leucate* 1801

defended the choice of religious themes in art on the grounds that they were 'richer, more beautiful, more romantic, more moving' than those of classical antiquity. However, subjects could be found in the ancient world, too, that transcended reasoned action; and when Gros exhibited his *Sappho at Leucate* in 1801, it had also gained the epithet 'romantic'.

170

Certainly the moment when the Greek poetess casts herself into the sea, after being abandoned by her lover, is anything but stoical: 'It was a fundamental deviation from the principles of Greek art to undertake the painting of despair', commented Charles Blanc in 1845. Contemporary critics objected not only to the subject's capitulation to emotion but also to an apparent arbitrariness in the handling, in particular the dominant blue-green of the mournful colouring and the unstable motion of the design. Arguing in a vein similar to that of Reynolds when he censured the free expression of fantasy in the visual arts (*see* p. 13), the *Journal de Paris* remarked: 'The scene is romantic, the colour ideal. This subject could present itself in such a manner to the imagination, but never to the eye.' Gros embroidered the legend by showing the suicide taking place at night – a circumstance that certainly heightens the pathos. In the moonlight the shapes become ambiguous. Sappho's cloak is translucent, like a ghostly shroud, the rocks behind her silhouettes of unearthly prescience. She herself emerges from their forms with a silent motion that cannot be continued in the imagination without destroying the picture's fragile equilibrium. Although more classically detailed in execution than Gros's Napoleonic narratives, it is even more psychologically disturbing: hardly surprising that it puts many commentators in mind of late nineteenth-century treatment of the same theme by the Symbolist Gustave Moreau.

Gros's *Sappho* is a plea that emotive effect can be conveyed as much through precision as through bravura. It was not simply the breadth and passion of his portraits and contemporary scenes that fascinated the younger generation, but a more indefinable excitation that Delacroix could only describe as 'this power of projecting me into that spiritual state which I consider to be the strongest emotion that the art of painting can inspire'.

No follower of David strayed further from his master in his choice of subject-matter than Anne-Louis Girodet (1767–1824). In Rome in 1792, while working on an antique scene of medical professionalism, *Hippocrates Refusing the Presents of Artaxerxes* for Trioson (the doctor who was later to adopt him as a son), he was at the same time engaged on a depiction of bewitchment, the *Sleep of Endymion*. In showing the Greek shepherd cast into an eternal sleep for the delectation of the enamoured moon-goddess, Girodet fixes upon the effulgence of the moonbeam as it plays over the languorous form of its victim. There is no rhetoric here, only wonderment.

171

171 GIRODET *Sleep of Endymion* 1792

After he returned to France in 1795 Girodet divided his time between fashionable portraiture, book illustration and the exploration of fantasy. He shared Chateaubriand's fascination with the mystique of Christianity and painted the author – to the latter's great delight – unkempt and melancholic, meditating among the ruins of Rome (1807; Musée de Saint-Malo). When it was exhibited at the Salon of 1810 Napoleon remarked that it made its subject (who had fallen into political disfavour) look 'like a conspirator who has just come down the chimney'. Yet in 1801 he had himself benefited from Girodet's fantasy *Ossian Receiving Napoleon's Generals*, a work whose bizarre iconography led David to conclude that his former protégé had taken leave of his senses.

Whatever David may have thought, Girodet emerged as a leading defender of classicism under the Restoration. His fantasies had never interfered with the fulfilment of more pragmatic requirements, such as the narration of Napoleonic triumphs during the latter years of the Emperor's rule. Even his most imaginative themes remained confined by his technique. *Endymion*, a picture about light, is far from suggesting the immaterial. With its frieze-like

172 PRUD'HON *Justice and Divine Vengeance Pursuing Crime* 1808

design and carefully modelled forms, it is hardly more ethereal than a well-staged tableau. For Keats the 'poetic romance' of *Endymion* was to become a hazy, breathtaking quest for the ideal. The emotions aroused by Girodet's picture, as by the sculptures of Canova, which he so admired, are more tangible than transcendent. The moment is not so much mystical as erotic.

Girodet's scruple in maintaining a surface rationality – a logic of forms if not of subjects – reveals his position in the controversy on the limitations of pictorial suggestion. Both he and Gros were to regret the lead they had unwittingly provided for an art of sensation and sensationalism.

The emotive tradition prevailed unrepentantly in the work of Pierre-Paul Prud'hon (1758–1823). Unlike Girodet and Gros, he was never a pupil of David. Trained first in Dijon, he was a student in Paris in 1780–83, a time when the Master's impact could still be avoided. During his subsequent years in Rome he preferred the softer Neo-classicism of Mengs, Antonio Canova and Angelika Kauffmann to that of the new French school; and he responded even more to Leonardo da Vinci and Correggio – painters of the High Renaissance with an incomparable feeling for floating grace and tender

173 PRUD'HON *Crucifixion* 1822

174 DELACROIX *Christ in the Garden of Olives* 1827

modelling. On his return to Paris in 1789 Prud'hon became a Jacobin and attended David's Club des Arts; but he still remained aloof from the declamatory manner, and continued to develop his own vein of sensibility in portraits, allegories and wistfully erotic book illustrations. During the Empire this 'French Correggio' – as he was known – played the court artist. A favourite of Josephine's, he portrayed the Imperial couple, worked as their interior designer and executed public decorative projects.

It would be possible to see Prud'hon as a survival of eighteenth-century elegance, were it not for the tragic dimension that came to the fore in the
172 great paintings of his later years. *Justice and Divine Vengeance Pursuing Crime* was commissioned to decorate the Salle de la Cour Criminelle of the Palais de Justice. The theme is elaborated with customary classical allusions. The fleeing murderer is based on a statue by Canova, and the flying deities are taken from one of Flaxman's outlines to the *Iliad*. Yet the overwhelming sense of guilt and retribution is conveyed by the masterful control of rhythm and illumination. The pale arc of the victim's body finds a response in the darkened curve of the pursuing deities, generating a relentless movement which already engulfs the hunched brooding figure of the assassin.

In his last years Prud'hon's own life became one of tragedy and remorse. His artistic reputation did not survive well in the Restoration, and in 1821 his personal life became blighted when his pupil and mistress, Constance Meyer, committed suicide. Perhaps an echo of these events can be found in his final
173 major work, the *Crucifixion*. Christ's tortured body is seen close to, at an angle, against a darkened void. His eyes and hands cast in shadow, he is a sightless, helpless torso.

It is a great disservice to such artists as Gros, Girodet and Prud'hon to see them purely as forerunners for a later Romanticism. Even at their most intimate, fanciful or tragic the painters of the Empire did not strive to be subversive in the way that their successors did. For all his excitation of compassion or melancholy, Gros's protagonists remain heroes. Even the suicide of Sappho – his most aberrant moment – seems positively selfless
189 when compared to the passionless destruction of Delacroix's *Sardanapalus*. One is aware, too, that Prud'hon's *Justice*, for all its evocation of mood, allows no wavering in our sympathies. A murder has been committed, and Justice is to be seen to be done. His *Crucifixion* shows a break with the classical frieze-like design – no doubt a reflection of the lead that had already been provided by such works as Géricault's *Medusa*. But even in his suffering and degradation Prud'hon's Christ remains noble. He is not the disturbingly
174 exhausted and unidealized figure of Delacroix's *Christ in the Garden of Olives* whose 'earthy and African colouring', according to the *Journal de Paris*, 'resembles more a man already dead than an immortal being'.

It was a key feature of this shift of emphasis that the irrational and the sensory should become dominant. Such obsessions drew the painters of the Restoration in France towards the more casual concern for sheer effect that was prevalent in contemporary English art. Since the mid eighteenth century the culture of the English had become a byword for informality. And just as they had brought 'naturalness' (or, if you preferred, 'wildness') to the garden, and had with West and Copley pioneered the modern-life history painting, so they introduced a nonchalant poise to High Romanticism. On a personal level this could be found both in the cult of the dandy – the meticulously studied understatement of dress of such figures as 'Beau' Brummel, the Prince Regent's boon companion – and in the stylish abandon epitomized by the poet Bryon.

It is perhaps to be expected that painterly brilliance was most cultivated in those pictorial genres where observation was more the intention than narrative: notably in portraiture, animal painting and landscape. The portraiture of the age was dominated by an artist who epitomized the notion of the dandy in both style and personality. Sir Thomas Lawrence (1769–1830) – a handsome, kindly philanderer – possessed all the ease of manners to make him acceptable in the most fashionable society. The apparently effortless expertise of his art brought him spectacular success at an early age. Like Turner he became an Academician at the earliest possible age; but for him the honours did not stop there. In 1815 he was knighted, and in 1820 he became President of the Royal Academy. By that time he had also taken Europe by storm. From the time that he was sent abroad by the Regent to paint the leading generals and rulers of the Allies in 1818 he was felt to be without rival. At the same time that he was exciting the young French artists he was also gaining official approval, and a visit to Paris in 1825 brought for him the Légion d'Honneur.

Lawrence's elegant portraits seem lacking in *gravitas* and mental power – especially when compared to those of Reynolds. However, what he lacked in breadth and discursiveness he made up for in his awareness of temperament. His peculiar empathy for the proclivities of his fashionable contemporaries can be felt in the portrait of Arthur Atterley, where he 176 captures the adolescent mood of the young man in its casualness and intensity. Shown walking, hat in hand, before a stormy landscape, Atterley turns to scrutinize us, giving his full attention to the momentary distraction. The pose is fleeting, yet it could not be more calculated in its balance, the dark circle of the hat generating a relaxed surface rhythm. Throughout the changeable lighting effects the paintwork is broadly laid, yet glistening and

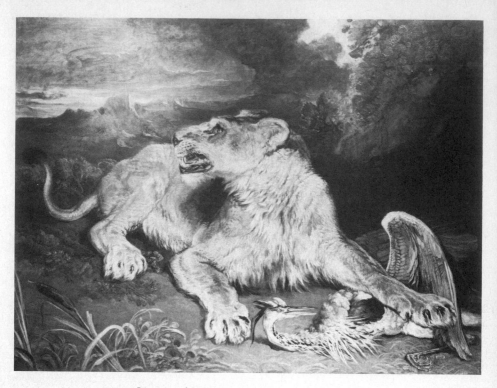

175 WARD *Lioness and Heron* 1816

fluid. The sheer refinement and sensibility of such works set a standard that was to be emulated later by Delacroix, Manet and Whistler.

The animal painter James Ward (1769–1855) was to bring about a similar shift towards the emotive in his own genre. Ward was another artist who succeeded by demonstrable expertise, but his pictures display a more troubled temperament; and if Lawrence's stylishness attracted Delacroix, it is appropriate that Ward's morbidity should have appealed particularly to Géricault.

Ward's interest in energy and expression had a religious basis. Himself a follower of the apocalyptic clergyman Edward Irving, he shared the sect's belief in the gift of tongues, was an admirer of Blake and was given to praying for inspiration in his studio. His fascination with wild beasts was in effect a fascination with the sources of primal energy. Such works as *Lioness and Heron* have an utterly animal violence, which is intensified not only by the stormy background, but also by the distortion of the lion's forepaw as it spreads forward to secure its prey. Stubbs' dramatic *Horse Frightened by a*

175

32

230

176 LAWRENCE *Arthur Atterley as an Etonian* 1790–91

Lion appears elegant and controlled by comparison. Ward's picture does not appeal, as Stubbs' work does, to our finer feelings, but to areas less susceptible to sensibility.

To those artists who had undergone the rigours of the French Academy, the English seemed enviable for their informality and emotiveness but ultimately devoid of more controlled qualities. Even Delacroix, for all his emulation of the expertise of Constable and Lawrence, felt 'all the great English painters' had the 'defect of exaggeration'. When reviewing the work of the school in his diary on 8 February 1860 he decided that this tendency to over-emphasis prevented them from achieving 'that quality of eternal youth characteristic of the great masterpieces'. Such an opinion highlights the principal dilemma that both Delacroix and Géricault felt in their art: how to paint in a lively and modern manner, to revel in sensation – and yet produce an art that was as sustained and penetrating, as continuous in its revelation, as that of the great masters.

Théodore Géricault

No work produced a more convincing answer to this problem than *The Raft of the Medusa* by Géricault (1791–1824). This vast canvas, so disconcertingly dominant at the Salon of 1819, became as much a talisman for the young artists of the Restoration as David's *Oath of the Horatii* had been for those of the Revolution.

Nothing underlines the disparate emphasis of these two great innovators more than their motivations. Both wished to produce an art that was powerful and arresting – Géricault's recorded ambition was 'to shine, to illuminate, to astonish the world'. Yet David's State-commissioned enactments of resolution and achievement are the converse of Géricault's presentations of defeat, conflict and disease. David's emotions served his sense of public duty; Géricault's bore witness to a private obsession.

Géricault's eager, febrile disposition keenly felt the disturbances that followed Napoleon's downfall. His own affiliations were uncertain: so much so, in fact, that he could celebrate the military prowess of the Empire in his first exhibited work in 1812, join the Royalist guards three years later, and in a further three years paint a searing indictment of the Restoration government. The son of a prosperous and indulgent – if uncomprehending – father, he was free from external pressures. He need exhibit at the Salon only when he had a special purpose (there were three such occasions); and when he received a Government commission that was not to his liking, he simply passed it on to his young acquaintance Delacroix.

Géricault's impetus was, therefore, fully at the mercy of his temperament. His career began casually enough with an apprenticeship in 1808 to the easy-

177 GÉRICAULT *Portrait of an Officer of the Chasseurs Commanding a Charge* 1812

going animal and battle painter Carle Vernet (1758–1836). Two years later, however, he transferred to the studio of Pierre-Narcisse Guérin (1774–1833), the master of a spirited classical style who also trained Delacroix and Huet. From Guérin, Géricault received a thorough grounding in the mechanics of monumental painting, the laborious study and assemblage that goes into the construction of the grand historical piece. From this time – at first in a dilatory manner, and then with mounting conviction – Géricault moved towards the creation of such a work: *The Raft of the Medusa*. Yet the equivocation with which this was received discouraged him from further concentration on such a project. Only on his death-bed, when it was too late, did he dream of creating some other *grande machine*.

183

Géricault was consistently the chronicler of those modern events that struck his own sympathies. During the Empire this accorded well with the action and modernity of Carle Vernet's horse paintings and battle scenes. He was never personally close to Gros, the master of the modern epic; yet he studied his style and shared his admiration for the colour and effect to be found in Venetian and Baroque painters. During his youth the Musée Napoléon was still intact, and he made free copies there of pictures by such masters of realism and drama as Caravaggio, Rembrandt, Rubens and Velazquez.

177

Géricault's first Salon exhibit, the *Portrait of an Officer of the Chasseurs Commanding a Charge*, was enthusiastically received. Painted while Napoleon was on his Russian campaign, it excelled even the military portraits of Gros in its vibrancy and action. The reception of its sequel,

178

Wounded Cuirassier Leaving the Field, was more uncertain. Exhibited at the time when Napoleon was imprisoned in Elba, it is redolent of defeat. It was not the frank topicality of the work that dismayed the critics; they were concerned more that the brilliance and vividness of the 'Chasseur' had been replaced by leaden tones and a subdued design.

The *Wounded Cuirassier* also taxed the critics by its scale. Since *Officer of the Chasseurs* had been exhibited as a portrait, there had been little objection to its being life-size. However, it was felt to be inappropriate that the *Cuirassier*, a mere genre piece, should have been painted on a scale reserved for weightier themes. Géricault, however, was to persist in treating the unheroic with all the gravity and dimensions formerly reserved for history painting.

The contemporary disillusion which Géricault monumentalized here was soon to be reinforced for him by a private torment. For around this time he began a near-incestuous liaison with the young wife of his maternal uncle. The diplomacy of Géricault's father managed to prevent the scandal becoming known outside the family, but within it the rift was irreparable. He began to find the 'terrible perplexity into which I have recklessly thrown

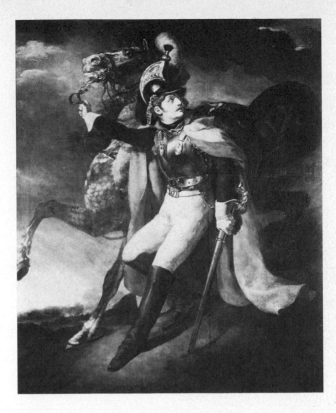

178 GÉRICAULT *Wounded Cuirassier Leaving the Field* 1814

myself' unbearable. His decision to go to Rome in 1816 was taken as much to escape his predicament as to complete his artistic education. Having failed to win the Prix de Rome, he left in the autumn of that year as a private student. In little more than a year he had been driven back to Paris – and to his mistress – by depression and loneliness.

If it did not solve his personal dilemma, Géricault's stay in Rome certainly enhanced his artistic potential. He was overwhelmed by the inner energy of Michelangelo's figures and the unsuspected vigour to be found in certain classical statues. He also found a modern subject that seemed capable of receiving these impressions, the popular race of riderless horses that took 181 place along the Corso in Rome every year at carnival time. It was his intention to paint an immense, thirty-foot canvas on the theme, and during his last six months in Rome he was preoccupied with making studies for it. These show a gradual narrowing down of interest from the general bustle of the event to the single action of conflict when Roman peasants are struggling to keep the excited horses in control just before the start of the race.

235

179 DELACROIX *Dante and Virgil in Hell* (detail of 187)

180 DELACROIX *Algerian Women in their Apartment* (detail of 190)

The final preparatory study is clearly based on a classical frieze in its design, in its profiling of forms, and even in the way all the individual features have become generalized. Perhaps there is a direct tribute to the horsemen of the Parthenon frieze, which had been brought to England by Lord Elgin in 1806 and which Géricault knew from plaster casts. Yet it is a classicism on the point of disruption. The horses are savage beasts, struggling to break loose. And while the underlying design is clear, its lines are broken up by the lighting. Instead of articulating the figures, light falls across them in arbitrary diagonals. The foreground man and horse are caught by a sunbeam, in a brief moment of equilibrium; but around them in the shadows are more frenzied silhouettes.

177 Géricault shared the Romantic fascination with the horse as an image of superhuman energy. A recurrent theme in his art from the time of the *Officer of the Chasseurs*, it also grew from personal proclivities. For he was himself a fanatical horseman, and in his last desperate years a series of reckless riding accidents hastened his untimely death.

Soon after Géricault left Rome he abandoned this painting; perhaps he felt it was too timeless and formal to startle the Salon. He now began to frequent the jovial, faintly Bohemian milieu of his master's son, Horace Vernet, entering into its stylish concern for the bizarre and the topical: for the political and social undercurrents of a world without momentous events. Like Horace Vernet and their mutual friend Nicolas-Toussaint Charlet (1792–1845), he turned to the new and rapid journalistic technique of lithography to chronicle the debris of the Napoleonic campaigns. Yet unlike his colleagues he dwelt in his scenes of the campaigns not on the humorous or the anecdotal but upon brutality and degradation.

Géricault's obsession with violence may have been temperamental; but it was also an attempt to make an unheroic age aware of the existence of extremes. And just as he was drawn by the vivid sense of *reportage* that could be gained from lithography, so he found that news stories provided him with appropriately sensational subject-matter. Already in 1817 he was turning to such sources in search of a suitable theme for the work with which he intended to dominate the next Salon. At first he considered using a current scandal, the brutal murder of a former provincial magistrate, Fualdès, in which it was suspected that an ultra-Royalist gang had been involved. He made a number of designs for this, but abandoned it in favour of a slightly older scandal which seemed capable of more epic dimensions.

183 The story of the shipwreck of the *Medusa* on 2 July 1816 had even more serious political implications than the Fualdès affair, since it implied governmental incompetence. The *Medusa*, flagship of a convoy carrying French soldiers and settlers to the colony of Senegal, had run aground off

238

181 GÉRICAULT *Race of the Riderless Horses* c.1817

West Africa, largely as a result of the ineptitude of the captain, a returned royalist émigré. As there had been insufficient lifeboats, 149 men and one woman were forced to board a makeshift raft, which it was intended would be towed by the lifeboats. However, the crews of these, in their eagerness to reach the shore, soon cut the raft adrift. There followed fifteen days of terrors, which included mutiny, cannibalism and a bitter moment of false hope at the sighting of a ship from their convoy, the *Argus*, which failed to notice them. When the raft was eventually found by the *Argus*, only fifteen of the 150 were still alive.

The Government tried to cover the whole incident up. The captain received a lenient sentence, and when two of the survivors, the doctor Savigny and the engineer Corréard, tried to sue for compensation, they were dismissed from Government service. Savigny and Corréard published a book which became a sensation throughout Europe.

Géricault met Savigny – possibly through Horace Vernet – and worked at the project for eighteen months. It was the kind of immense undertaking

that most artists would have contemplated only with the support of a Government commission. Even for Géricault, a man of means, it was a strain on his resources. He hired a studio especially to work on the vast canvas; and the confined space made its impact all the more overpowering to those who came to visit him at work. Delacroix, after seeing the picture there, found himself breaking involuntarily into a run down the street.

Géricault took some time to decide on which moment of the disaster to depict, toying with such violent and morbid incidents as the mutiny and the outbreak of cannibalism. In the end, however, he chose a less horrific but more emotionally distressing event; the first sighting of the *Argus*. The picture itself shows a gradual crescendo from despair to false hope. In the foreground a brooding figure sits among the dead. Behind him other survivors gradually turn to face the horizon; two are waving their shirts. But the ship they are hailing is a tiny speck, hardly discernible between the dark rolling waves. It is clear that they must be invisible to it; and some have already sunk back into a desolate torpor.

This ebb and flow of moods is controlled by a composition that combines movement with precision. The final design has replaced the classical frieze by a series of diagonals moving up from the foreground towards the divergent apexes of mast and group of waving figures. Instead of a surface unity there is a sense of dispersal as the light picks out the distinct actions of the separate groups: and the sense of randomness is enhanced by the way in which the figures involved in the main incident are turned away from the spectator. Yet the position of every figure is so precisely thought out, so clearly described, that the conflicting gestures are held in a coherent pattern that has the powerful simplicity of truly monumental art. As in the *Race of the Riderless Horses*, the semi-nude figures are posed academy studies. These victims of fifteen days adrift show no emaciation. Their bodies are grand and vigorous, turning the sensation of the moment into a timeless drama.

181

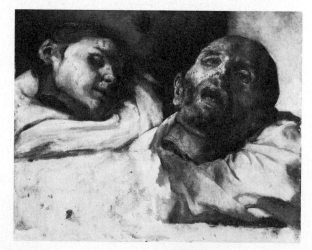

182 GÉRICAULT
Severed Heads 1818

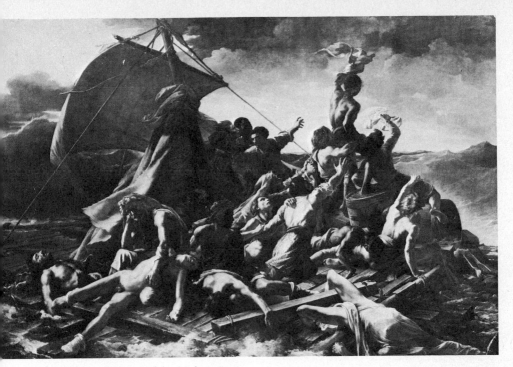

183 GÉRICAULT *The Raft of the Medusa* 1819

Yet for all his careful planning and use of generalized forms, Géricault's picture gains an actuality from his obsessiveness. The dead and diseased bodies of the foreground were derived from studies that Géricault had made in his studio of dead bodies and severed limbs gathered from the hospital and the morgue. Like the picture itself, these represent an amazing feat of control, of clear-sighted description in the face of the extreme. None of them was directly used for the final picture, but their lurid presence can be felt in it, from the dead bodies in the foreground to the bruised green and purple tones of the sky.

To Géricault's bitter disappointment the reception of his work was not so much hostile – it was prominently reviewed, and the artist was awarded a medal by the Government – as tepid. Most criticism was of a niggardly kind – complaining that Géricault had dared to treat 'genre' on a monumental scale, or that the colours were too dark, or that the record of the incident was not sufficiently faithful: all remarks that failed totally to appreciate the new direction that Géricault was attempting. The Government medal, too, was a way of acknowledging the artist without approving his work. All

182

241

suggestions that the work should be acquired by the State were pointedly ignored until after the artist's death.

Even Géricault's friends could not understand why the mildly favourable reception of the work caused him so much distress. When the artist Gérard asked him what it was that he wanted, he replied 'what I want is the trial of misfortune'. Nothing could show up the bankruptcy of society more than the way it had responded to his affront.

Géricault's picture received a somewhat more enthusiastic reception in London, at the Egyptian Hall, Piccadilly, in 1820. There a dislike of the Davidian school and a less strict insistence on the decorum of the genres could lead to a more liberal appreciation of the way 'the bold hand of the artist has laid bare the details of the horrid facts with the severity of Michelangelo and the gloom of Caravaggio'. Géricault went to London for the exhibition, and became one of the first of the younger French artists to respond to the spirited spontaneity of Lawrence, Ward and the landscape painters.

The visit brought no relief from his obsessions. In London he was attracted not only by the British passion for sport, but also by the image of a city in the throes of an unprecedented urban expansion. The city which Gautier was later to call the 'native town of *spleen*' was already in the grip of that horrifying process of dehumanization that was to fascinate so many artists.

184 GÉRICAULT *Draymen at the Adelphi Wharf* 1821

185 GÉRICAULT *The Cleptomaniac*

To record this Géricault turned once again to lithography, in an unsuccessful 184
effort to make a commerical success out of a medium that was still a novelty
in England. Like his scenes of the Napoleonic campaigns, these images show
figures persisting in a world that has lost all human scale or relevance.

Géricault returned to Paris in December 1820, still exhausted in mind and
body from the exertions of the *Medusa*. He was never to undertake another
major work; but his unflinching observation never left him. He could still
produce works as remarkable as the series of portraits of madmen and 185
madwomen for his friend the psychiatrist Georget, one of the earliest
specialists to see madness as a disease that could respond to sympathetic
treatment. However, one should not overestimate the extent of Georget's
advances. Just as the 'natural philosopher' of the day could still find a use for
the descriptive penetration of the artist, so psychology was still at that stage
where it could be supposed that inner disturbance could be diagnosed from
external features. More sophisticated than Lavater, Georget nevertheless still
sought to classify madness through physiognomic observation. And while
Géricault's portraits of mental patients – of which five now survive – are

different from those used by Georget in his book *De la folie* (1820), it has been suggested by Klaus Berger that they were used as demonstration material in courses on pathology. In the sympathy that they arouse these works exceed the bounds of medical illustration as the *Medusa* rises above pictorial journalism. Yet in both cases the emotion grows out of the frankness of the observation, out of the ability to record without flinching. The portrait illustrated here does not epitomize kleptomania (or is it homicide? – the confusion over the title makes its own point about Georget's theories). But it is an incomparable evocation of a man preoccupied and debilitated by his own inner obsessions. No other artist of the period but Goya could capture the world of derangement with such insight; but while Goya seeks to invoke the mental state, Géricault proceeds always from a clear description of actual appearances.

183 As his death approached, Géricault felt, characteristically, that he had failed. His *Medusa* seemed too incomplete a record of his aspirations. Yet in its strange morbidity, its heroic desolation, it provided an authentic alternative at last to the school of David. He had created a path for the Romantics to follow, and had resolutely shown that the bizarre and the topical were not simply a matter for the minor genres, but were of central importance to an age of disenchantment.

Eugène Delacroix

The year in which Géricault died, 1824, was that in which Delacroix (1798–1863), as he put it, 'was enlisted willy nilly into the Romantic coterie',
186 as a result of his contribution to the Salon of that year, *The Massacre of Chios*.

This timing has made it customary to see him as a successor to Géricault, a Titian to his Giorgione – the longer-lived survivor who brought the young innovator's work to fruition. Delacroix certainly learned a lot from Géricault (and was deeply moved by the tragedy of his death), but he was never particularly close to him either personally or artistically. Géricault, passionate and unstable, threw himself into the immediate and topical with obsessive vigour. Delacroix, on the other hand, concealed all emotion
12 beneath an iron control. With the exception of *Liberty Leading the People*, he painted nothing that had overt bearing on contemporary France. Most of his scenes were from history and literature, and those that were modern were set in distant lands. His exploration of violence and sordidness never interfered with the purely pictorial thrill of brilliant paint surfaces and vibrant colour harmonies. Only one sentiment seems ever to have rivalled these concerns as a motivation in his work: and that was *spleen*, a Baudelairean sense of tedium that can be felt lingering even in the most impassioned of his paintings, and
180 which is unmistakable in the *Algerian Women*.

244

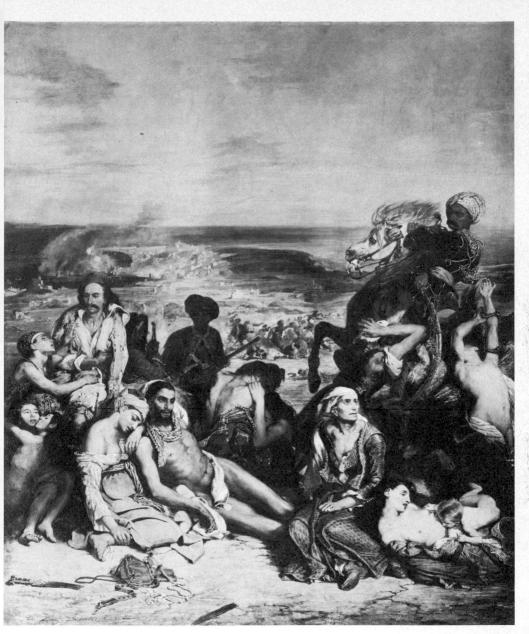

186 DELACROIX *The Massacre of Chios* 1824

For Baudelaire it was this disengagement that made Delacroix supreme among living artists. He supposed that it was the outcome of disillusion, that a soul of passion was hidden beneath the enchanting exterior, that he was 'a volcano artistically concealed beneath a bouquet of flowers'. Yet the artist was so great a master of concealment that even now Baudelaire's statement remains no more than a supposition. The diaries and letters reveal little more than the surface of his uneventful life. In them he is polite, courteous, highly intelligent and full of sensibility; yet he never drops the mask. When reading Baudelaire's translation of Edgar Allan Poe's fantasies he was led to reflect on the distance between them and his own inclinations:

'In these truly *extraordinary* – I mean *extra-human* – conceptions, there is the fascination for the fantastic which may be an attribute of some temperaments from the North or elsewhere, but which is certainly not in the nature of Frenchmen like ourselves. Such people only care about what is beyond nature, or extra-natural, but the rest of us cannot lose our balance to such a degree; we must have some foundation of reason in all our vagaries.'

Of the French paragon of Romanticism, Victor Hugo, he complained that 'he never came within a hundred miles of truth and simplicity'; and when he was himself hailed as the 'Victor Hugo of painting', he retorted 'I am a pure classicist.' Similarly, he regarded the music of Beethoven, 'the man of our time . . . romantic to the supreme degree', as worthless, especially when compared to that of his own hero, Mozart. He explained that where Beethoven is 'obscure and seems lacking in unity, the cause is not to be sought in what people look upon as wild originality, the thing they honour him for; the reason is that he turns his back on eternal principles; Mozart never'.

Yet, for all his insistence on control and reason, Delacroix's art is redolent of the *material* of Romanticism. He may have been more intelligent and more perceptive than the other painters of his generation, but he certainly shared their predilections.

Unlike Géricault, he did not begin to train as an artist until after the fall of the Empire. Yet he, too, had nostalgic memories of its past glory, for during this time his family had been relatively influential and wealthy. His father, who died in 1804, had been Minister of Foreign Affairs; and there was a rumour, too, that his real father had been that supreme diplomat and *éminence grise*, Talleyrand. The year of Napoleon's defeat was also that of the death of Delacroix's mother. He entered the Restoration young, impoverished and with only an elder sister to provide any guidance.

Trained, like Géricault, in the studio of Guérin (which he entered in 1815), Delacroix was fully committed to the painting of *grandes machines*. From the start he was anxious to obtain Government commissions, and felt, unlike

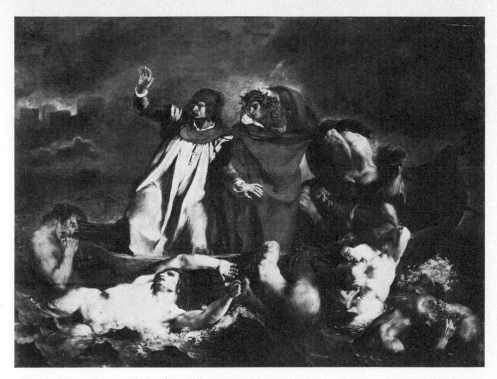

187 DELACROIX *Dante and Virgil in Hell* 1822 (see also 179)

Géricault, no compunction about working on those allegories and religious themes that were the staple of State patronage at the time. Nothing better expresses the difference between Géricault's and Delacroix's attitudes than the younger artist's début at the Salon, the *Dante and Virgil* of 1822. This 179,187 picture paid homage to the *Medusa* in its air of nautical disaster. Yet instead of a contemporary event, Delacroix chose a scene from Dante's *Inferno*, showing the moment when the poet is rowed across the 'murky pool' towards the infernal city in the company of Virgil. The literary source had been fashionable since the outlines produced by Flaxman three decades previously; and in its handling of the raking light and foreground display of nudes *à la* Michelangelo this is a perfect Academy piece. Furthermore, the darkened tones are made far more attractive than the lurid greys and greens of the *Medusa*. The fiery city of Dis provides a rich glow in the background; the greens of the foreground are enlivened by the red of Dante's headdress and the russet of Virgil's cloak; and the whole of this central area is brought into a chromatic balance by the shaded blue of the cloak of Phlegias, the

247

oarsman. Such harmony already shows that concern for purely pictorial problems that was to dominate the work of his later years.

Dante and Virgil was an official success. It was bought by the Government, and hailed by the influential critic Adolphe Thiers as evidence of genius. More important still, it was praised by Gros, who called Delacroix a 'subdued Rubens' and allowed him to study in his studio, where he could become familiar with those masterly propaganda paintings of the Empire which could no longer be shown in public.

Delacroix's next major exhibit, at the Salon of 1824, was awarded a gold medal (albeit second class), and was acquired again by the Government for display in the Galerie du Luxembourg. But there was more to disturb in *The*
186 *Massacre of Chios.* This picture of the defeated Greeks in a recent battle in the Greek War of Independence was not subversive, but it was topical. More disconcerting than this was its negativism. Gros, in chagrin, dubbed it *The Massacre of Painting.* For although Delacroix had profited – as he later
40 confessed to Alexandre Dumas – from studying Gros's *Plague at Jaffa*, he had reversed the principles on which that picture is based. *Chios* is a painting of anti-climax. The defeated await death, or slavery, with indifference. There is suffering and misery, but no villains and no heroes. Stendhal accused the artist of having made a massacre seem like a plague. Certainly there is nothing in this scene to connect it with *Marat* or the *Medusa*, and only Baudelaire could discern in such nonchalance a 'terrifying hymn in honour of doom and irremediable suffering'.

The muted lethargy of this picture is perhaps a comment on the vagaries of fate: Delacroix himself provides no clue. In his personal life he was already adopting the undemonstrativeness of the Anglophile 'dandy', and it is significant that this picture marks the point at which his art begins to show a debt to the techniques of English painters. For shortly before the picture was
136 exhibited he saw *The Haywain* of Constable, the work that was to be shown with such success at the Salon of that year. As Delacroix himself told Théophile Silvestre, the sight of the freshness of this picture caused him to rework parts of his own canvas; and both the background and the immediate foreground show a new lightness. When he later went to visit Constable in England, Delacroix was most impressed by the way that the English artist used broken colour – in particular to enliven his greens – and this technique also accorded with his own observations of the methods of Rubens.

Delacroix's interest in the brightness and informality of English art was enhanced by his own acquaintances in Paris, notably Richard Parkes
188 Bonington (1802–28). A member of a Nottingham lace-making family which settled in France when he was eighteen, Bonington was a pupil of Gros in 1820–22. Yet this fully Parisian training did not prevent him from

being to his French contemporaries a representative of English art. His penchant for watercolour certainly added to this impression, and the brilliance and lightness of his style accorded with all that was to be expected of his countrymen. Delacroix later wrote to Théophile Thoré: 'Nobody in this modern school, or possibly even before him, has had that lightness of touch which particularly in watercolour, makes his pictures as it were like diamonds that delight the eye, quite independently of their subject or of any representational qualities.'

In England in 1825 Delacroix ran into Bonington, whom he already knew slightly, and the two became firm friends. Later in Paris they shared a studio, and Delacroix watched the Englishman carefully to achieve a similar expertise. Their common interest in exotic subject pieces developed apace.

Bonington was also looking for a more extreme kind of literature to excite his imagination. In the late 1820s he shared the current fascination with the exoticism of Byron's poems and Goethe's *Faust*. In his lithographed illustrations to the latter – which were published in 1828 – he responded to the Gothicism of the theme with astonishing vigour, producing scenes that surpassed in emphatic angularity anything attempted in this line by German illustrators. Byron, however, captured his imagination more extensively. Delacroix's own obsession with Greece seems largely to have stemmed from his admiration for Byron and for the poet's part in the Wars of Independence; and the artist constantly heightened Byron's excesses.

This was certainly the case with the picture that Delacroix referred to as his 'second massacre', the *Death of Sardanapalus*, which was the largest and most challenging of the six canvases that he submitted to the Salon of 1827. 189

If *Chios* had caused consternation, *Sardanapalus* produced an uproar. *Chios* 186 had, nominally at least, been a subject of sympathy. *Sardanapalus* depicted nothing but selfish destruction. The scene, inspired by Byron's play, shows a sybaritic Assyrian potentate who, defeated by insurgents, has himself burned on a funeral pyre. In Byron's play Sardanapalus seeks only to bring peace and plenty to his land, and his suicide forms a heroic conclusion to the story. He steps on to the pyre alone, and is then joined in death voluntarily by Myrrha, his favourite concubine. Delacroix changed all this, replacing it with an orgy of destruction, in which the king reclines impassively.

The theme – with its extremes of cruelty and indifference – is expressed by cacophony. The tilted diagonals destroy any sense of coherent space. The colours are violent and full-blown: each one makes the others more febrile. The white flesh of the concubines becomes pliant and helpless against the clashing reds of the bed and draperies and the black skin of the Negro slave. In the midst of the confusion is the vibrating discord of the yellow elephant's head on the bed corner and the blue of a concubine's headdress.

As with the *Chios*, it is hard to discern Delacroix's intentions. There is something frantic in the work's excesses, and it is tempting to see Delacroix himself in the impassive figure of Sardanapalus. The enclosed make-believe of the scene certainly has more than a hint of the voyeur at the brothel about it. Yet the curious inconsequentiality of the scene brings the attention back in the end to the technical achievement. For Delacroix has succeeded here in bringing the utmost confusion and discord under his control.

Delacroix never again painted so subversive a subject. Apparently he received an official warning; but the rejection of extremes seems also to have accorded with his own personal development. From now on he was to use ambiguity and irony for more evasive purposes.

There could be few more neatly balanced gestures from this point of view than that of the large painting that he submitted to the Salon of 1831, *Liberty Leading the People*. The subject here is a celebration of the Revolution of the previous year, which had led to the régime of the 'Bourgeois King', Louis-Philippe, who was committed to a constitutional monarchy. Typically, Delacroix took no part in the fighting, but when the outcome was clear he set out, like so many other painters, to celebrate it. 'I have undertaken a modern subject, a barricade', he wrote to his brother, a general, 'and if I have not conquered for my country, at least I will paint for her.'

Altogether the Salon of 1831 contained twenty-three celebrations of the events that had brought the new King to the throne; among these Delacroix's was unique for its lack of idealization. Even the figure of Liberty, as she rushes forward in her Phrygian cap with a gun in one hand and the tricolour in the

188 BONINGTON *The Colleone Monument, Venice* 1826

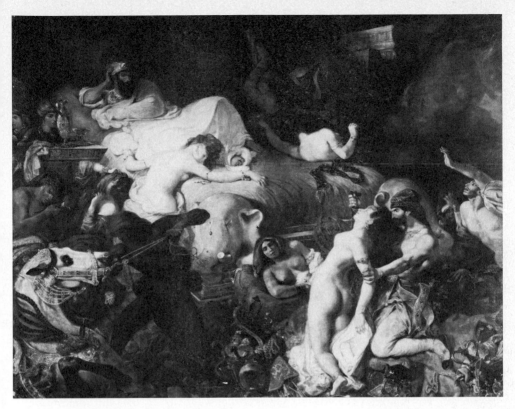

189 DELACROIX *Death of Sardanapalus* 1827

other, is no frigid allegory: she is a very different woman from the objects of pleasure in *Sardanapalus*, but she is still full-blooded and sensuous. What was more disconcerting to most people was the rabble she was leading. Delacroix was taken to task for having taken his models 'from the populace, rather than from the people'. There were no figures in the work that the genteel visitors to the Salon could have identified with; even the man in the top hat is clearly no gentleman. Implicit in the work was an unpleasant reminder: the Revolution that benefited the bourgeoisie was fought by a less fortunate class.

Despite such disturbing implications, the picture was unquestionably in the heroic mould, and under the control of a noble design. Viewed from near to the ground, among the dead soldiers, the diagonals rise triumphantly towards the centrally placed tricolour. Perhaps, as the critic Gustave Planche suggested, Delacroix was moved most by a desire to monumentalize the topical, to make 'at a distance of five months, a barricade that is at the same time true, beautiful and poetic'. In any case, one cannot accuse him of a secret

sympathy for the populace, who are represented here with emphatic coarseness. For Delacroix was a confirmed conservative and a firm supporter of the Government of Louis-Philippe (who appointed him to the Légion d'Honneur for this work, bought it, and locked it away), and received the majority of his large monumental commissions under its aegis.

Through his contacts in official circles, he travelled with the entourage of the Count de Mornay, Envoy to the Sultan of Morocco, in 1832. French colonialist ambitions in North Africa were accompanied by a wave of Orientalism among artists; Horace Vernet, too, the nostalgic chronicler of Napoleonic power, became involved in this new area of French ambition.

Although Delacroix fully entered into the exoticism of his subject, the journey was most influential in confirming directions in which he was already developing. It helped emphasize his traditionalism, for like Rousseau and the travellers of the eighteenth century, he found reminiscences of antiquity in the modern 'primitive'. 'I have Greeks and Romans on my doorstep . . .', he wrote in Tangier; 'I now know what they were really like; their marbles tell the exact truth, but one has to know how to interpret them, and they are mere hieroglyphs to our wretched modern artists.' In his search for 'permanence' it was the nobility and *gravitas* of antiquity that he emulated, not its details.

But above all, the journey intensified his awareness of the sensuous means of art: colour and light. His *Algerian Women in their Apartment*, exhibited at the Salon of 1834, was relatively small in size and devoid of all historical pretensions; and yet he himself recognized it as one of his most important works. It shows how colours could be made effective without the cacophony of a *Sardanapalus*. Here they float in half shadows. The door in the background, with its juxtaposition of the complementaries of red and green, creates a powerful base for the rose and dull gold tints of the women. Delacroix had been aware when painting *Dante and Virgil* of the way complementary colours strengthen each other when placed in close proximity, and had used small touches of them in the drops of water and in the foreground bodies. But now he seemed to become more fully concerned with the creation of a surface pattern of colours which would mutually intensify each other and in which both lighted and shaded areas would have a positive effect. Possibly he was influenced in this development by the theories of the chemist Eugène Chevreul, on the simultaneous effect of complementary colours; but if so, he never pursued these ideas to the point of a dogmatic statement, as the Neo-Impressionists were to do. The use of colour remained for him a matter of personal sensibility. Nor, indeed, did his concern for colour effect ever become independent of association. In the *Algerian Women* it suggests a heightened sensuality – Renoir swore he could

180, 190

179

252

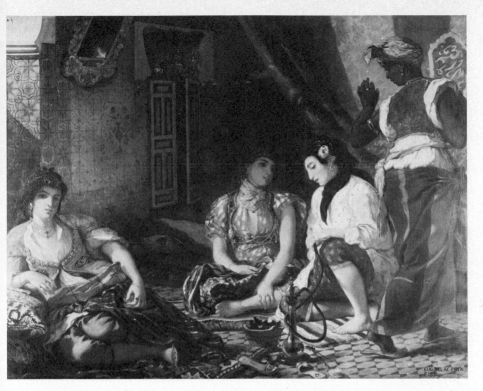

190 DELACROIX *Algerian Women in their Apartment* 1834 (see also 180)

smell the incense in it — which is all the more disturbing when combined with the lassitude of the women as they lounge in their confined chamber. As they sit there in their monotonous world, one staring at the spectator with insolent listlessness, they exude an eroticism that is more pervasive than that of the submissive odalisques of Ingres. Baudelaire recognized in them a thoroughly contemporary claustrophobia; that of the nineteenth-century Parisienne pent up in her bourgeois domesticity. In the same year Delacroix painted a portrait – his only contemporary figure in an interior – that seems 191 to share the same lassitude and longing. In it, Madame Simon, the wife of the ballet-master of the Paris Opéra, rests listlessly in a darkened interior through which a single sunbeam cuts like a knife, giving a startling expectancy to the harmless tedium of the scene.

The year after his return from Morocco saw the first of a series of commissions for monumental decorations that were to occupy him for nearly all the rest of his life. Thiers, the critic who had acclaimed *Dante and* 179 *Virgil* in 1822, was now Minister of the Interior and in a position to arrange

253

such undertakings. Delacroix started with the Salon du Roi in the Palais Bourbon (1833–37) and then went on to paint the library of the Palais du Luxembourg (1840–47), the ceiling of the Galerie d'Apollon in the Louvre (1849–51), and the Salon de la Paix in the Hôtel de Ville (1850–53). Finally he painted the Chapelle des Anges at Saint-Sulpice, a work that was completed in 1861. Only ill-health prevented him from executing more, and Delacroix must be counted the most fortunate of all mural painters in the nineteenth century, both for having as much work as he pleased and for having such a free hand in the planning of it. These schemes are the most distinguished of the century; and in pursuing them he gradually moved away from the preoccupations of the Romantics. For he was not only a traditionalist in considering monumental painting to be the highest of artistic endeavours; he also sought to keep close to what he considered to be his pictorial inheritance – the art of the Venetian High Renaissance and the Baroque. By the 1840s the quest for 'permanence' had become the leading obsession. And in the sense that colour, staging and composition in these murals show a reworking of time-honoured conventions, he lived up to his claim to be a 'pure classicist'.

For all their traditionalism, these later works are more than a coda to the art of the past: there is a wistfulness about the subjects that is all his own. Those for the library of the Palais Bourbon, on the theme of the benefits of learning and the arts, begin with Orpheus bringing the gift of civilization and end with the destruction of this inheritance by Attila the Hun. In the colour, too, there is a tendency towards deep reds, blue-greens and pale gold that suggests an all-pervasive nostalgia.

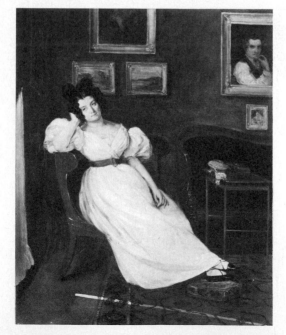

191 DELACROIX
Portrait of Madame Simon 1834

192 DELACROIX
Jacob Wrestling with the Angel
1856–61

Nostalgia, like ennui, is a motionless mood. Perhaps this is why his calm works are the most alluring. This is certainly so at Saint-Sulpice, which shows three instances of angels in combat on behalf of the Lord. On the ceiling is a celestial battle – St Michael defeating Satan – while the two large paintings on the walls are of earthly battles. On the right is the expulsion of the Syrian interloper Heliodorus from the Temple in Jerusalem by a 'mysterious horseman'. On the left is the curious incident of 'Jacob wrestling 192 with the Angel': the struggle lasted all night and ended when the angel put Jacob's leg out of joint at daybreak and said 'your name shall no longer be Jacob but Israel, because you strove with God and with men, and hast prevailed'. Delacroix interpreted this as 'a symbol of the ordeals which God sometimes imposes on his elect'; and whereas the other two paintings concentrate on dramatic action, this one emphasizes reflection.

As a prototype for the design of *Jacob* he chose Titian's *St Peter Martyr*, a picture that was then held to be the origin of historical landscape for the way in which it used a dominant outcrop of trees to articulate the violent murder

255

that was taking place in its lower foreground. However, whereas Titian's martyrdom is enhanced by the splayed violence of the trees, the vast oaks in Delacroix's picture seem to disperse the struggle that takes place at their side. It is the still-life in the foreground that provides a formal link for the colours of the brightly lit areas. The trees, looming in the semi-darkness of the receding night, emphasize the quiet poignancy of the moment before dawn which brings with it both defeat and divine revelation.

193, 198

Delacroix's distaste for self-styled Romanticism is understandable – especially after 1830 when it became an 'official' style, dispensed by such as Delaroche and Horace Vernet. His own predominant interests, his explorations of colour and symbolism, reached – like those of Turner – far beyond the level of propagandist imagery and sectarian controversy. Yet – unlike Turner – he maintained a detachment which leaves his art with a sense of loss. Perhaps, as Baudelaire believed, the passions smouldered still beneath the impeccable surface; perhaps the volcano had long since been extinct. Either way, his fastidiousness and disdain inhibited that sheer credulity, the urge to paint at the edge of vision, that Turner, Goya, Friedrich and Géricault all showed. He was Romanticism's greatest casualty.

The Romantic genre

Romanticism as a critical and stylistic notion applies to such major figures as Géricault and Delacroix in varying and complex ways; Romanticism as a credo, as an artistic label voluntarily assumed, belongs essentially to lesser artists, and to their choice of subject. There is no mistaking the untrammelled emotion, the extremes of ecstasy and fear proclaimed in their art.

It is this interest that makes the representation of animals – purely sensate beings – so much the vogue. Géricault and Delacroix both explored themes of animals struggling or confronting the elements; and the genre was sufficiently in demand for artists like James Ward and Horace Vernet to become specialists in it. Even in sculpture – the medium normally considered least conducive to Romanticism – there emerged a distinguished group of

207

animaliers, notably Antoine-Louis Barye (1796–1875).

Horace Vernet (1789–1863), the third famous artist in this distinguished family of painters, combined a brilliant expertise with a straightforward boldness. Making his début in the same Salon as his friend Géricault, that of 1812, he was immediately employed by the Imperial family to paint an equestrian portrait of Jérôme Bonaparte. Unlike Géricault, Vernet remained a committed Bonapartist. His brash Napoleonic subjects made him a suspect figure under the Restoration, and it was not until the July Monarchy of 1830 that, like so many other Romantic leaders, he began to receive State patronage. Aptly, he had to paint Napoleonic battle scenes at Versailles.

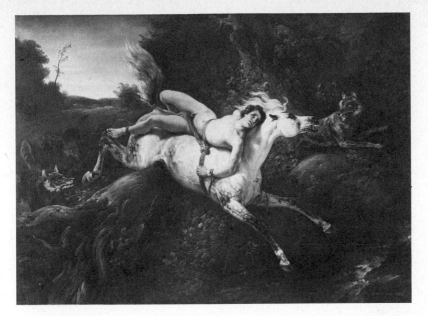

193 HORACE VERNET *Mazeppa* 1826

For Vernet the artist's job was one of simple description; and, while he might choose the most dramatic subjects, he chronicled them with the pedantry of a topographer – a habit that Baudelaire found painfully vulgar. Nothing could contrast more strongly with the imaginative impact that Byron had on Delacroix than Vernet's illustration of a Byronic theme, *Mazeppa*. The story of a Polish page who was punished for making love to 193 his Queen by being strapped naked to a wild horse which was then driven into the woods would seem to offer even more opportunity for an exhibition of cruelty and violence than *Sardanapalus*. Yet although Vernet has chosen the moment when Mazeppa is in danger of being torn to pieces by wolves, he has treated the whole as if it were painted on porcelain.

The concern for sensation brought a new piquancy to traditional genre painting. The small interiors that Delacroix, Bonington and Eugène Deveria (1805–65) were painting in the 1820s took on something of the colourful fantasy of what was called the *style troubadour*. Deveria practised this in the most harmless manner, and was for a time considered the leading 'Romantic' history painter – but his place in the popular affection became usurped in the 1830s by Paul Delaroche (1797–1856), who achieved a more sustained and persuasive rhetoric. It was on the *intimiste* level that Deveria's fantasy was at its best. Pictures like *Young Girls Seated* are full of a playful amorousness. 196 Nothing could be further from the lassitude of Delacroix's *Madame Simon* 191

than the tender abandon of these slumbering damsels. The sparkling paint casts them in a magical glimmer as the young man – half voyeur, half Prince Charming – intrudes.

Such scenes – more wish-fulfilment than *reportage* – are invoked through a pervasive charm of handling. It was a mode that was soon emulated outside France. In England the distinguished Sir David Wilkie (1785–1841) – renowned throughout Europe for the anecdotal appeal of his Dutch-inspired interiors of Scottish peasant life – was inspired to set out in new directions after his tour of the Continent in 1825. Much impressed by Spanish, Netherlandish and north Italian art, he developed aspirations towards the grand manner that took most of his contemporaries by surprise. Yet despite his Old-Master prototypes these scenes have all the imaginative modernity 195 of Romantic genre. *Josephine and the Story Teller* was based on a much-repeated fable about the Empress Josephine, in which she was supposed to have had her fate foretold when a young girl. There is an air of expectancy in the scene, in the glances and the fluttering rhythm of the paint. The feeling is so intimate that – despite the grandiose arch in the background – it is hard to realize that this is a large-scale picture, with the figures nearly life-size.

In all the pictures in the Romantic mode there is an emphasis on the sensuous in both the theme and the handling. It is hardly surprising that the sensory nature of death, too, should be emphasized – whether as a dream-like ecstasy of the kind to be found in Novalis' *Hymns to the Night* or as a rank invocation of fear. The contrast between the classical and medieval concepts of death – the former as a beautiful youth, the latter as a fearful skeleton – was brought into prominence by the artistic conflicts of the period. The sentimental, classically inspired image of death survived in the sorrowful and tranquil youths that appear so frequently on the monuments of Neo-classical sculptors like Canova and Flaxman; while the horrifying skeleton appears in such apocalyptic scenes as Benjamin West's *Death on a Pale Horse* or Alfred 194 Rethel's grim moralities. In subject painting the heroic death, the *exemplum virtutis*, had almost vanished by the mid nineteenth century, while murders, executions and suicides were rife. Few of these could have played more on

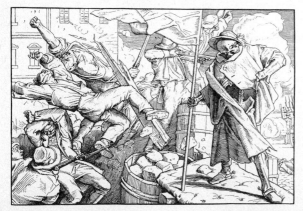

194 RETHEL *Another Dance of Death* 1848

195 WILKIE *Josephine and the Story Teller* 1837

196 DEVERIA *Young Girls Seated* 1827

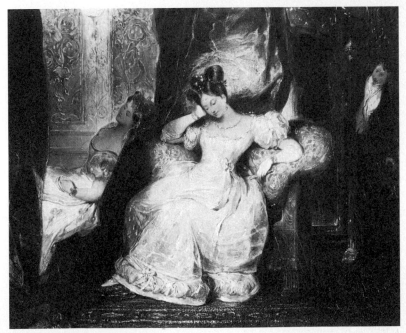

197 WIERTZ
Buried Alive
1852(?)

197 contemporary fears than the *Buried Alive* of the bizarre Belgian megalomaniac Anton Wiertz (1806–65) – a theme inspired by the danger of death certificates being incorrectly issued during cholera epidemics.

Historicism

The unclassical fascination with the evocation of a specific location had already become clear during the Empire both in the contemporary history paintings of Gros and in the medieval interiors of such pioneers of the *style troubadour* as Richard. But the generation of the 1820s was gripped by a new historicism, a historical awareness and longing for authenticity, that helped to make Sir Walter Scott the most popular novelist of the age. And just as Scott heightened his vivid account of the past with an equally vivid presentation of character and situation, so the historicist had to provide an image that was as convincing emotionally as it was historically.

198 While few would agree today with Henry James that Delaroche's *Princes in the Tower* combines 'a reconstruction of a most ancient history with the most subtle modern psychology', this work certainly shows why this artist's appeal to a historically conscious age was so strong. Delaroche had been a pupil of Gros, and, like Delacroix, evolved much of his sense of staging and atmosphere from this master. Yet everything in his art is subordinated to description. Not only are the features of the scene described with a minuteness equal to that of Horace Vernet, but the whole composition is generated by the narrative. It is a picture about uncertainty. All is tilted at an

260

198 DELAROCHE
*Princes in the
Tower* 1831

angle, and as the two young princes huddle together in the darkness, the younger of them looks round in apprehension. What he fears he cannot see. But our attention is guided by the dog to the door, where the crack of light is partly obscured by the shadow of their oppressor, Richard III.

Romantic subject painting had from Géricault onwards taken the role of the outsider when it cast a comment on contemporary politics, and it has often been cited as a dilemma for the Romantics that they should in the 1830s have found themselves on the side of the Government. Only Delacroix, through his negativism, preserved his individuality. Heinrich Heine was probably going too far when he detected in Delaroche's *Princes in the Tower* a picture showing the victims of usurped power – a reference to the recent 'usurpation' of power in France by Louis-Philippe; and yet, in assuming a political relevance, he was doing no more than follow a line of thought that had been dominant in historical painting since the time of David.

Outside France, Romantic history painting assumed similar political overtones. In Belgium the head of the school, Gustaav Wappers (1803–74), made his reputation with the bizarre and politically charged *Burgomaster Van der Werff of Leyden Offering his Own Body for Nourishment to the Citizens during the Siege of the City in 1576* – a macabre reminder of the Netherlands' struggle for independence, painted at a time when the Belgians were about to revolt against the union with Holland that had been forced on them in 1815. He mirrored the revolutions of the French Romantics, overthrowing the classicism of the émigré David in favour of the 'national' style of Rubens.

Even in Germany, where Nazarene art had become unequivocably aligned with the established regimes, the new historicism took on a subversive role. In Düsseldorf – the centre of the rapidly expanding industrial region that was at the same time witnessing the activities of the young Karl Marx – the most popular young history painter was Carl

199 Friedrich Lessing (1808–80). His *Hussite Sermon* still has the symmetrical composition of a Nazarene painting; but it is crammed with the detail of the fourteenth century and with evocative effects of lighting and smoke. What made it so popular was not simply its immediacy, but the way in which this depiction of a medieval insurrection against the Catholic Church – it shows the followers of the Bohemian heresiarch Jan Hus at their devotions – mirrored a contemporary dispute about Church authority in the Rhineland.

It is appropriate that artists like Vernet, Wappers and Lessing, who were so programmatic in their art, should have been partisan in their politics. This was indeed an indication of their aesthetic limitations. For in linking themselves so unquestioningly to a cause, they sacrificed that individualism and independence of action that had been characterized so effectively by Schiller as the ultimate responsibility of the artist.

199 LESSING *Hussite Sermon* 1835

'Romanticizing the world'

Limitations

This book began by stating that there was in the early nineteenth century a self-conscious Romantic movement. It then set out to examine not only the history of the movement, but also its *claim*: namely, that the term 'Romantic' could be applied to all that was unique about the contemporary world.

In this final chapter it is the limits of this claim that will be considered. First, in relation to the society of the time, then to the arts themselves, and lastly to the new form of modernity, Realism, that emerged in the 1840s and which, in its turn, was hailed as the successor to Romanticism.

In social terms, the Romantic claim was of the most extreme. For it was the Romantics who first asserted that artists were the mouthpiece of their age, what Shelley called the 'unacknowledged legislators of the world'. The artist owed this position to his creative imagination, through which he reached to a level of understanding that transcended all rational enquiry.

'The world must be romanticized, that the original meaning may be rediscovered', exclaimed the poet Novalis in 1799, adding by way of explanation 'in so far as I give to the commonplace a lofty meaning, to the ordinary an occult aspect, to the well-known the dignity of the unknown . . . I am romanticizing them'.

This assertion gained respectability in the writings of A.W. Schlegel, where it was explained that such 'romanticizing' was in fact a striving towards the spiritual commensurate with the rise of Christianity. By 1820 the notion had received further status by being absorbed into the philosophy of Hegel. For just as Hegel's view of history was one that saw a dialectic development of man from the material towards the spiritual, so he saw this development as being objectified in the work of art. And in his scheme 'Romantic' art became the unique representative of the modern Christian era.

Such notions certainly added considerable authority to the Romantic claim of relevance, of spirituality and modernity. And while Hegel, like Schlegel, used the word 'Romantic' to refer to art throughout the post-classical world, both firmly directed their attention to those eras – notably the Middle Ages and the Baroque – in which the antique influence had been

least manifest. They gave to Romantic art a historical location of its own, made it the inheritor of a totally modern Western European tradition.

The most important outcome of this was that Hegel succeeded in bringing the notion of the relevance of culture to human development into the mainstream of historical thought. And, indeed, the degree to which one finds it helpful to think of the early nineteenth century in terms of Romanticism depends on the extent to which one can accept the notion of cultural history that the Romantics themselves pioneered.

It is certainly a tempting notion, and one can readily bring to mind innumerable associations between the strictly cultural movement of Romanticism and the major events of the age. In political terms the emphasis on ethnic identity gave great stimulus to the emergent nationalist movements. The assumption of an indigenous culture and the assertion of a national identity ran parallel, for example in Germany during the Wars of Liberation (p. 109), in Belgium during the uprising of 1830 (p. 261) and in England in the early Victorian era (p. 126). Similarly, the Utopian vision of the Middle Ages, as the root of modern European society, was a powerful stimulus to anti-Utilitarian economists as different as Carlyle and the young Marx.

It is interesting, too, to see how the Romantic emphasis on change and development coincided with a rapid expansion in the study of the natural sciences. This was the time of such major innovations as the first scientific theory of evolution (that of the Frenchman Lamarck), and the establishment of the new discipline of comparative anatomy (one of whose pioneers was Carl Gustav Carus, the doctor and amateur artist who was a follower of Caspar David Friedrich). The concern for the understanding of the actual life force also took on startling new directions. On the physical level there were discoveries like that of Galvani that muscles could be stimulated by an electrical impulse (in itself the basis for Mary Shelley's fable of the 'Modern Prometheus', *Frankenstein*), and on the psychological level a growing curiosity about irrational behaviour, evident in the new and more sympathetic treatment of insanity.

Naturally such associations remain in the sphere of speculation. The kind of interaction one is talking about is too complex, too full of counter-currents and turbulences to be calculable. Yet they can at least represent the scope of the engagement between the Romantics and their world. And it is as well to remember too that Novalis, the poet who sought to 'romanticize' the world through his creative faculties, was in his professional life gauging it in his capacity as a surveyor and mining engineer.

Novalis himself in fact felt genuinely inspired by the potential of his profession, and in his unfinished masterpiece *Heinrich von Ofterdingen* wrote a

200 TELFORD Craigellachie Bridge 1815

eulogy to the miner – the discoverer of hidden treasures in the bowels of the earth – that must have made ironic reading for anyone familiar with the abject status to which these craftsmen had sunk in the developing industrial areas of Britain. Most engineers had more tangible reasons for taxing their fantasy. The daring new technological advances – the multiplication of human potential in the mechanized factory, the use of metal to create bridges of unheard-of span and of steam to build a transport system of unthinkable speed – was the outcome of economic incentives that hardly needed the encouragement of any Romantic theory. And while the effect that these new productions had on the imagination of contemporary artists is clear enough (*see* p. 20), the engineers themselves tended to be more constrained than liberated by the stylistic conventions of their day. Thus, when Thomas Telford built an iron bridge at Craigellachie in the Scottish Highlands, he felt 200 it necessary to supplement his sublime achievement with castellations.

Such concessions to current taste were largely perfunctory; but the movement's effect on personal mores was of a different order. The changing styles of costume – that touchstone of social mood – suggest a growing abandonment of constraint. By 1800 the wig, that curious habit that had prevailed since the time of Louis XIII, had been given up; while women's dress had been pared down almost to the point of nudity. And, if a certain formality began to reassert itself during the Empire, natural hair remained, as did the introduction of such lower-class garments as full-length trousers into fashionable male dress. Such changes were as distressing to the old guard as the replacement of the formal intricacies of the minuet by the shockingly intimate variant of a South German peasant dance, the waltz: 'the first step to

seduction', as it was described by a correspondent to the *Gentleman's Magazine* in 1817.

Often Romantic postures had a direct effect on fashion, as when the beau adopted something of the sentient lassitude of the melancholic, or ladies during the Restoration followed the medieval craze by dressing in 'Mary Stuart' costumes. Yet perhaps the most important change was that, even after the mainstream of bourgeois society had reverted to more formal clothes, there remained an alternative, freer style. From the time of the Nazarenes long hair and flowing garments became the hallmark of the aesthetic non-conformist.

Such distinctiveness, of course, had its own significance – a way of emphasizing a much-vaunted independence. And when the Romantic movement dispersed, the habit of separateness remained. The Primitifs, Nazarenes and Ancients were the ancestors of a permanent *avant-garde* that became established in Paris during the 1830s in the disaffected world of the Bohemians. Alienation is one of Romanticism's most lasting legacies.

The hierarchy of the arts

The belief in artistic separateness was intimately connected with the notion that the work of art could provide a unique revelation. And this, in its turn, affected the way in which the arts themselves were evaluated. No doubt every generation plays the game of comparing the different arts, but the Romantics became obsessed with this – particularly when it involved the question of which art expressed most completely the properties of Romanticism.

For them – as for earlier ages – poetry was supreme. But it became appreciated now above all for its evocative and speculative qualities. For Shelley 'the great instrument of moral good is the imagination' and it is poetry that strengthens it 'in the same manner as exercise strengthens a limb'. The emphasis in Romantic poetry was on the symbol, the intensive enigma, while formal structure became a secondary consideration.

To some it seemed that such suggestiveness could be achieved even more effectively by the art that transcended descriptiveness, and was devoted to pure communication: music. From the time of Rousseau – himself a musician – the highest premium was placed on music by those writers and artists who explored the emotive. For Wackenroder, despite his predominant interest in visual art, it was music that was the 'balm of the soul', the inexplicable language that brought man closer to an intimation of the Divine.

The Romantics had no more interest in formal abstraction in music than they had in metric rules in poetry. It was the evocative qualities of pure

266

sounds that led E.T.A. Hoffmann to consider the most Romantic of all artistic forms to be the symphony, that type of music that was free of all descriptive requirements but which had the fullest tonal range. And when Jean Paul remarked that 'no colour is so Romantic as a tone', he was expressing a similar preference.

It is easy enough to see how the music of the day supported such an interpretation. It was indeed the age in which the symphony came into its own. That exploration of effect and breaking of conventions that Delacroix so deplored in the 'Romantic' Beethoven (p. 246) became the dominant tendency in nineteenth-century music; and it is appropriate that this art should have been the one in which Romantic notions remained influential the longest.

Such preferences were also reflected in pictorial art. For theorists, from A.W. Schlegel to Théophile Gautier, were agreed that painting was the true visual medium for Romanticism. The reasoning – embodied in Schlegel's Berlin lectures of 1802–03 and not materially altered since – was as follows.

Of the three principal visual arts – painting, sculpture and architecture – painting was the only one that was two-dimensional and which therefore relied completely on illusion for its effect. The point becomes all the more clear when painting is compared directly with sculpture, since both are descriptive arts. Sculpture reproduces the material aspect of its subject, its solidity and volume; while painting evokes, through colour and contour, the intangibles of light and space. Thus painting can suggest the ethereal or the impassioned without the encumbrance of materiality.

For the historically minded Schlegel this observation took on further implications. Taking up a remark made by the Dutch theorist Hemsterhuis in relation to the sculptors Bernini and Pigalle – that in the ancient world painting was too much like sculpture and in the modern world sculpture is too much like painting – Schlegel developed the idea of each art being uniquely suited to one of these ages. The ancient world had achieved a physical, but not a spiritual, perfection, and it was this that the 'material' art of sculpture was capable of presenting. The modern world, on the other hand, having achieved through Christianity a direct revelation of the eternal, tends always towards a more aspiring and immaterial expression of the kind that can be intimated in a painting. It is this that explains as well the difference between the Greek temple and the Gothic cathedral.

The status of sculpture

The remarkable thing about this account is not so much its viability – it is, after all, not so hard to imagine an evocative sculpture, and few would wish to censure Bernini now for his 'painterliness' – as that it was taken so

seriously by contemporaries. On a popular level the problem was stated frequently in terms similar to those of Mrs Jameson who, in her travelogue of Germany in 1833, exclaimed: 'Now why should not sculpture have its gothic (or Romantic) school as well as its antique or classical school?' and came back to Schlegel's equation. And when, in 1866, Gautier published his obituary of the Romantic movement he not only pronounced the failure of sculpture to participate in it, but gave again as the reason the inability of this tangible medium to escape the materiality of the antique: 'One can say that this art, so noble and so pure, thrives even today on the antique tradition, and that it has degenerated every time it has moved away from it.'

It is certainly true that the classical tradition prevailed in nineteenth-century sculpture more consistently than in painting. The most internationally famed sculptor of the turn of the century, the Italian Antonio Canova (1757–1822), may have flirted with sentiment in his works, but this remained an overtone. Both the imagery and technique of his art – as can be seen from the figure of mourning death from his monument to Maria Christina in Vienna – were faithful to the classical tradition. Nothing interferes with the clarity of his surfaces – a point all the more striking when his sculptures are compared to the few paintings that he executed, which are

201

268

201 CANOVA Monument to Maria
Christina, Vienna, 1799–1805

202 THORWALDSEN *Shepherd Boy*
1817

203 FLAXMAN *Come Thou Blessed.*
Sketch for monument to Agnes
Cromwell, 1800

rich in *sfumato*. Canova's successor in reputation, the Dane Bertel
Thorwaldsen (1770–1844), was even more assiduous in his adherence to
antique purity. And this move towards greater simplicity makes a striking
contrast to the direction indicated in Neo-classical painting by the
progression from the directness of David to the intricacies of Ingres. What is
more curious is that Thorwaldsen, like Canova, was a great enthusiast for
those revivalist tendencies in the visual arts represented by the Nazarenes.
Canova, indeed, arranged for the Germans to be employed by the Vatican,
while Thorwaldsen – who spent most of his working life in Rome – became
a close friend of Overbeck and Schadow.

202

 Yet although those sculptors who came into contact with Christian-
Romantic circles seem to have accepted the material limitations of their own
art, this hardly precluded the practical use of sculpture for religious
monuments. Thorwaldsen himself devoted a large part of his life to creating
a religious cycle for the Church of Our Lady in Copenhagen; although the
style in which they were created owed little to modern Europe. The English
sculptor John Flaxman certainly attempted a more ambitious solution to the
problem. Throughout his life he took an active interest in medieval artefacts,
and went so far as to proclaim that the art of sculpture had been ruined in

203

204 RUDE
Maréchal Ney 1852–53

England by the Reformation. Yet although his numerous relief monuments show a certain Gothicism in their patterning, there is nothing of the medieval in the morphology of his figures or in his free-standing work. This situation was repeated throughout the monumental sculpture of the period. While artists and patrons became fully prepared to sanction the use of full Gothic effects in architectural ornament, anything that counted as free-standing sculpture remained classical in style. One can see such a discrepancy in the contrast between the figures and decorative elements in the Scott Memorial in Edinburgh.

87

Outside the sphere of Christian-Romanticism there was certainly a more spirited attempt to create a sculpture for the modern age. Yet the outcome was hardly decisive. If one excepts the kind of spontaneous modelling that certain painters turned to from time to time as an extension of their pictorial interests – as in the case of Géricault and Daumier – there was really little created that was strikingly sensory or evocative. The greatest French sculptor of the period, François Rude (1784–1855), propagated an uneasy eclecticism. Trained in a rigorous classical tradition, and a strong admirer of David, he devoted the first part of his career to executing strictly classical works. An ardent Bonapartist, he went into exile in Brussels in 1814, like

270

David himself, and did not return to France until 1828. In the 1830s he certainly tried to come to terms with the current fashion of Romanticism – executing remarkably expressive reminders of the former heroism – notably in the *Departure of the Volunteers of 1792* on the Arc de Triomphe. He also made a series of statues of heroic figures from French history, such as Joan of Arc and Maréchal Ney, that were unrepentantly in the modern mode, showing the figures in the costume of their day rather than in classical drapes. Yet these concessions to current historicism did not undermine a pervading sense of structure. Spiritually Rude still belonged to the Davidian age of dramatic classicism, and in his later years he reverted almost completely to the themes and styles of antiquity. It was left to lesser figures like P.J. David d'Angers (1788–1856) to give themselves over completely to modernity. D'Angers, a kind of Horace Vernet of sculpture, built up a reputation by touring Europe making portraits of famous contemporaries. Very much interested by the physiognomic theories of Lavater, he would dash down spirited and exaggerated accounts of the features of Men of Genius. It was the kind of reportage that was in its element with such a subject as the daring virtuoso Paganini; yet even here the bulging brow, flowing hair and impassioned expression amount to little more than high-class journalism – and, it must be added, a journalism without the perception of Daumier's magnificent evocation of the mythical *agent provocateur* 'Ratapoil'.

204

205

206

205 DAVID D'ANGERS *Paganini* 1830

206 DAUMIER *Ratapoil* 1850

Yet if such experiments lent substance to Gautier's claim that excursions away from classicism had failed to establish any comparable alternative, there was one genre which can be said to have come into its own. This was animal sculpture, whose leading light was A.-L. Barye (1796–1875). A pupil of Gros, Barye certainly lived up to his master's sense of staging. From an early age he devoted himself to themes that enabled him to explore violence and conflict. In his emphasis on the non-human, the sensory, and the significance of what had been till then thought of as a minor genre, Barye was certainly subversive. Like Géricault, his 'minor' subjects gain authority from the precision with which they are observed and controlled. And there is a sense of continuous exploration in them not simply in the complexity of their movement, but also in the unresolved relationship between such animal passions and the human emotions of the spectator. In this sense they take on a symbolic function of a kind envisaged by Carl Gustav Carus when he supposes that the 'only kind of Romantic sculpture' that could arise would be in the 'symbolic' genre of the *animalier*.

207

207 BARYE *Lion Attacking Serpent* 1832

208 HUGO *The Broken Bridge* 1847

Illustration

If painting was preferred to sculpture by the Romantic theorists on account of its ability to suggest the intangible, these were not, as has already been said, looking for an art of total abstraction. Association was their key interest. And more important to them than any hierarchy of the arts was the way in which the arts related to each other. For comparisons between them seemed to enhance their sensory qualities. The doctrine of synaesthesia – in which one sensation will set off another in a different sphere; a sound evoking a colour, or a colour a taste or smell – became highly attractive for this reason, and artists like Philipp Otto Runge prefigured that union of the arts, the 'Gesamtkunstwerk', that was to be explored by Wagner and by the Symbolists.

Given this interest in association, it is perhaps hardly surprising to find so much interest being taken during the period in illustration. There was, it is true, a commercial incentive in the rapidly expanding book trade for an increasingly literate populace and the innovation of cheaper and more rapid reproduction techniques like lithography and wood-engraving. Yet there was also a concern for the whole concept of illustration, for the way which one art could respond to an image evoked by another. And just as musical analogies were frequently invoked by writers, so many took an active

interest in the way in which pictorial techniques could suggest literary ideas.

There is no more extreme example of this than the drawings of Victor Hugo (1802–85). For this great writer drawing was a constant release, and while he attempted some topographical work in his earlier days he came increasingly to use the medium to express that 'vague and indefinable fantasy' that he considered to be the epitome of Romanticism. For this he worked with an experimental freedom that few professionals could emulate. He told Baudelaire that he used all kinds of mixtures – charcoal, soot, sepia and even coffee grounds – to gain the rich textures and lively movement of his monochromes.

Théophile Gautier was convinced that Hugo would have been a great painter if he had not been a great writer, and compared his fantastic effects of lighting to those of Goya and Piranesi. Yet however much the impenetrable shadows and startling bursts of luminosity may be reminiscent of these artists, these works lack their curiosity and attentiveness. Hugo does not

209 MERYON
Le Petit Pont
1852

210 CRUIKSHANK *London Going Out of Town* 1829

press in them to the edges of his experience, as Goya did, but lets the imagery – the castles, ruins, storms and condemned men – flow freely from his random markings. His art is akin to fire-gazing, in which memories and fancies are allowed free play.

Hugo's imagery had no parallel among the professional illustrators. Yet there were many who fully explored the associative range of their art. Hugo's own favourite black and white artist was the etcher Charles Meryon (1821–68), an ailing man who worked in monochrome on account of his colour blindness. Meryon turned to art in the late 1840s after having previously spent several years at sea. He remained something of an outsider – even, Baudelaire hinted, an innocent – in the Parisian milieu. Never able to reconcile himself to the stigma of his own illegitimacy, Meryon was obsessed with the sinfulness of the modern world. Yet much though he hated the contemporary Babylon, he could not ignore it, and his *Etchings of Paris* are full of an incomparable spleen. He uses the etching needle with devastating precision to bring out the latent menace of the city. The Cathedral of Notre-Dame becomes a macabre, looming presence, and the Seine beneath it a satanic river which featureless figures surround like lost souls. It seems all too inevitable that he eventually lost his reason.

Meryon's sense of the supernatural was haunted by tragedy, yet the art of association also encouraged a more playful fantasy. The savage

209

275

211 GRANDVILLE *The Metamorphoses of Sleep* 1844

metamorphoses that Gillray introduced into the political· cartoon mellowed in England after the Napoleonic wars into more innocuous puns. It is a change that can be seen in the art of the illustrator George Cruikshank (1792–1878), who began his career in the Gillray style and had already turned by the 1820s to social comment. His *London Going Out of Town* was a protest against a proposed encroachment on Hampstead Heath. Yet the sheer enjoyment of an anthropomorphic game – the turning of building tools and materials into a relentless army and haystacks and trees into despairing fugitives – has taken over from any sense of outrage. In later life Cruikshank was to pay dearly for such levity, when he tried to convince his contemporaries of the seriousness of his campaign against the evils of drink.

210

For the French illustrator Grandville (1803–47), the development was reversed. For after beginning his career as a satirist he turned under the growing impact of censorship towards a world of pure make-believe where one thing turns continuously into another. In such works as *Another World* the spectator is continuously presented with one new way of looking after another. It is a dream without end, an infinity of metamorphoses that turn out to be merely marking time.

169

211

276

Realism

Like so many other artists in the 1840s, Grandville was suffering from a sense of stagnation. In political terms, the predicament was clear enough, and led to its own solution in the Revolution of 1848. Pictorially, the promise of 1830 had soon withered, for the much-vaunted liberty that would allow Daumier the honesty of publishing a searing exposure of a senseless massacre of working-class citizens asleep in their beds by Government troops was gradually stifled through censorship. And the outcome was not simply the make-believe of Grandville, but also an alternative dissatisfaction with fantasy. The 'Bohemian' world of the 1830s – so picturesquely recounted by the novelist Henri Murger in his *Scenes of Bohemian Life* (1847–49) – was in fact a world of abject squalor, a last refuge for those who had set out to embody the Romantic notion of the artistic individual. It was they who paid the full price for the attempt to 'romanticize the world'; their discontent gave the lie to the textbook Romanticism of the Salon.

And finally, there was, as well as criticism, assertion. When the young Gustave Courbet (1819–77) came to Paris at the age of twenty-one, and determined to teach himself to paint, he entered a milieu in which Romanticism was the norm. For such an egotist the lure was irresistible, and,

212

212 DAUMIER *Rue Transnonain* 1834

213 COURBET *The Stonebreakers* 1849

during the decade in which he gradually found his feet, he produced innumerable dramatizations of young men – frequently himself – rendered with a fashionable Spanish bravura. Yet by the end of the 1840s Courbet had emerged with an art that, while remaining utterly personal and largely autobiographical, could present its themes without make-believe. *The Stonebreakers* does not seek to excuse, condemn or plead for these labourers at their backbreaking toil. Turned away from us, their faces obscured, the young boy and old man proceed with their tasks unmindful of us. There is no rhetoric here, only an uncompromising presence. And the man who could turn bravura into honest description was also the man who reversed the Romantic assessment of his own métier by proclaiming that 'painting is an essentially *concrete* art' and that 'imagination in art consists in knowing how to find the most complete expression of an existing thing, but never in inventing or creating that thing itself'.

The association of Courbet's artistic revolution with a political one fitted with a neatness that one has come to expect from French nineteenth-century art. Yet if the confluence of Realism with Radicalism in 1848 seems to follow on an example already set by Neo-classicism in 1789 and Romanticism in 1830, it is at least as remarkable that this strictly Parisian phenomenon should

278

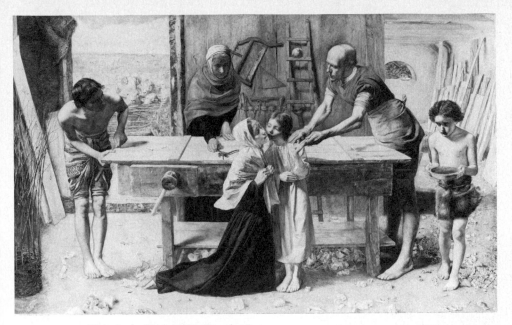

214 MILLAIS *Christ in the House of his Parents* 1850

have been matched in Berlin by Adolph Menzel's (1815–1905) uncharged reportage, and in London by the emergence of a new brotherhood who turned the tenets of revivalism on their heads. For the Pre-Raphaelites did not look to the past for mystic piety, but for 'truth to nature'. And when John Everett Millais (1829–96) painted his *Christ in the House of his Parents*, 214 which shows the Christ Child with a wound that prefigures his suffering on the cross, he could not have been further from the Nazarenes in his meticulous description of an actual carpenter's shop, or his use of an actual carpenter's body for that of Joseph. For the early Victorians such an unidealized presentation of a devotional scene amounted to blasphemy.

Unlike Courbet, the realism of the Pre-Raphaelite Brotherhood still had strong narrative and moralizing elements. For one of the members, Dante Gabriel Rossetti (1828–82), make-believe too was to remain a potent force. In the decade following the uproar over Millais's 'realist' Holy Family he wove a world out of Dante and the Arthurian legends that gave a very different meaning to the term 'Pre-Raphaelite'. A year after his death Ruskin was to call him the leader of the 'romantic school in England', explaining that by 'romantic' he meant 'the habit of regarding the external and real world as a singer of Romaunts would have regarded it in the Middle Ages'.

Rossetti was in fact not so much a Romantic as a romancer, enveloping his
215 life with dreams. In *Beata Beatrix* he sought to conceal the sad fate of his
neglected wife (who had died, probably by suicide, the year before) by
portraying her as Dante's beloved at the moment of death. Yet his Beatrice is
not the beatific vision of the medieval poet. Her languorous, doom-laden
eroticism betrays the stifling encirclement of the Victorian aesthete.

Unlike Novalis, Stendhal, Goya or Turner, the idealists of the later
nineteenth century used their art not to explore life but to retreat from it.
Dreamers and Realists were no longer the same people; and in the separation
of the one from the other lay the tacit admission that the attempt to
romanticize the world had been abandoned.

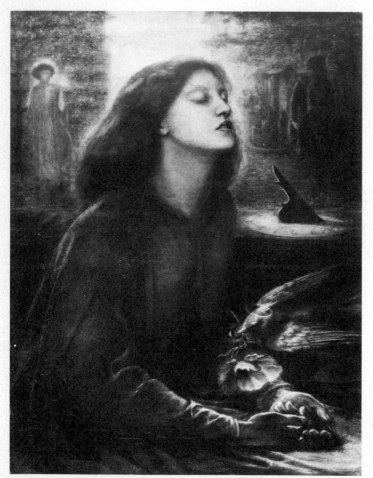

215 ROSSETTI
Beata Beatrix c.1863

Sources

In most cases the authors and titles of sources quoted are mentioned in the text. The majority of these are available in current publications. The following is a list of sources not identified in the text, or difficult to come across.

PAGE 14
'Romantic situated'; Turner, J.M.W., 'Midland' Sketchbook, 1794, p. 5. British Museum, London, Turner Bequest XIX.
'Romantic [branches]': Gilpin, William, *Observations Relative Chiefly to Picturesque Beauty, Made in the Year 1776 . . .*, vol. I, London, 1786, p. 116.
Schelling on Heidelberg Castle: notebook, 1796; in Sandkühle, H.J.,

F.W.J. Schelling, Stuttgart, 1970, p. 66.

PAGE 15
'Grotesque and romantic': Gilbert White, 1776, in Clay, R.M., *Samuel Hieronymus Grimm*, 1941, p. 75
'Wild and romantic' (*sauvages et romantiques*): Rousseau, J.J., *Les Rêveries du promeneur solitaire*, 1778, 5e promenade.
Klinkowström on the Riepenhausen brothers: Runge, P.O., *Hinterlassene Schriften*, Hamburg, 1840 (reprint Göttingen, 1965), II, 272–73.

PAGE 16
Crabb Robinson on Flaxman: Robinson, H.C., Diary, 7 May 1825, ms. in

Dr Williams' Library, University of London.

PAGE 50
Powell on Fuseli: Powell, N., *Fuseli, 'The Nightmare'* (Art in Context Series), London, 1972, New York, 1973.

PAGE 69
Vogt on Boullée: Vogt, A.M., *Boullées Newton-Denkmal, Sakralbau und Kugelidee*, Basel, 1969.

PAGE 173
Crabb Robinson on Turner's *View of Dieppe*, shown at Royal Academy in 1825: Robinson, H.C., Diary, 7 May 1825, ms. in Dr Williams' Library, University of London.

Further Reading

General
The art of the period in Europe is covered in Novotny, E., *Painting and Sculpture in Europe, 1780–1880* (Pelican History of Art), Harmondsworth, 1960, New York, 1973; that of England in Boase, T.S.R., *English Art 1800–70* (Oxford History of English Art), Oxford, 1959; that of America in Novak, B., *American Painting of the Nineteenth Century*, New York, 1969. All of these have extensive bibliographies.

The following exhibition catalogues are invaluable both for commentary and reference:

The Romantic Movement (Arts Council), Tate Gallery, London, 1959.
Romantic Art in Britain, Paintings and Drawings 1760–1860, Philadelphia Museum of Art, Philadelphia, 1968.
The Age of Neo-Classicism (Arts Council), Royal Academy, London, 1972.
De David à Delacroix, Grand Palais, Paris, and Detroit Institute of Art, Detroit, 1974.
La Peinture en Allemagne à l'époque du romantisme, Orangerie, Paris, 1976.

The most convenient compendium of writings by artists, critics and theorists of the period is Eitner, L., *Neo-Classicism and Romanticism*, 2 vols., Englewood Cliffs, N.J., 1970. Among

the most useful modern editions of writings are:

Reynolds, Sir Joshua, *Discourses on Art* (ed. Wark, R.), London, 1966, New Haven, Conn., 1975.
Wakefield, D., ed., *Stendhal and the Arts*, London, 1973.
Baudelaire, Charles, *Art in Paris, 1845–62* (ed. Mayne, J.), London, 1965.
Herbert, R.L., ed., *The Art Criticism of John Ruskin*, New York, 1964.

Some major studies of themes within the period are:

Todd, R., *Tracks in the Snow*, London, 1946.
Klingender, F.D., *Art and the Industrial Revolution*, 1947.
Praz, M. *The Romantic Agony*, 2nd edn., London, 1950, New York, 1970.
Williams, R., *Culture and Society*, London, 1958, New York, 1970.
Hofmann, W., *The Earthly Paradise*, New York 1961, (as *Art in the Nineteenth Century*) London, 1961.
Brookner, A., *The Genius of the Future*, London, 1971.
Haskell, F., *Rediscoveries in Art*, London, 1976.

In the following chapter bibliographies, books are listed in accordance with the sequence of topics discussed.

1 Attitudes and ambiguities: pp. 9–26
There have been numerous studies of the term 'Romantic' by literary critics, notably Smith, L.P., *Four Words*, Society for Pure English, Tract 17, 1924; Wellek, R., *Concepts of Criticism*, New Haven, Conn., 1963; Frye, N., ed., *Romanticism Reconsidered*, New York, 1963. There has, however, been no systematic investigation of the term as applied to the visual arts.

2 Hope and fear: pp. 27–54
Honour, H., *Neoclassicism* (Penguin 'Style and Civilization' series), Harmondsworth, 1968, New York, 1973.
Rosenblum, R., *Transformations in Late Eighteenth Century Art*, Princeton, N.J., 1967.
Burke, E., *A Philosophical Enquiry into the Origin of our Ideas of the Sublime and Beautiful* (ed. Boulton, E.T.), London, 1958, New York, 1975.
Hussey, C., *The Picturesque*, London, 1927.
Schiff, G., *Johann Heinrich Füssli*, Zürich, 1973.
Taylor, R., *Stubbs*, London, 1971.
Waterhouse, E., *Gainsborough*, London, 1958.

3 The heroic era: pp. 55–99
Schiller, F., *On the Aesthetic Education of*

Man (ed. Wilkinson, E.M., and Willoughby, L.A.), Oxford, 1967.

Pérous de Montclos, J.M., *E.L. Boullée*, Paris, 1969.

Brookner, A., *Greuze*, London and Boston, Mass., 1972.

Hautecœur, L., *Louis David*, Paris, 1954.

Blunt, A., *The Art of William Blake*, London, 1959, New York, 1974.

Bindman, D., *William Blake*, London, 1977.

Hill, D., *Fashionable Contrasts*, Greenwich, Conn., 1965, London, 1966.

Harris, E., *Goya*, London 1969.

Gudiol, J., *Goya*, Barcelona, 1971.

4 The medieval revival: pp. 100–31

Rosenblum, R., *Ingres*, New York and London, 1967.

Andrews, K., *The Nazarenes*, Oxford, 1964.

Clark, K., *The Gothic Revival*, London, 1928, Atlantic Heights, N.J., 1970; still the best introduction.

Frankl, P., *The Gothic: literary sources and interpretations throughout eight centuries*, Princeton, N.J., 1960.

Germann, G., *Gothic Revival in Europe and Britain; Sources, Influences and Ideas*, London, 1972, Cambridge, Mass., 1973.

5 Transcendent landscapes: pp. 132–83

Berefeld, G., *Philipp Otto Runge zwischen Aufbruch und Opposition*, Uppsala, 1961.

Sumowski, W., *Caspar David Friedrich-Studien*, Wiesbaden, 1971.

Grote, L., *Die Brüder Olivier*, Berlin, 1938.

Grigson, G., *Samuel Palmer: The Visionary Years*, London, 1947.

Turner 1775–1851, exhibition, Royal Academy, London, 1975.

Gage, J., *Colour in Turner*, London, 1969.

Reynolds, G., *Turner*, London and New York, 1969.

6 'Natural painture': pp. 184–221

Leslie, C.R., *Memoirs of the Life of John Constable, R.A.* (ed. Mayne, J.), London, 1951.

Fleming-Williams, I., Parris, L., Shields, C., *Constable*, exhibition catalogue, Tate Gallery, London, 1976.

Gage, J., *A Decade of English Naturalism*, London, 1971.

Watercolours by Thomas Girtin, exhibition, Victoria and Albert Museum, London, 1975.

Bazin, G., *Corot*, Paris, 1973.

7 Sensation: pp. 222–62

Friedlaender, W., *David to Delacroix*, Cambridge, Mass., 1952.

Garlick, K., *Sir Thomas Lawrence*, London, 1954.

James Ward, exhibition, Arts Council, London, 1960.

Delacroix, E. (ed. Wellington, H.), *Journal*, London, 1951.

Eitner, L., *Géricault's Raft of the Medusa*, New York, 1973.

Berger, K., *Géricault et son œuvre*, Paris, 1968.

8 'Romanticizing the world': pp. 263–80

Easton, M., *Artists and Writers in Paris: The Bohemian Idea 1803–67*, London, 1964.

Gautier, T., *Histoire du romantisme*, Paris, 1872.

Georgel, P., *Drawings by Victor Hugo*, exhibition catalogue, Victoria and Albert Museum, London, 1974.

Clark, T.J., *The Absolute Bourgeois: Artists and Politics in France, 1848–51*, London, 1973, Boston, Mass., 1973.

Hilton, T., *The Pre-Raphaelites*, London and New York, 1970.

List of Illustrations

The medium is oil on canvas except where specified. Measurements are given in inches and centimetres, height first.

52 *When the Morning Stars Sang Together . . .* from *The Book of Job* 1823–25. Engraved page 8⅛ × 6½ (20.6 × 16.5). British Museum, London.
53 *Whirlwind of Lovers c.* 1824. Ink and watercolour 14¾ × 20⅞ (37.4 × 52.9). Birmingham Museum and Art Gallery.
72 *Angels Watching over the Tomb of Christ c.* 1806. Watercolour 16⅝ × 12⅜ (42.2 × 31.4). Victoria and Albert Museum, London.
110 *Cottage by a Stream* from Virgil's *Pastorals* 1820. Woodcut 1⅓ × 3½ (3.5 × 8.4). British Museum, London.

BLECHEN, Carl (1798–1840)
134 *Galgenberg c.* 1832. Gemäldegalerie Neue Meister, Staatliche Kunstsammlungen, Dresden.

BONINGTON, Richard Parkes (1802–28)
188 *The Colleone Monument, Venice.* Pencil and wash. Cabinet des Dessins, Musée du Louvre, Paris.

BOULLÉE, Etienne-Louis (1728–99)
43 *Project for a Cenotaph to Sir Isaac Newton* 1784. Ink and wash 15¾ × 26 (40 × 66). Bibliothèque Nationale, Paris.

BRANDOIN, Charles (1733–1807)
14 *Exhibition of Royal Academy Paintings* 1771. Mezzotint. British Museum, London.

BUTTERFIELD, William (1814–1900)
94 *All Saints' Church, Margaret Street, London* 1849–59.

CANOVA, Antonio (1757–1822)
201 *Death with Lion* from the Monument to Maria Christina, Vienna.

CARSTENS, Asmus Jacob (1754–98)
45 *Night with her Children, Sleep and Death.* Black and white chalk on beige 29¼ × 38¾ (74.4 × 98.5). Kunstsammlungen, Weimar.

CHURCH, Frederick Edwin (1826–1900)
131 *Landscape with Rainbow* 1866. 56¼ × 84½ (142.9 × 214). California Palace of the Legion of Honor, Museum purchase, H.K.S. Williams Fund for the Mildred Anna Williams Collection.

CHUTE, John (1701–76)
71 *Library at Strawberry Hill* 1754. Engraving from Horace Walpole, *A Description of Strawberry Hill.*

COLE, Thomas (1801–48)
130 *Youth* from *The Voyage of Life* 1840. 52 × 78 (132 × 198). National Gallery of Art, Washington DC, Ailsa Mellon Bruce Fund.

CONSTABLE, John (1776–1837)
136 *The Haywain* 1821. 51¼ × 73 (130.5 × 185.5). National Gallery, London.
145 *Dedham Vale* 1802. 17⅛ × 13½ (43.5 × 34.4). Victoria and Albert Museum, London.
146 *Borrowdale* 1806. Pencil and watercolour 5¼ × 14⅞ (13.5 × 37.8). Victoria and Albert Museum, London.
147 *Flatford Mill from a Lock on the Stour c.* 1811. 9¾ × 11¾ (24.8 × 29.8). Victoria and Albert Museum, London.
149 *Boat Building on the Stour* 1814. 20 × 24¼ (50.8 × 61.6). Victoria and Albert Museum, London.
152 *Study of Clouds* 1821. Oil on paper on board 9¾ × 11½ (24.8 × 29.2). Royal Academy of Arts, London.
153 Study for *The Leaping Horse* 1825. 51 × 74 (129.4 × 188). Victoria and Albert Museum, London.
154 Sketch for *Hadleigh Castle* 1829. 48½ × 66 (125 × 168). Tate Gallery, London.

CORNELIUS, Peter (1783–1867)
79 *Faust and Mephisto on the Brocken c.* 1811. Ink. Städelsches Kunstinstitut, Frankfurt am Main.
82 *Four Horsemen of the Apocalypse* 1845. Charcoal on paper 185⅞ × 231½ (472 × 588). Nationalgalerie, Staatliche Museen zu Berlin.

COROT, Jean-Baptiste-Camille (1796–1875)
158 *Geneva, Quai des Paquis* 1841. 13⅜ × 18⅛ (34 × 46). Musée d'Art et d'Histoire, Geneva.

COTMAN, John Sell (1782–1842)
141 *Chirk Viaduct c.* 1804. Watercolour 12½ × 9⅛ (31.7 × 23.2). Victoria and Albert Museum, London.

COURBET, Jean-Désiré-Gustave (1819–77)
213 *The Stonebreakers* 1849. 62⅜ × 102 (159 × 259). Destroyed; formerly in Gemäldegalerie Neue Meister, Staatliche Kunstsammlungen, Dresden.

COZENS, Alexander (c. 1717–86)
27 *Ink blot composition* 1785. Ink on paper 9¼ × 12⅛ (23.5 × 30.8). British Museum, London.

COZENS, John Robert (1752–97)
28 *View from Mirabella* 1782–83. Watercolour 9⅞ × 14¾ (25.1 × 37.5). Victoria and Albert Museum, London.

CROME, John (1768–1821)
144 *Moonrise on the Yare* 1811–16. 28 × 43¾ (71 × 111). Tate Gallery, London.

CRUIKSHANK, George (1792–1878)
210 *London Going Out of Town* 1829. Etching with watercolour 7½ × 10⅝ (19 × 27). British Museum, London.

DAHL, Johann Christian Clausen (1788–1857)
157 *Rising Clouds in the Mountains* 1826? 31½ × 22 (80 × 56). Sammlung Georg Schäfer, Schweinfurt.

DANBY, Francis (1793–1861)
163 *Clifton Rocks from Rownham Fields c.* 1822. Oil on panel 16 × 20 (40.6 × 50.7). City Art Gallery, Bristol.

DAUMIER, Honoré (1808–79)
206 *Ratapoil* 1850. Bronze 16⅞ × 5⅞ × 7⅛ (43 × 15 × 18). Louvre, Paris.
212 *Rue Transnonain* 1834. Lithograph 11¼ × 17⅜ (29 × 44). Antoine de Halasz Collection, France.

DAVID, Jacques-Louis (1748–1825)
38 *Oath of the Horatii* 1784. 129⅞ × 167¼ (330 × 425). Louvre, Paris.
39 *Death of Marat* 1793. 65 × 71⅝ (165 × 182). Musées Royaux des Beaux-Arts, Brussels.

DAVID, Pierre-Jean, d'Angers (1788–1856)
205 *Paganini* 1830. Bronze h. 24½ (62). Louvre, Paris.

DELACROIX, Eugène (1798–1863)
12 *Liberty Leading the People* 1830. 102⅜ × 128 (260 × 325). Louvre, Paris.
174 *Christ in the Garden of Olives* 1827. 116 × 143 (294.6 × 363.2). Louvre, Paris.
179, 187 *Dante and Virgil in Hell* 1822. 74⅞ × 96⅞ (189 × 246). Louvre, Paris.
180, 190 *Algerian Women in their Apartment* 1834. 70⅞ × 90⅛ (180 × 220). Louvre, Paris.
186 *The Massacre of Chios* 1824. 175⅝ × 166¼ (422 × 352). Louvre, Paris.
189 *Death of Sardanapalus* 1827. 155½ × 194⅞ (395 × 495). Louvre, Paris.
191 *Portrait of Madame Simon* 1834. Oil on panel 23½ × 19¼ (59.7 × 48.9). Birmingham Museum and Art Gallery.
192 *Jacob Wrestling with the Angel* 1856–61. Oil and wax 281 × 191 (714 × 488). Saint-Sulpice, Paris.

DELAROCHE, Paul (1797–1856)
198 *Princes in the Tower* 1831. 71¼ × 64⅝ (181 × 215). Louvre, Paris.

DEVERIA, Eugène François-Marie-Joseph (1805–65)
196 *Young Girls Seated* 1827. 13 × 16¼ (33 × 41). Louvre, Paris.

HOGARTH, William (1697–1764)
54 *Characters and Caricaturas* 1743. Engraving 7¾ × 8⅛ (19.7 × 20.6). British Museum, London.

HUET, Paul (1803–69)
133 *Landscape with a Lake at Evening (The Storm)* 1840. 37⅜ × 50 (95 × 127). Musée Crozatier, Le Puy.

HUGO, Victor (1802–85)
208 *The Broken Bridge* 1847. Black chalk, ink, sepia and body colour 7⅛ × 8⅛ (18 × 20.6). Maison de Victor Hugo, Paris.

INGRES, Jean-Auguste Dominique (1780–1867)
48 *Dream of Ossian* 1809. Watercolour, ink and gouache 9⅝ × 7⅞ (24.7 × 18.7). Fogg Art Museum, Harvard University.
73 *Mlle Rivière* 1806. 39⅜ × 27½ (100 × 70). Louvre, Paris.

JONES, Thomas (1743–1803)
138 *Pencerrig* 1772. 9 × 12 (22.8 × 30.5). Birmingham Museum and Art Gallery.

JUEL, Jens (1745–1802)
98 *Northern Lights c.* 1790. 12¼ × 15½ (31.2 × 39.5). Ny Carlsberg Glyptothek, Copenhagen.

KEMP, G.M. (1795–1844)
87 The Scott Monument, Edinburgh 1836.

KENT, William (*c.* 1685–1748)
25 Rousham gardens, Oxfordshire.

KERSTING, Georg Friedrich (1785–1847)
168 *Before the Mirror* 1827. Oil on wood 18⅛ × 13¾ (46 × 35). Kunsthalle, Kiel.

KOCH, Joseph Anton (1768–1839)
135 *Schmadribach* 1808–11. 48⅜ × 36¾ (123 × 93.5). Museum der bildenden Künste, Leipzig.

LANE, Fritz Hugh (1804–65)
166 *Brace's Rock, Eastern Point, Gloucester* 1863. 10 × 15 (25.4 × 38.1). Private Collection.

LAWRENCE, Sir Thomas (1769–1830)
176 *Arthur Atterley as an Etonian c.* 1790–91. 49½ × 39½ (125.7 × 100.3). Los Angeles County Museum of Art.

LEDOUX, Claude-Nicolas (1736–1806)
44 Customs house, Paris 1784.

LESSING, Carl Friedrich (1808–80)
199 *Hussite Sermon* 1835. 90½ × 114¼ (230 × 290). Kunstmuseum, Düsseldorf.

LEWIS, George Frederick (1782–1871)
150 *Hereford, from the Haywood: Noon* 1815. 16⅜ × 23½ (49 × 59). Tate Gallery, London.

LINNELL, John (1792–1882)
151 *Study of Buildings* 1806. Oil on board 6½ × 10 (16.5 × 25.4). Tate Gallery, London.
162 *Canal at Newbury* 1815. Oil on canvas on wood 17¾ × 25⅝ (45.1 × 65.2). Fitzwilliam Museum, Cambridge.

LOUTHERBOURG, Philip James de (1740–1812)
10 *Coalbrookdale by Night* 1801. 26¾ × 42 (68 × 106.7). Science Museum, London.

MARTIN, John (1789–1854)
128 *The Great Day of His Wrath* 1851–54. 77⅜ × 119⅜ (197.5 × 303.2). Tate Gallery, London.

MENGS, Anton Raffael (1728–79)
17 *Cleopatra before Octavius* 1760. 118 × 83 (299.7 × 210.8). Stourhead, National Trust.

MERYON, Charles (1821–68)
209 *Le Petit Pont* 1852. Etching.

MESSERSCHMIDT, Franz Xavier (1736–83)
30 *The Worried Man* after 1770. Lead h. 17¾ (45). Österreichische Galerie, Vienna.

MICHEL, Georges (1763–1843)
155 *The Storm.* 19 × 25 (48 × 63). Musée des Beaux-Arts, Strasbourg.

MILLAIS, Sir John Everett (1829–96)
214 *Christ in the House of his Parents* 1850. 34 × 55 (86.4 × 139.7). Tate Gallery, London.

NASH, John (1752–1835)
84 Luscombe, Devon, begun 1799.

NUYEN, Wijnandus Josephus Johannes (1813–39)
132 *Ruin by a River* 1836. 39 × 55½ (99 × 141.5). Rijksmuseum, Amsterdam.

OLIVIER, Ferdinand (1785–1841)
109 *Saturday* 1818–22. Lithograph 7¾ × 11 (19.5 × 28).

OLIVIER, Friedrich (1790–1859)
96 *Withered Leaves* 1817. Ink 8¾ × 11 (22 × 28). Albertina, Vienna.

OVERBECK, Friedrich (1789–1869)
75 *Franz Pforr* 1811. 24⅜ × 18½ (62 × 47). Staatsbibliothek, Berlin.
80 *Sale of Joseph to the Ishmaelites* 1816. Fresco 95⅝ × 119¾ (243 × 304). Staatliche Museen zu Berlin.

PALMER, Samuel (1805–81)
111 *Early Morning* 1825. Sepia drawing 7⅞ × 9¼ (18.8 × 23.2). Ashmolean Museum, Oxford.
112 Sketchbook 1824, page 2. Pencil, ink and watercolour. 4½ × 7⅞ (10.5 × 18.8). British Museum, London.
114 *Self-portrait* 1827. Black chalk, heightened with white, on buff paper, 11½ × 9 (29.1 × 22.9). Ashmolean Museum, Oxford.
115 *A Hilly Scene* 1826–28. Watercolour, pen and tempera (varnished) on panel, 8⅛ × 5⅝ (20.3 × 13.6). Tate Gallery, London.

PFORR, Franz (1788–1812)
78 *Shulamit and Maria* 1812. Oil on wood 13⅜ × 12⅞ (34.5 × 32). Sammlung Georg Schäfer, Schweinfurt.

PIRANESI, Giovanni Battista (1720–78)
19 *Pyramid of Caius Cestius* 1748. Etching 15¼ × 21 (38.5 × 53).
21 *Carcere d'invenzione c.* 1745–61. Etching 16 × 21⅝ (40.5 × 55). Bibliothèque Nationale, Paris.

PRUD'HON, Pierre-Paul (1758–1823)
34 *Georges Anthony* 1796. 39 × 32⅝ (99 × 83). Musée de Dijon.
172 *Justice and Divine Vengeance Pursuing Crime* 1808. 96 × 115 (244 × 292). Louvre, Paris.
173 *Crucifixion* 1822. 109½ × 65 (278 × 165). Louvre, Paris.

PUGIN, Augustus Welby Northmore (1812–52)
8, 9 *Contrasts* 1841. Engravings, from *Contrasts*, 2nd edn.
92 Frontispiece to *An Apology for the Revival of Christian Architecture* 1841.

RAMBOUX, Johann Anton (1790–1866)
90 *The Construction of Cologne Cathedral* 1844. Pencil and watercolour 25⅞ × 42⅛ (60 × 107). Stadtmuseum, Cologne.

REHBENITZ, Theodor (1791–1861)
77 *Self-portrait* 1817. Pencil 7¾ × 6¼ (19.6 × 16). Kupferstich-Kabinett, Staatliche Kunstsammlungen, Dresden.

RETHEL, Alfred (1816–59)
81 Illustration for the *Nibelungenlied*. Woodcut by F. Unzelmann 1840. British Library, London.
194 *Another Dance of Death* 1848. Plate 5. Woodcut. British Library, London.

RICHARD, Fleury (1777–1852)
74 *Louis IX Showing Deference to his Mother* 1808. Arenenberg, Musée Napoléon.

285

RICHMOND, George (1809–96)
113 *Christ and the Woman of Samaria* 1828. Oil on wood $16\frac{1}{2} \times 20$ (42×51). Tate Gallery, London.

RICHTER, Adrian Ludwig (1803–84)
95 *The Harper's Return* 1825. $15 \times 18\frac{3}{4}$ (38×47.5). Gemäldegalerie Neue Meister, Staatliche Kunstsammlungen, Dresden.

RIEPENHAUSEN, Franz (1786–1831) and Johannes (1789–1860)
6 *Life and Death of St Genevieve* 1806. Engraving.

ROBERT, Hubert (1733–1808)
20 *Pont du Gard* 1786. $95\frac{1}{4} \times 95\frac{1}{4}$ (242×242). Louvre, Paris.

ROSSETTI, Dante Gabriel (1828–82)
215 *Beata Beatrix* c. 1863. 34×26 (86×66). Tate Gallery, London.

ROUSSEAU, Théodore-Pierre-Etienne (1812–67)
156 *A Marshy Landscape* 1842. Oil on paper on canvas $8\frac{3}{4} \times 11\frac{1}{2}$ (22.2×29.2). Private Collection.

RUDE, François (1784–1855)
204 *Maréchal Ney* 1852–53. Bronze. Place de l'Observatoire, Paris.

RUISDAEL, Jacob van (c. 1628–82)
15 *Jewish Cemetery* c. 1670. $33\frac{1}{4} \times 37$ (84×94). Gemäldegalerie Alte Meister, Staatliche Kunstsammlungen, Dresden.

RUNGE, Philipp Otto (1777–1810)
99 *Morning* from *The Times of Day* 1803. Pencil $28\frac{3}{8} \times 19$ (72.1×48.2). Kunsthalle, Hamburg.
100 *The Hülsenbeck Children* 1806. $51\frac{1}{4} \times 55\frac{1}{4}$ (130.4×140.5). Kunsthalle, Hamburg.
103 *The Child in the Meadow* 1809–10. Fragment of *Morning*. $12 \times 12\frac{3}{8}$ (30.5×31.5). Kunsthalle, Hamburg.

SALVIN, Anthony (1799–1881)
88 Harlaxton Hall, Lincolnshire 1835. From the North.

SANDBY, Paul (1725–1809)
140 *Distant View of Leith* 1747. Watercolour and pencil $6\frac{3}{8} \times 17\frac{7}{8}$ (16.2×45.3). Ashmolean Museum, Oxford.

SCHICK, Christian Gottlieb (1776–1812)
76 *Sacrifice of Noah* 1805. $98\frac{1}{2} \times 128\frac{3}{4}$ (250×327). Staatsgalerie, Stuttgart.

SCHINKEL, Karl Friedrich (1781–1841)
86 *Study for a Monument to Queen Luise* 1810. Watercolour $26\frac{1}{8} \times 18\frac{5}{8}$ (66.4×47.2). Staatliche Museen zu Berlin, Nationalgalerie.

SOANE, Sir John (1735–1837)
85 Court of Chancery, Westminster 1820–24. Watercolour by J. M. Gandy $22\frac{3}{4} \times 27\frac{1}{4}$ (57.5×69.7). Sir John Soane's Museum, London.

STANFIELD, Clarkson (1793–1867)
127 *The Abandoned* 1856.

STUBBS, George (1724–1806)
32 *Horse Frightened by a Lion* 1770 $39\frac{3}{4} \times 49\frac{5}{8}$ (100×126). Walker Art Gallery, Liverpool.

TELFORD, Thomas (1757–1834)
200 Craigellachie Bridge 1815.

THORWALDSEN, Bertel (1770–1844)
202 *Shepherd Boy* 1817. Copy, 1822–25. Marble h. $58\frac{1}{4}$ (148). Thorwaldsens Museum, Copenhagen.

TURNER, Joseph Mallord William (1775–1851)
3 *Heidelberg Seen from the Opposite Bank of the Neckar* 1844. Pencil and watercolour. British Museum, London, CCCLII-17.
4 *Nottingham Castle* 1838. Engraving from *Picturesque England*.
26 *Fonthill* c. 1799. National Trust for Scotland, Brodick Castle, Isle of Arran.
116 *Light and Colour (Goethe's Theory) – the Morning after the Deluge* 1843. 31×31 (78.7×78.7). Tate Gallery, London.
117 *Fishermen at Sea* 1796. 36×48 (91.5×122). Tate Gallery, London.
118 *Wreck of a Transport Ship* 1805–10. $68\frac{1}{8} \times 94\frac{7}{8}$ (173×241). Fundacão Calouste Gulbenkian, Lisbon.
119, 126 *Slavers Throwing Overboard the Dead and Dying – Typhoon Coming On* 1839. $35\frac{3}{4} \times 48$ (91×122). Courtesy Museum of Fine Arts, Boston.
120 *Interior at Petworth* c. 1837. $35\frac{3}{4} \times 48$ (91×122). Tate Gallery, London.
121 *Rain, Steam and Speed* 1844. $35\frac{3}{4} \times 48$ (91×122). National Gallery, London.
122 *Hannibal Crossing the Alps* 1812. 57×93 (145×236). Tate Gallery, London.
123 *Walton Reach* c. 1810. Oil on wood 14×29 (35.6×73.7). Tate Gallery, London.
124 *Norham Castle* c. 1840. $35\frac{3}{4} \times 48$ (91×122). Tate Gallery, London.
125 *The Campanile and Ducal Palace at Venice* 1819. Watercolour $8\frac{7}{8} \times 11\frac{1}{4}$ (22.5×28.6). British Museum, London.

UPJOHN, Richard (1802–78)
93 Trinity Church, New York c. 1844–46. Lithograph after the artist's drawing, 1847. The J. Clarence Davies Collection, Museum of the City of New York.

VERNET, Claude-Joseph (1714–89)
22 *A Storm with a Shipwreck* 1754. Wallace Collection, London.

VERNET, Horace (1789–1863)
193 *Mazeppa* 1826. $43\frac{5}{8} \times 54\frac{3}{8}$ (110×138). Musée Calvet, Avignon.

VIOLLET-LE-DUC, Eugène Emmanuel (1814–79)
91 The Chapter House, Notre-Dame, Paris 1847.

WARD, James (1769–1855)
175 *Lioness and Heron* 1816. Museo de Arte de Ponca (The Luis A. Ferre Foundation), Puerto Rico.

WEST, Benjamin (1738–1820)
37 *Death of General Wolfe* 1770. $59\frac{1}{2} \times 84$ (151.1×213.3). National Gallery of Canada, Ottawa, Gift of the Duke of Westminster, 1918.

WIERTZ, Anton (1806–65)
197 *Buried Alive* 1852(?). $71 \times 100\frac{3}{4}$ (180×225). Musée Wiertz, Brussels.

WILKIE, Sir David (1785–1841)
195 *Josephine and the Story Teller* 1837. 83×62 (210.8×157.5). National Gallery of Scotland, Edinburgh.

WILSON, Richard (1714–82)
137 *Holt Bridge on the River Dee* c. 1762. $58\frac{1}{2} \times 76\frac{1}{2}$ (149×194). National Gallery, London.

WRIGHT, Joseph, of Derby (1734–97)
16 *Sir Brooke Boothby* 1781. $58\frac{1}{4} \times 81\frac{1}{4}$ (148×206). Tate Gallery, London.
29 *Philosopher Giving a Lecture on the Orrery* 1766. 58×80 (147.3×203.2). Derby Art Gallery.

PHOTO CREDITS

Index